FROM HELL TO HOLLYWOOD

The Incredible Journey of
AP Photographer Nick Ut

HAL BUELL

Foreword by Bob Schieffer Afterword by Peter Arnett

The Associated Press
200 Liberty Street
New York, NY 10281
www.ap.org

Paperback: 978-0-9990359-9-3
(Published by The Associated Press, New York)

Cover Design: Deena Warner Design, LLC
Cover Photo: Courtesy of Remo Buess
Interior Book Design: Kevin Callahan, BNGO Books
Project Oversight: Peter Costanzo

Visit AP Books: www.ap.org/books

AUTHOR'S NOTE

In telling the story of Nick Ut and his iconic photograph, we have avoided the use of jargon. Thus military, diplomatic and journalistic terms are expressed in everyday language, not insider terms. At the same time, it would be cumbersome to avoid shorthand descriptions of organizations and groups that are repeated. The following brief glossary of these terms should help readers unfamiliar with the history of the Vietnam War:

ARVN—The Army of the Republic of Vietnam (South Vietnam)

NVA—The army of North Vietnam

NLF—The National Liberation Front, the official name of the opposition group in South Vietnam and the formal name of the Vietcong.

VIETCONG—Pejorative but common reference to the guerrilla forces that opposed the government of South Vietnam.

VC—Short for Vietcong.

VIETMINH—Descriptive of the guerrilla force that opposed the French colonial government after World War II and eventually defeated the French at Dien Bien Phu in 1954.

AP—Associated Press, the American news agency.

UPI—United Press International, American news agency that was a competitor to AP.

CAO DAI—A religion with some 5 million followers that originated in Vietnam. The Cao Dai temple figures prominently in the story of the Napalm Girl photograph.

• • •

Vietnamese names are stated in what Westerners would consider reverse order. Thus in the name Huyhn Cong Ut, Huyhn is the family name, and Ut is the given name. Huyhn equals Smith, Ut equals Tom.

Americans pronounce Nick Ut's name as in "nut." Vietnamese pronounce his name as in "boot."

Lastly, during my career at The Associate Press, I was frequently involved with Vietnam photo coverage. When those duties are relevant to this story the term "I" refers to the author.

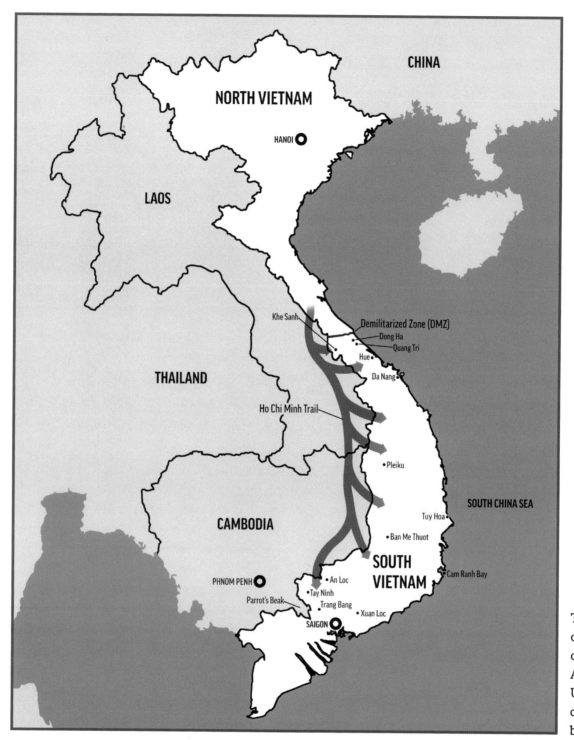

CHINA

NORTH VIETNAM

HANOI ◉

LAOS

THAILAND

Khe Sanh
Demilitarized Zone (DMZ)
Dong Ha
Quang Tri
Hue
Da Nang

Ho Chi Minh Trail

Pleiku

CAMBODIA

SOUTH CHINA SEA

Tuy Hoa

Ban Me Thuot

SOUTH VIETNAM

Cam Ranh Bay

PHNOM PENH ◉

An Loc
Tay Ninh
Parrot's Beak
Trang Bang
Xuan Loc
SAIGON ◉

This map locates many of the cities and areas of South Vietnam where AP photographer Nick Ut captured moments of the nation's war between 1965 and 1975.

CONTENTS

FOREWORD

BOB SCHIEFFER, CBS NEWS

In December of 1965, I wandered unannounced into the Associated Press bureau in Saigon. I was a reporter for my hometown newspaper, the Fort Worth Star-Telegram, and I had come to Vietnam to cover the war.

I must have been quite a sight to bureau chief Ed White, who was the first person I saw. Because it was winter back in Texas, I had worn a wool suit on the flight over and I was dragging an 80-pound suitcase in the days before suitcases had wheels.

By the time I made my way to the AP office, wrestling with the suitcase in Saigon's heat and humidity had left me exhausted and sweating so profusely that I had actually sweated through the tops of my shoes.

I felt a little dizzy but I told him who I was and I'll never forget his first words: "Do you want a drink of water?"

I did. To be specific: I wanted a drink of water more than anything in the world at that particular moment.

I had come to the AP office because I didn't know where else to go. I was the first reporter that the Star-Telegram had sent overseas since World War II, so there was no one to meet me. Luckily, Mike Cochran, the AP correspondent in Fort Worth, told me to be sure and stop by the AP bureau in Saigon, which is how I came to meet Ed White.

He asked if I had a place to stay and when I said no, he told me I could use one of the rooms the AP reserved in Saigon's historic Continental Palace Hotel. (It was the one place in Saigon that I at least knew about. It was featured in Graham Green's novel, The Quiet American, which I had read on the flight over.)

Before the day was out, White told me I could use the AP office to get my mail, showed me where I should go to get credentials and where to buy equipment to go into the field. (That turned out to be the black-market stalls in the streets outside the bureau.)

He also introduced me to the staff. He put faces to the bylines I had been seeing on the AP stories and pictures—Peter Arnett,

Richard Pyle and George Esper and the photographers Horst Faas and Eddie Adams. Peter, George and especially Eddie would become lifelong friends.

There was also a friendly young Vietnamese teenager cleaning and working in the photo darkroom. After reading this book, I realized that teenager was almost certainly Nick Ut. Nick's older brother My, who had been killed in combat a few months earlier, had been a CBS News cameraman who had been recruited by Faas to become an AP photographer.

As you will read in this book, Nick had pestered the bureau to let him replace his brother, but Faas and White at first refused to take on an untested 15-year-old boy and assign him to one of the most dangerous jobs in the world. They finally agreed to let him help out around the bureau, running errands and doing odd jobs. Finally, they gave him a camera and sent him into the field.

Vietnam became known as the television war, and certainly it was that. But I always felt that it was the still photos that froze a moment in time that had the greatest impact on our psyche. And there was only one way to get them—whatever the danger, a photographer had to be there at that specific moment.

There were some great photographers in Vietnam, but none better and none braver than the Associated Press crew. I say that with good reason. As the months rolled by, I became friends with Eddie Adams. We traveled in the field together. I helped him with cutlines, and he taught me to take pictures.

It is not by coincidence that the three most iconic photos of the war were all taken by AP shooters—Malcolm Browne's picture of the monk setting himself on fire on a Saigon street, Eddie's picture of the South Vietnamese colonel holding a gun to the head of a Vietcong prisoner and executing him. And perhaps the most unforgettable of them all, Nick Ut's picture of the naked and badly burned child fleeing the napalm bomb that had been dropped by mistake on her village.

This book of Nick Ut's pictures and Hal Buell's wonderfully spare prose about Nick's life is so much more than a long-deserved tribute to Ut. It is a recognition of the courage, bravery and professionalism of all the photographers whose work in Vietnam helped us to understand the awful cost of war.

We owe all of them for that.

Foreword

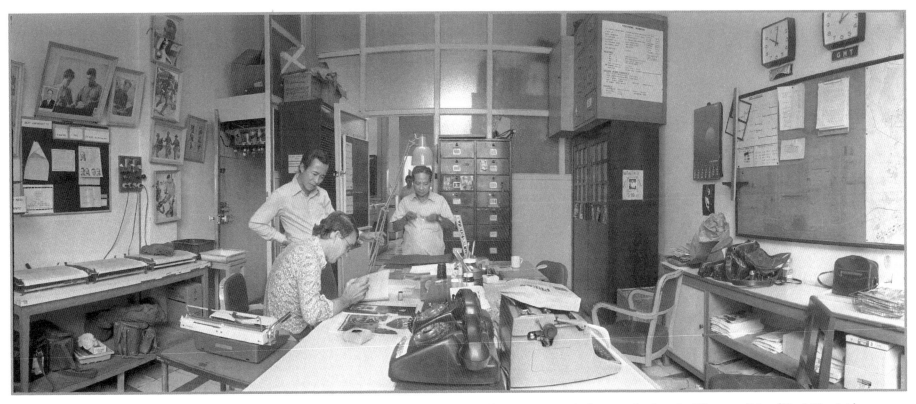

▲ The photo operations of AP's Saigon bureau where photographers and editors processed pictures during the Vietnam War. (Neal Ulevich)

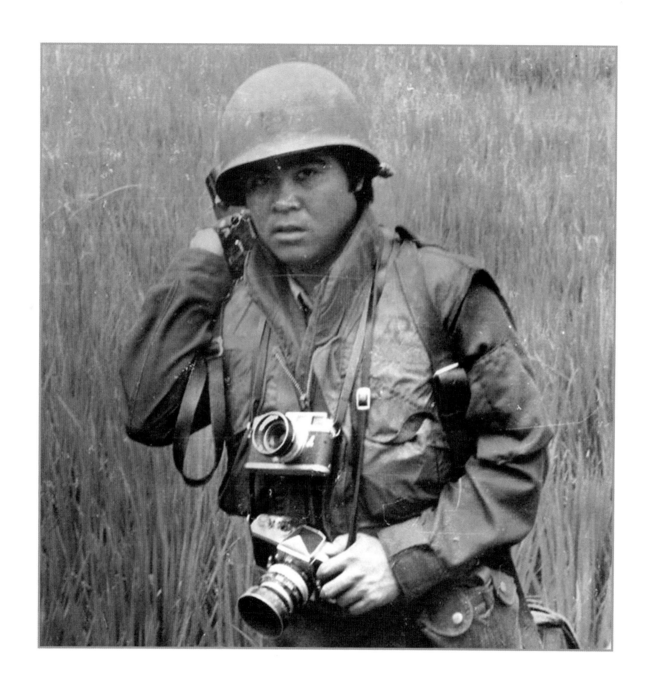

INTRODUCTION

Most of the world saw the Vietnam war through the lens of a camera. That is not surprising. War has drawn photographers to its bloody encounters since the invention of photography. Just as certain as war's magnetism for photographers are the deadly risks of combat photography, risks that often prompt photographers to wonder in the madness of battle, "What am I doing here?" Regardless of the answer, they visit the madness again another day.

That was not the case with Huynh Cong Ut, better known as Nick Ut. He did not seek out war; war and its risks came to him. Nick's childhood in Vietnam's Mekong Delta exposed him to on-again, off-again firefights between Vietcong and government troops as well as night encounters with Vietcong seeking to draft young fighters. As a boy and well into his youth, Nick Ut lived daily with violent conflict.

The Vietnam War that Nick knew was photographed unlike any previous war; it is unlikely any future war will be photographed the same. Access to conflict in recent wars has not been as available to photographers as it was to those in Vietnam. Nick Ut did not know that. He did not know the history of combat photography nor was he aware of the role photography played in the world of power politics. Nick simply wanted to be like his brother whom he deeply admired: the brother who preceded him as a combat photographer, the brother who wanted to record his country's struggle to survive, the brother who hoped his photographs would help end the bloodshed. Because of his brother, Nick was exposed to photography in his pre-teen years, and his brother's death in battle instilled a powerful ambition in his heart and mind to become a photographer. Just 14 when his brother was killed, Nick knew that to achieve his ambition would be difficult for many reasons, not least his youth and inexperience. But he prevailed and became an AP combat photographer.

On a June day in 1972, Nick Ut made a photograph of a young, naked girl severely burned by the inferno of exploding napalm. The photo was widely published and was awarded a Pulitzer Prize as well as many other journalistic honors. It endured over the decades as a

reminder of the horror faced by innocents caught in war's violence. The image is said to be "a picture that does not rest."

It is easy—and it is accurate—to say a photograph captured at 1/400th of a second can become the defining moment of a person's life and, by extension, the lives of others washed over by its influence. There is more to it than that. There is a before and an after, preceding and following that split second. In Nick's case, the before and after make up the story of a photographic journey that he traveled for more than half a century, a unique journey not envisioned by the boy who grew up in the Mekong Delta. It is a story of unrelenting war, of bearing the grief of family and colleagues slain in battle, of the bond created by the image of a child-victim of war, of refugee camps, of leaving homeland and family, of being thrust into challenging foreign lifestyles. Throughout that journey Nick's constant companion was his camera, as much a part of his dress as the clothes he wore. The camera became more than a metal and glass tool. It was and remains the way he speaks to the world.

Nick caught his share of breaks. He landed a job with The Associated Press, where he was mentored by the best photojournalists in the risky world of combat photography. He was gifted with a winning personality. Seriously wounded, he came to know how far to go before the rules of chance turned against him.

His instincts, his photographer's eye trained in that milieu, did not fail him that June day when the severely burned child emerged from battle smoke on a Vietnamese highway.

The photographic icon Nick made of Kim Phuc launched his life—and hers—beyond the borders of their homeland. That fraction of a second on that distant highway bonded Nick and Kim forever. They traveled separate roads, roads that intersected at times and in places far from Vietnam. Their bond never weakened. It remains today, after nearly five decades, stronger than ever.

Nick Ut's story extends past the boundaries of war and Vietnam. Though his journey tells us how the war was fought and photographed and how those photos delivered a message of war's brutality, his life has also seen an unlikely passage to the fantasy glitz of Hollywood.

Why another book on Vietnam?

Most books on Vietnam are in words. Some are in pictures. Few are in words and pictures. Most Vietnam photo books are by Western photographers who lived in Vietnam during the war. A search fails to reveal a book about a Vietnamese photographer, let alone a Vietnamese photographer who lived with the war from childhood.

At the same time, Nick Ut's story does not pretend to be the ultimate, representative tale of the Vietnam experience at mid-20th century. It is the story of a single person who experienced war, closeup and personal, and who survived to live a totally different postwar life in another world.

Finally, this unique story illustrates the human spirit and its capacity to meet and overcome obstacles that seem, at moments in time, to be insurmountable.

Introduction

(Courtesy, Scott Templeton)

Each day you work as a photographer you face issues, some trivial, others more grave. And you never know what is going to be the moment of grand success or total failure. But it is that desire to tell the story, to reach out with the language that needs no words, which keeps us going.

— David Burnett
Co-Founder, Contact Press Images

A Boy's Life in the Delta

In his village of Ky Son in Vietnam's Mekong Delta, Huynh Cong Ut moved quickly to a stack of discarded boxes, crawled in among them, pulled one large box in front of him and waited quietly. The 12-year-old in the hastily built cardboard cave was invisible to casual glances of passing Vietcong troops, but he worried that the flimsy hiding place would not withstand the thrust of their bayonets.

The boy took to hiding because he was all too familiar with what could happen on dark, moonless nights here. This night, awakened from sleep, he had peered through a window; black figures were faintly visible in the dark hours before dawn's first light. He moved quietly from the window to the boxes, his breath barely a whisper in his ear. The near silence amplified the rushing sounds of the river, mixed with the closer, muffled drag of stealthy movements.

He crouched motionless in the boxes as the VC unit, traveling from their sanctuary near the Cambodian border, passed through Ky Son. Other nights the village was not so fortunate. Vietcong sometimes came in search of rice or other food. Or to threaten village leaders and force them to cooperate with plans for anti-government attacks. VC might be positioning themselves for an attack on nearby government units. Or to conscript—or, better said, seize—young boys like Ut, take them to their Cambodian camp and indoctrinate them into the ways of the Vietcong. Boys from Ut's village had disappeared only to return to Ky Son weeks later armed with weapons and in the company of Vietcong.

Tonight's immediate danger passed, however. His family was not roused from slumber, and soon the dawn forced the intruders back to their camps. Young Ut would never know why they came

or whom they visited. He left his hiding place and prepared for his bicycle ride to school. That is, if school was not closed as it often was when Vietcong were suspected or reported active in the area.

Ut's hometown area had often been threatened. After the French colonial rulers were defeated at Dien Bien Phu in 1954, battles between government troops and VC guerrillas were fought for years in Long An province, often within earshot of Ky Son. Ut sometimes heard the rattle of automatic weapons or the explosions of hand grenades. While the night belonged to the VC, there were times when they paraded in daylight along the village's main road waving their arms to salute victories claimed over the skimpy Army of the Republic of Vietnam, or ARVN, forces. Ut and other villagers watched in silence.

Still, during pauses in the fighting, life retained much of the Mekong Delta's historic ways. In the farming community of Ky Son, with its canals and tributaries of the 2,700-mile-long Mekong River, rice crops were bountiful. Silt deposited annually by the river nourished paddies that made the Delta Vietnam's rice basket.

Ut was born in Ky Son on March 29, 1951, the 11th of 12 siblings, all boys except for a single daughter. The area was relatively quiet immediately after the 1954 French defeat. No longer disturbed by fighting between the French and the anti-French Vietminh, rice farmers worked their paddies.

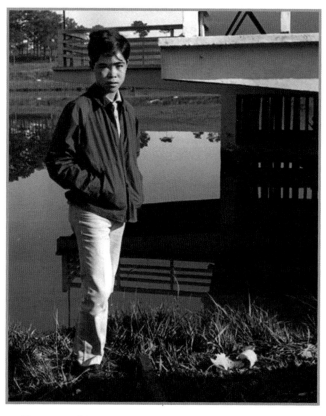

▲ Teenager Huynh Cong Ut, near his home in Ky Son, South Vietnam.

But the peaceful interlude faded. Ky Son fell under the crosshairs of government skirmishes aimed at breaking up heavily armed crime groups, one widely known as Binh Xuyen. Soon outright battles were fought and public places were bombed in Saigon, only an hour's drive away. National elections were promised to resolve whether North and South Vietnam would merge as a single nation, but a 1956 voting deadline passed and hopes for elections were abandoned.

South Vietnam established itself as an independent nation, and soon the North reactivated the old Vietminh units, renamed Vietcong, and an all-out guerrilla war took root. Aggressive anti-government activities by Vietcong terrorized villages and cities of the Mekong Delta, and generally throughout South Vietnam. The U.S. came to the new government's aid in an effort to block communist expansion in the region.

As Ut grew into his teenage years, new faces appeared in the Delta: American military advisors who trained ARVN troops. The Americans often joined Vietnamese troops in firefights with the Vietcong on the rivers and in the muddy paddies around Ky Son.

Other changes, too, were felt by the Huynh family. In 1963, a Buddhist monk set fire to himself in Saigon to protest the Catholic-dominated national leadership's treatment of Buddhists nationwide. A photograph of the immolation made by AP's Malcolm Browne

flashed around the world, boosting Vietnam's backyard war into international headlines where it remained for more than a decade. In the same year, South Vietnam's President Ngo Dinh Diem was assassinated, as was America's President John F. Kennedy. Ut saw tears shed by Ky Son villagers for the two leaders' deaths.

War steadily expanded, and the family felt a personal impact: Two of Ut's brothers were directly involved in the conflict, one an ARVN soldier, the other a journalist with American news organizations.

As often happens in families with many siblings, Ut grew attached to one special brother, Huynh Than My. My was more than 10 years older and was a brother to admire. He was strikingly handsome and had, before the Vietcong activity, moved to Saigon where he acted in Vietnamese movies and became reasonably well known. But he changed careers and took a job with CBS-TV, which along with other international TV networks and news agencies covered an Indochina war that was growing hotter by the day.

My worked as a photographer and sound man lugging the heavy, cumbersome television equipment to battle sites in the Delta. Colleagues at CBS as well as other correspondents marveled at My's stamina and at his daring in battle. They found him a trusted companion in combat and in Saigon. When on assignment in the Delta, My would visit his home in Ky Son, spending time with Ut who often helped him with equipment organizing, cleaning and packing gear.

Ut spent hours hearing stories of his big brother's movie experiences, about the pretty young women who paid him attention in Saigon and about the war and his sense of a duty to show it to the world. In 1963, My was recruited by Horst Faas, AP's Saigon photo boss, to join the growing AP staff of still photographers. My showed Ut the pictures he made of war in the Delta, inciting in the teenager's imagination an ambition to become a war photographer like his brother.

Ut recalled later: "He told me that he wanted to make photos that showed how bad the war was. He hoped his pictures would help bring the war to an end."

He added: "My brother taught me photography and taught me how to use his Rollei camera. I wanted to learn how to use the Nikon and the Leica that he used covering the war." My told his brother that he would become a photographer, but it would take time to learn, that he was still a young boy and inexperienced.

As they grew closer, Ut called his brother Anh Bay, No. 7, because he was the seventh child born to the family. Ut's name meant the youngest of the family, so called because he was thought to be the final child. (A 12th child was born and called Ut-2.)

In 1963, My married Hieu Arlette who as a child in 1954 fled North Vietnam with her family. Ut and several members of the family attended the wedding in Dalat, the hometown of the Hieu family, where Arlette's father had been captain of the local police. Though My's parents objected to the wedding because Arlette was a Northerner, Ut liked the bride, who would become a life-long friend. My's fellow AP staffer and friend Le Ngoc Cung photographed the wedding party.

As the bond between My and Ut grew stronger during these years, the early 1960s, the older brother feared that escalating warfare in the Delta threatened his young sibling's safety. He suggested Ut live with him and Arlette in Saigon where, despite some terrorist activity, he would be safer than in the Delta. The family concurred, and Ut moved in with his brother in 1964.

Saigon offered the teenager a more exciting lifestyle than Ky Son. Architecture in the French manner lined many boulevards shaded by huge trees. From shops and on sidewalk blankets, vendors shouted the benefits of products that met every need of a cosmopolitan populace. Exotic aromas from food stalls and wagons tempted Ut

as he dodged through streets crowded with bicyclists, motor bikes and Vespa scooters. Many of the cyclists were young women dressed in ao dai, the flowing garment, usually white, that looked more like a negligee than street dress. Armed ARVN at important buildings were constant reminders that the war continued and that Saigon's restaurants and bars could be targeted by VC bomb throwers.

Ut signed up for school, but his focus was on working with his Rollei. Whenever My was home—he was often on assignment in the Delta—there was time for the brothers to talk over dinner in one of Saigon's restaurants. They discussed photography and reviewed photos made by My, who continued to encourage Ut to become a photographer.

Arlette gave birth to a baby daughter, Teena, in 1965. That delighted Uncle Ut, who frequently took care of her while My and Arlette were away. Years later when he recalled those times, his voice and body language reflected his empathy for children. Especially children like those he saw in My's photos, youngsters trapped in war or fleeing the violence of battles that destroyed their villages or left them orphans.

In May 1965, My suffered an arm wound while on assignment with an ARVN patrol in the Delta. Ut helped take care of him during his week-long hospitalization and during several weeks of recuperation. The brothers had long conversations about the war and the way My photographed its brutality, My always telling Ut that he wanted his photos to help end the violence.

Once fully recovered, My went back to covering the war in the Delta, where his knowledge of the terrain and the Vietcong guided him to areas of VC activity.

And Ut returned to his boyish routines. School bored him, but he compensated by experimenting with photography. Persistent shadows of the war were a constant reminder of his ambition to follow his brother's example, his dream of becoming a cameraman one day. One day soon.

Meanwhile, at home there were frequent visitors for an afternoon of conversation and a friendly card game. On October 13, 1965, five family members dropped by. The meal Arlette prepared filled the house with the delicious smells of Vietnamese cuisine, and baby Teena was quiet, making only an occasional call for attention. Cards were dealt, and the players who gathered around the table chatted over their hands. When Arlette's turn came to pick a card, she drew a black knight. That was a bad omen as she interpreted it, Ut would recall later.

The game continued. After a while, the players were interrupted by the sudden appearance at the apartment of AP photographer Le Ngoc Cung and a friend. Tears filled their eyes and streaked their faces. In barely audible tones, they told Ut and Arlette that My had been in a battle at Can Tho, not far from Ut's birthplace. Cung reported what he knew: that My had suffered bullet wounds to his chest and shoulder. As he awaited helicopter evacuation, the Vietcong overran the ARVN position—and killed the wounded.

In that moment, the worlds of Huynh Cong Ut and Arlette collapsed. She was now a 21-year-old widow with a 5-month-old daughter. He was a teenager whose mentor, the central foundation of his life, was taken away. No longer would there be stories of photography in the Delta; no longer would there be pictures to discuss, a future to plan. His brother was gone and with him the source of inspiration that nurtured Ut's ambitions. For both Arlette and Ut, life would have to go on but it would not be shared with the man they loved and admired.

The next day, AP Chief of Bureau Ed White and photo editor Sam Jones went to the Delta to recover and escort the return of My's body to Saigon for burial. My's death had a double impact

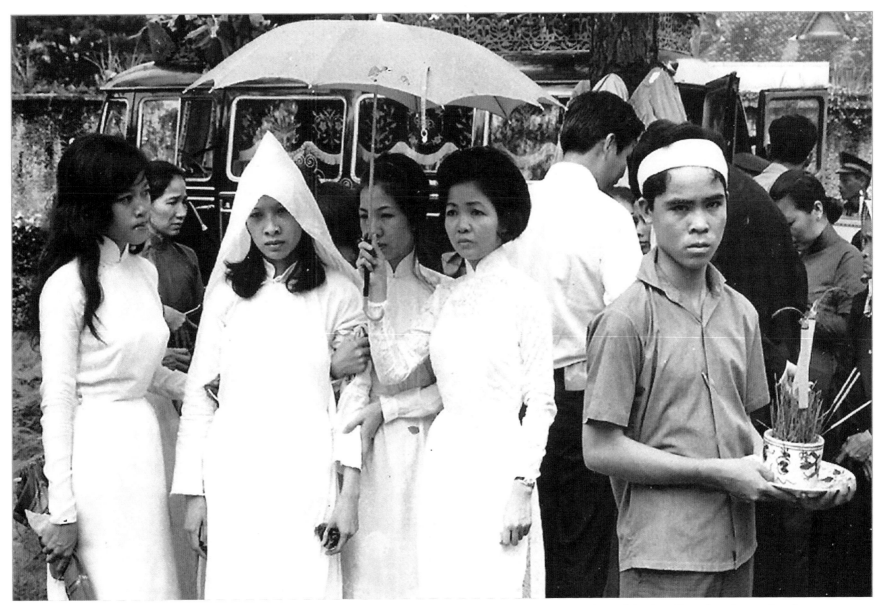

▲ Mourners gather at the funeral of Huynh Thanh My in Saigon in October 1965. At far right wearing white headband and carrying incense is Huyhn Cong Ut, My's younger brother. In the center dressed in a white mourning gown and a white pointed mourner's hat is My's widow, Arlette. Others are newsmen and family members. (AP Photo/Le Ngoc Cung)

on the AP staff. Weeks earlier, Bernie Kolenberg, a photographer from the Troy, New York, Times-Union, only recently arrived in Saigon to join the AP staff, was killed in a fighter-bomber crash in Vietnam's Central Highlands. White and Jones recovered his remains also.

My's death had a sobering effect on the ranks of the Saigon media, well known as he was for his work with AP and CBS since the earliest days of the war.

Horst Faas, who recruited My from CBS, was in New York to make a presentation on the war to a major AP meeting when word of My's death reached headquarters. I recall his reaction clearly. We were in a corner of the fourth-floor photo section at the Associated Press building in Rockefeller Plaza. Our conversation stopped when the message came through from Saigon. Horst sat down at a desk and reread the message, which was teletyped on a narrow scrap of paper. He put his arms on the desk, lowered his head on them and wept as only a fellow photographer who covered the war could weep. Teletype printers clacked away, their sound mixing with the squeal of photo transmissions and the muffled conversation of editors. Twenty feet away: the body-shaking image of Horst, nearly silent. It was a concerto never to be forgotten.

In Vietnam, My's funeral was attended by most of the Saigon press corps. Ut would proudly recall the large showing for the Buddhist ceremony: "Oh, a hundred people, journalists and family members . . ."

During the rites, much attention was paid to Arlette, who was dressed in a ceremonial, full-length white gown and tall, pointed headwear. Buddhist chants mingled with hushed conversation among the news people. Young Ut, wearing a mourner's white headband, accepted condolences from both Vietnamese and foreigners.

It was his first meeting with the AP staff. Ed White was present as was Sam Jones, along with photographers Rick Merron, Henry Huet, Eddie Adams, editor Carl Robinson and others. Though paying attention primarily to My's young widow, the AP staff members noted that My's brother, despite his youth and his boyish appearance, conducted himself with maturity.

Asian ceremonial music, mixed with Buddhist chants, accompanied the cortege on the two-mile walk to the cemetery.

Several weeks later, Arlette and Ut visited the AP bureau. She was there to arrange final details on insurance provided to the families of staff who died in the war. While in the office, she talked with Faas about a job for young Ut as a photographer with AP, in effect filling the vacancy left by My's death. They lobbied that Ut needed the job, another brother in the ARVN had been killed in battle, and only two years earlier Ut's father had died. The family needed the resources Ut would provide. Both Faas and White were adamant in their view that there was no place on the AP staff for such a young, inexperienced photographer. Faas contemplated the risks involved and how yet another death could affect the family; he could not accept the responsibility for someone so young. Return home and go to school, he told the teenager, or seek employment in some other way.

Ut was devastated once again. His dream of becoming a combat photographer and his hope of following his brother were dashed. He saw an empty future. My, his mentor, had told him how to evade Vietcong patrols in Ky Son. My taught him photography, brought him to Saigon where he found a new life. My helped him build ambition. Young Ut was at a loss as to what to do. But there was no big brother, no Anh Bay, No. 7, to guide him.

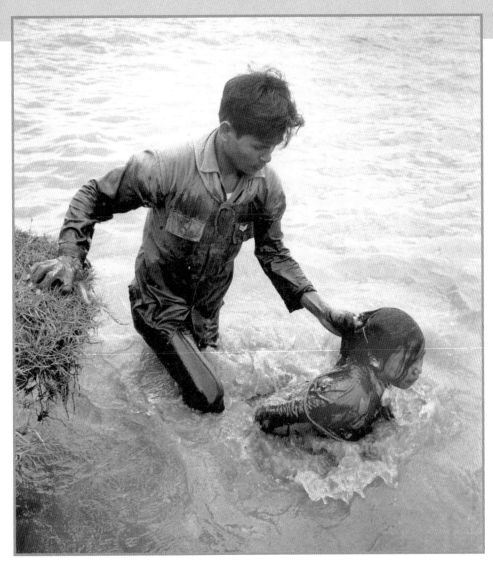

▲ A South Vietnamese soldier interrogates a female Vietcong suspect by dragging her underwater during an operation in the Mekong Delta, August 1965. (AP Photo/Huyhn Thanh My)

▶ Line of body bags containing ARVN fatalities await evacuation on a rice paddy dike in Tan Dinh island. (AP Photo/Huyhn Thanh My)

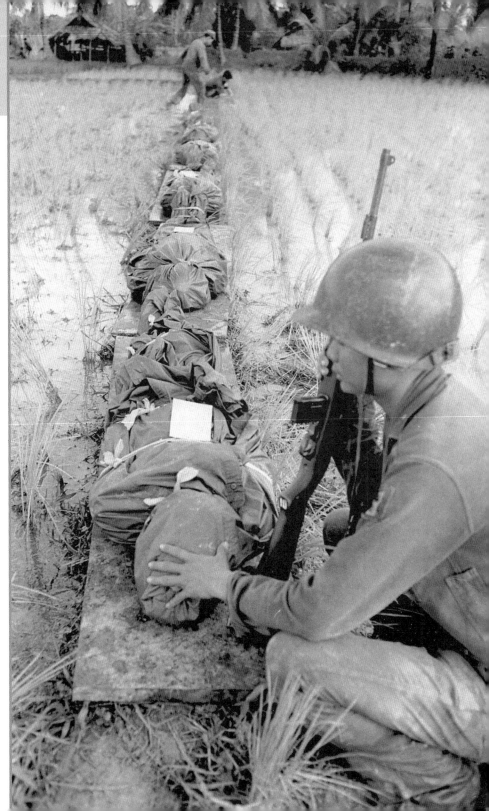

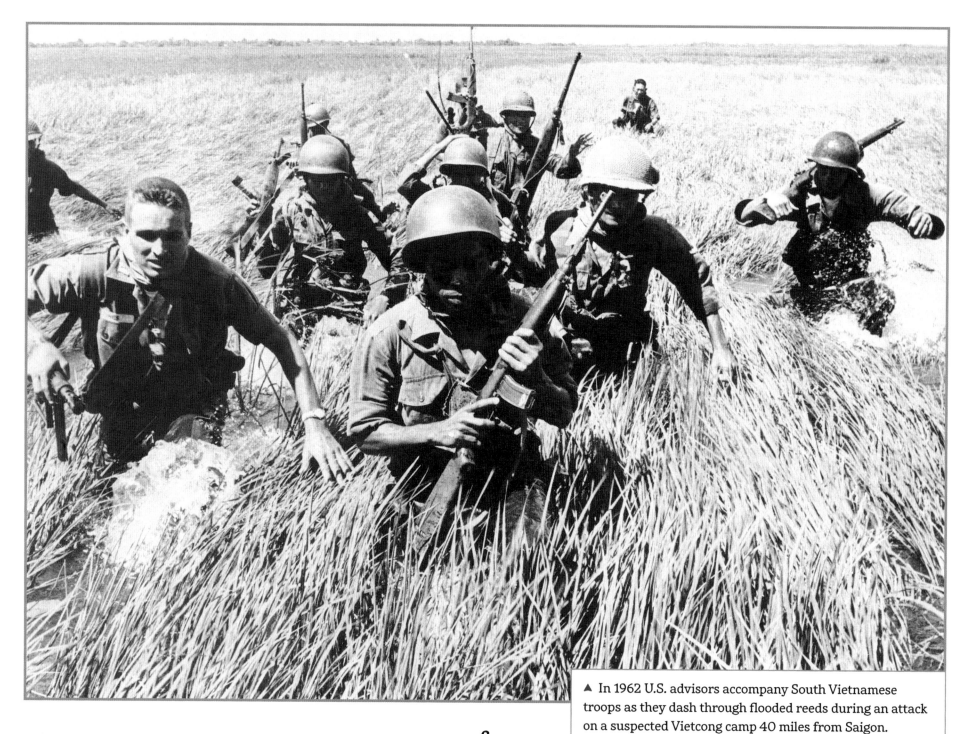

▲ In 1962 U.S. advisors accompany South Vietnamese troops as they dash through flooded reeds during an attack on a suspected Vietcong camp 40 miles from Saigon.

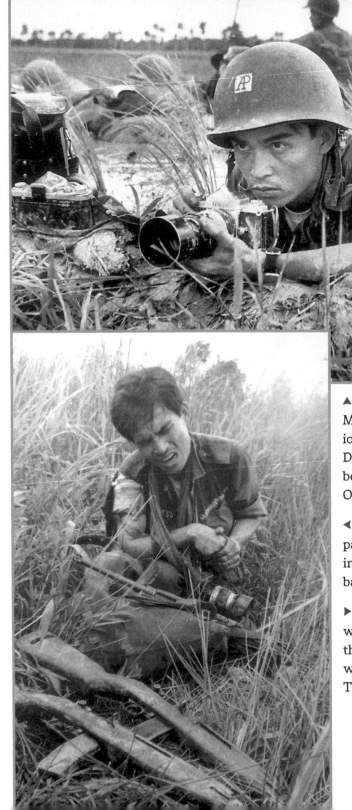

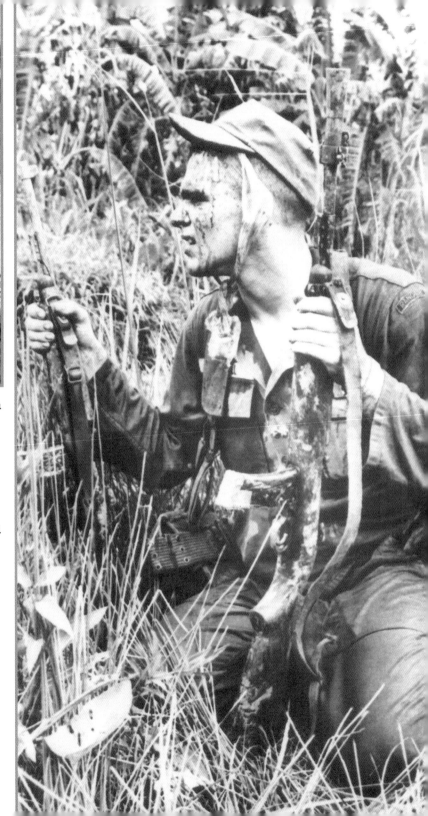

▲ Ut's older brother, Huynh Thanh My, covers a Vietnamese battalion pinned down in a Mekong Delta rice paddy about a month before he was killed in combat on October 10, 1965.

◄ Huyhn Thanh My struggles with pain of a shoulder wound suffered in the spring of 1965 during a battle in the Mekong Delta.

▶ Moments before he was wounded Huyhn Thanh My made this photo of an American advisor wounded. (AP Photo/Huyhn Thanh My)

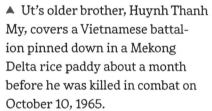

9

▲ Wounded South Vietnamese soldier helped by his buddies during May 1965, battle in the Mekong Delta. (AP Photo/Huyhn Thanh My)

Working at the Saigon Bureau

War in Vietnam escalated dramatically in 1965. The U.S. dispatched combat troops to Indochina for the first time, increasing the 23,000-man advisor corps to 185,000 mostly combat personnel; the number would rise to more than 550,000 by 1968. The Associated Press in Saigon likewise increased both American and Vietnamese news and photo staff. Added American presence was reflected in photo coverage; pre-1965 photos of combat presented primarily a Vietnamese face, which afterward morphed into an American face.

At the same time, Huynh Cong Ut 's life went on hold. Gone, it seemed, was the opportunity to emulate the brother he so admired. He continued to live with his sister-in-law Arlette and his baby niece Teena, but his ambition to become a photographer seemed more elusive than ever.

Horst Faas, AP's Saigon photo boss, had valid reasons for ruling out a staff spot for Ut. The teenager's youth and inexperience were at the top of the list. His reluctance to hire Ut was also influenced by the personal pain Faas suffered over the death of My, whom he had aggressively recruited from CBS and whose telling photographs of Mekong Delta fighting he respected.

As for My's little brother, Faas later recalled: "Ut was an unknown entity to all of us, because he was a child at the time; he was 15 years old. We didn't know he existed. Never heard from his brother about Ut. I didn't hear much about his family. I knew that Huynh Than My had just been married and they had a child and were happy. And that he made money and was famous in Vietnam as a cameraman."

When My's widow came to the office after his funeral and said the family would like AP to employ Ut, "I was dead set against hiring

him because he was a child," Faas said. "And even under the best of circumstances working in the AP office was a bit of a rough thing, and I couldn't have children there."

Faas understood the dangers of combat photography. He took charge of the Saigon photo operation in 1962 after AP assignments in the Congo and Algeria. Challenges to personal safety in Africa were a daily reality while chasing meaningful picture subjects in an unpredictable political and revolutionary environment. Faas built a reputation as a seasoned journalist who had a way with a camera, and that experience guided his Vietnam photography. In 1965, he won the first Pulitzer Prize awarded to Vietnam photo coverage with a remarkable collection of images that captured war's brutality as seldom seen previously and that set a standard for future coverage. One of his photos showed a father holding his burned child's body; others ranged from interrogations in the jungle to violent street demonstrations in Saigon.

At the same time, Faas organized a staff of local photographers and stringers, and when the bureau moved to larger quarters, he constructed a professional photo lab to replace the toilet that served as AP Saigon's first darkroom.

Faas believed the Ut issue settled, but he underestimated the persistence the teenager would bring to bear in his pursuit of a job. A week after his first meeting with Faas and consistently thereafter, Ut pestered both Faas and White for a photographer's slot. He finally said he would do anything—run messages, sweep the floor and clean up—if AP would just give him a chance. At last, Faas and White relented. They would make a spot for him—but with Faas' hard-and-fast rule, no exceptions permitted, that Ut would not photograph combat. Not ever.

Young Ut jumped at the chance and joined AP early in 1966.

AP's office was in central Saigon. Depending on whether one used the French or American system of counting floors, it was on the fourth or fifth. AP and NBC shared the entire floor, creating an atmosphere and flavor of busy news operations. The AP quarters were L-shaped, with a reception desk at the front, clipboards with stories for visiting correspondents, and a couple of offices. Bulletin boards with stories, messages, photographs and maps lined the walls. The newly built darkroom stretched along one side.

Ut was assigned to the darkroom where the picture flow was on the upswing, matching the increased U.S. combat action in Vietnam. He soon learned to develop film, make prints and keep the darkroom clean and tidy, all to Faas' exacting standards. Package shipments increased, stuffed with film and prints by AP staffers and shipped to Tokyo and New York distribution points. Newspapers assigned staffers to Vietnam to photograph hometown draftees fighting the war, and those photographers brought their film to AP for processing and printing. Handling the growing darkroom workload with Ut were Dang Van Huan and Le Ngoc Cung, who doubled as a photographer, and a darkroom technician. Ut also ran errands and sometimes visited Saigon's huge black market to find items needed for the bureau—field gear, perhaps, or a jacket or helmet. In time, with money in his pocket, he rented a small apartment not far from the office.

In the mid-1960s world of photography, there was much for Ut to learn in the darkroom. Printmaking from 35mm negatives taught him how important lighting was to good images. Seeing countless combat pictures made from every possible angle with a variety of lenses underscored the use and importance of composition despite difficult conditions. Ut was not daunted by the steep learning curve; in fact, he often said he loved the darkroom and seeing the pictures

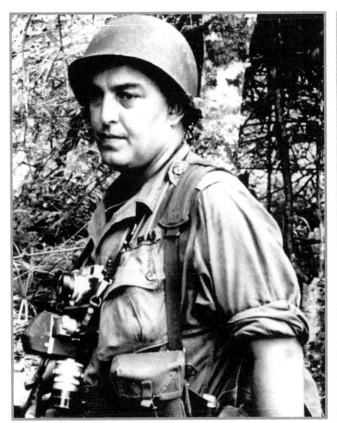

(Left to right) Horst Faas, Eddie Adams, Henri Huet

that passed through. Photo knowledge that he absorbed enhanced his ambition; his work in the darkroom, as much as he enjoyed it, did not reduce his compelling desire to photograph the war. Or his constant reminders to Faas that he wanted to be in the field himself.

Joining AP placed Ut in an environment of more foreigners than he had ever encountered. Years later he would remember how tall the Westerners were and how impressed he was by the kindness they showed him. They in turn recalled Ut's willingness to take on gopher work with a smile. Three bureau photographers soon became his mentors: Faas, Henri Huet and Eddie Adams. They made an impressive trio, respectively German, French/Vietnamese and American. Each was a distinct personality, and they dealt with Ut from different perspectives. Their influence would mark his career for decades. Their advice would guide him through the violence of future combat photography, a future that was still a dream but a dream closing in on reality as the months became a year. His good fortune was that his mentors were each dedicated picture journalists; from them he learned photography the hard way, day by day, print by print.

Faas was a demanding editor. Poorly printed photos were returned to the darkroom with an order to improve the quality. Faas scissored

prints to create dramatic cropping—the negative sent back to the darkroom for a new version. His critical eye watched over the temperature of chemicals to insure quality. All work required speed to make shipment schedules or for a run to the Saigon public communications station for transmission by radio to world points. In the wire service darkroom, Ut learned that there was more to news photography than shooting pictures.

Henri Huet, son of a French colonial engineer and a Vietnamese mother, was recruited by Faas with the help of Eddie Adams and joined AP about the same time as Ut. Huet had worked for UPI, where he scored world publications with his sensitive images made under fierce battle conditions. As a youth, Huet had studied art in Paris with an eye to becoming a painter. But he was drafted into the military and assigned as a photographer during the French war. He loved photography and Vietnam. After the French defeat in 1954, he opted to take his army discharge locally and remained in Indochina. Huet spoke Vietnamese, French and English and was considered one of Vietnam's finest photographers. A lovely, considerate, empathetic man, he developed a close relationship with Ut, teasing him about his boyish appearance and his young age. He called the teenager Nic-Nic, a Vietnamese idiom for the youngest member of a family or a group.

Eddie Adams was a former U.S. Marine Corps photographer in Korea. After that war, he won a long list of awards for his photography at American newspapers and during his years with AP in New York. He was assigned to Vietnam when U.S. Marine combat units arrived in 1965. Adams worked mostly out of the Marine base at Danang but when in Saigon he spent time with Ut, who developed his film shipments. Adams spared no one his prickly personality when he sensed interference in his photography, and Ut was quick to take note. He was especially impressed by Adams'

obsession to make "perfect pictures." Their friendship continued after the war.

Of his three mentors, Ut was closest to Huet, language being a natural connection. Despite his bravery on the battlefield, Huet was not the swashbuckling war photographer one might expect. He was a gentle man, given to quiet humor, private in many ways, and he was the AP staffer who most resembled Ut's brother. Huet's pictures were sensitive, often artistic, and obviously required remarkable courage that captured war's dramatic reality. He was easily liked and had many friends among both correspondents and the military that he met on his frequent trips to firefights and patrols.

Two Vietnamese shooters, Dang Van Phouc and Le Ngoc Cung, were also AP staff photographers.

Fierce battle was familiar to Phouc who had covered the war for several years as a stringer for AP before becoming a staffer in 1966. He was a longtime colleague and friend of Ut's brother, My. His bravery as a photographer was legend; he was wounded numerous times, once shot in the eye. Sent to Hong Kong for treatment, he returned to Saigon with a blue artificial eye contrasting with his real brown eye. Cosmetic surgery further left him with a decidedly Western look in one eye, which was eventually repaired. Phouc's father was an ardent anti-communist and village leader who was betrayed by relatives and murdered by the Vietcong. Phouc knew who killed his father and often sought assignments near Danang, hoping to find his father's killer. He frequently carried a weapon but never caught up with his target.

Cung likewise was a friend of My, and first covered string assignments before becoming an AP photographer. He also shared darkroom duties before Ut joined AP. Cung was the tearful photographer who brought word of My's death to his family members that night as they played cards in their Saigon home.

A minor problem arose as Ut became part of the staff. It was clear that, in the American way, he needed an AKA. His full name was complicated for the foreign staff and the brief "Ut" was not catching on. "Ed" and "Horst" and "Henri" were easy; others too. But what to call this new, young member of the crew? "Nic-Nic," Huet's teasing name, caught on, and some on the staff shortened that to Nic, which turned into Nick.

It stuck. Nick Ut. Not only in Vietnam but for the rest of his life. He was "Nicky" to his friends, and his smile made everyone his friend.

As Nick moved around Saigon—on errands, out for lunch, to and from his apartment—he made pictures. Street scenes, pretty young women in their sensual ao dai, vendors, anything that would catch his eye. And he would show his work to his mentors, listen to their critiques and absorb their tips. His photography of Saigon street life led Nick to his first break: He made pictures for a local story written by AP Pulitzer Prize-winner Peter Arnett, a feature on the city's sidewalk urchins—shoe shine boys, beggars, sellers of petty merchandise, and the like. The war created an army of orphans and homeless children, many of whom made a living by their wits harassing passersby in busy sections of the city. Nick 's photos were sent to New York, matched with Arnett's story, and won considerable display in newspapers.

Tearsheets sent to Saigon delighted Nick and inspired a vigorous campaign to do more photography. Faas endured a steady dose of Nick's pestering; in response, he reiterated his strict rule. There would be no combat in store for Nick. Maybe an occasional photo story around Saigon, but nothing more than that.

In December 1967, Faas was seriously wounded during a rocket attack, his leg and his life saved thanks to the quick action of an American military medic who applied a tourniquet and other battlefield repairs to a bleeding artery. By the time Faas, on crutches, returned to work, Nick had finessed local photographic assignments from substitute editors. He would often sleep on a cot in the darkroom so that if and when a bombing or rocket strike hit the city he could hop on his scooter and be first on the scene.

"Nick was unstoppable," Faas would recall, "and when I was in the hospital with an injury Nicky took over completely and had cameras . . . and when I got out of the hospital he took daily photographic assignments. I couldn't stop it anymore."

Huet was also wounded in 1967 and was out of action to heal, then assigned to Tokyo. Nick picked up more city assignments. Still, there was no combat photography outside Saigon for Nick—not yet. But Tet, in January and February of 1968, was just a few weeks away.

Tet is the greatest of Vietnamese holidays. It celebrates the Lunar New Year with a colorful mix of Christmas, New Year, National Day, birthday festivities and more. It is enjoyed by Vietnamese and foreigners over several days. The nation is on the move as country folk living in the city go home to visit family, pay off debts and party. In the cities, fireworks explode and many businesses close. Even war could be called off for the holiday.

In 1968, Tet fell from January 27 to February 2, and both sides announced a short truce that resulted in some components of the armed forces being given leave. The truce didn't cover the full seven days of Tet, but there was time for home visits as many took advantage of the promised interlude in fighting. Some military observers had reservations about the Vietcong and the North Vietnamese and remained skeptical of the enemy's holiday intentions; unusual troop movements were noted, and some American and ARVN units were put on alert. Overall, however, a holiday casualness prevailed. Nick took the opportunity to visit his family in Ky Son.

Skeptics were right. Early on Jan. 31, a massive force of some 80,000 Vietcong troops backed up by North Vietnamese regulars attacked most major cities in Vietnam. ARVN and U.S. troops,

caught off-guard, were unable to prevent enemy forces from over-running parts of cities, including Cholon, the Chinese section of Saigon. The U.S. Embassy was compromised when Vietcong suicide attackers breached a wall of the compound and killed several U.S. Marine guards. The invaders were killed and the embassy secured, but the incident was not lost on the American home front.

Fighting erupted around Ky Son, too. Nick made pictures and then rode his scooter back to Saigon unaware of the widespread fighting. Making it to the AP bureau, he excitedly reported he had photos, only then learning that Vietcong attacks were underway throughout the city and the country.

Citywide firefights and combat photography during the Tet Offensive swept Nick into urban guerrilla warfare. He knew Saigon; he knew the areas that were "safe" and where the danger was greatest. He rode his scooter to battles. He connected with Vietnamese troops that drove Vietcong fighters out of hiding. He witnessed and photographed the build-up of bodies. Along with other AP photographers, he followed the action over several weeks of the battle in the capital and its outer limits.

Early in the Tet fighting, he took inspiration from the image Eddie Adams made of a sidewalk execution, the iconic Pulitzer Prize-winning photo of Col. Nguyen Loan as he shot a Vietcong prisoner. Like Adams and the other AP photographers and reporters, Nick went looking for war. "I follow the smoke," he explained as his way of locating battles, since rockets and gunfire usually created towering black clouds. Following the smoke guided him to areas in Cholon where he found Vietnamese or American troops searching crowded wooden houses, kicking in doors of suspected Vietcong hideouts and training volleys of rifle fire at possible sniper locations.

Covering the house-to-house urban fighting was fraught with risk. Any window overlooking Saigon's crowded streets or any doorway in a darkened alley could conceal a sniper. And frequently did. Any quiet, seemingly deserted boulevard could suddenly explode into a fierce exchange of gunfire. ARVN and U.S. combat patrols were caught on open streets, photographers with them likewise a target. The simple act of going home—on those nights when he did not sleep in the AP bureau—exposed Nick to the conflict.

Tet turned out to be Nick Ut's baptism in combat photography. Danger was relentless, and his knowledge of the city's neighbor-hoods offered only limited protection. Yet once his pictures were made, his trusty scooter sped him back to the bureau and they flowed into AP's international photo distribution system.

In the end, U.S. and ARVN fighters punished enemy forces, inflicting on the Vietcong as well as the North Vietnamese regulars the greatest casualties of the war. North Vietnam planners of the massive attack hoped that their widespread actions would inspire an overall uprising and the collapse of the government's regime. That did not happen. While the government and U.S. troops won an important military victory, the psychological impact on the U.S. home front was negative and it inspired antiwar activity anew. It made the Tet Offensive a turning point in the war.

For Nick, too, it was a turning point. Up to then, he had not gone to war. Tet brought war to Nick. His behavior and the photos he made established his credibility as a combat photographer—despite his youth, despite his inexperience, despite the concerns of AP colleagues. Those colleagues and his boss could no longer make a case against Nick covering the greater war in the countryside. After two years, he was on the brink of achieving his goal: to follow his brother as a full-time AP staff photographer and face new challenges.

Later he would put his transition to combat in his own words, echoing, as he always did, the direction and inspiration that his brother, My, Anh Bay, No. 7, instilled in him as a boy. My taught him how to use different cameras—Nikon, Leica, Rolleiflex—and stressed the potential impact of the images they could capture. He repeated the lessons as Nick helped him recover from his wounds and prepare to return to combat coverage.

"You know," Nick recalled, "my brother told me, before he was killed . . . , he said, 'The war needs more photographers.'"

▲ Nick Ut dries newly made prints in AP's Saigon darkroom.
(AP Photo/Steve Stibbens)

▲ Huyhn Cong Ut, called "Nick" by AP colleagues, in the Saigon bureau.

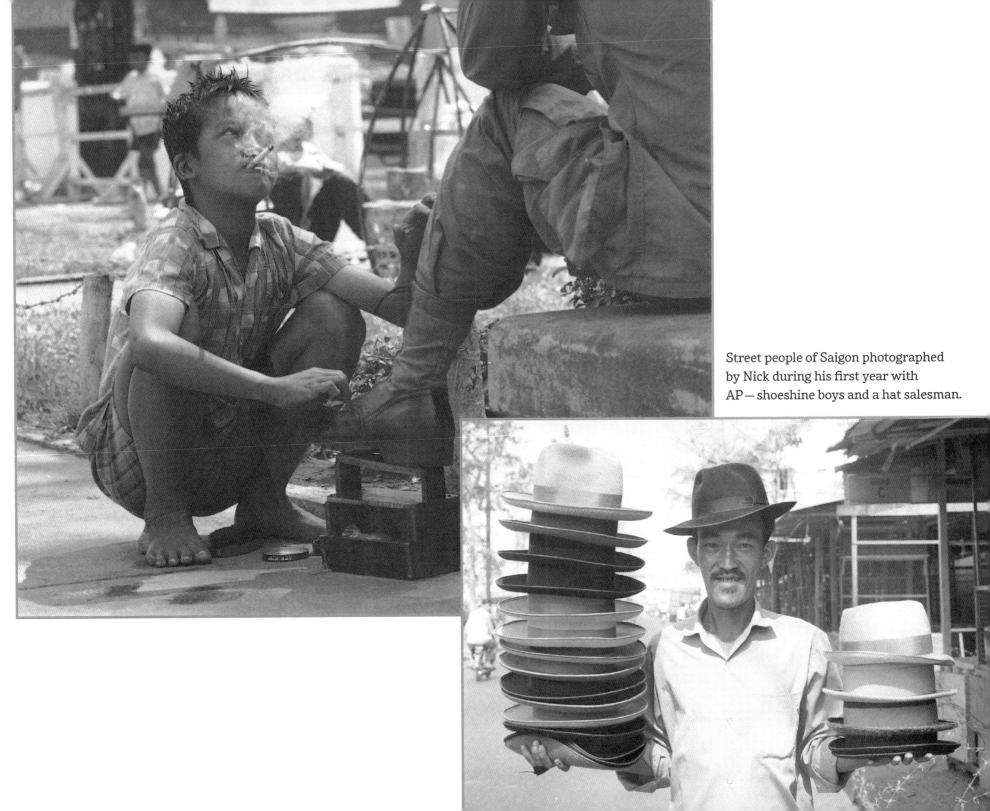

Street people of Saigon photographed by Nick during his first year with AP — shoeshine boys and a hat salesman.

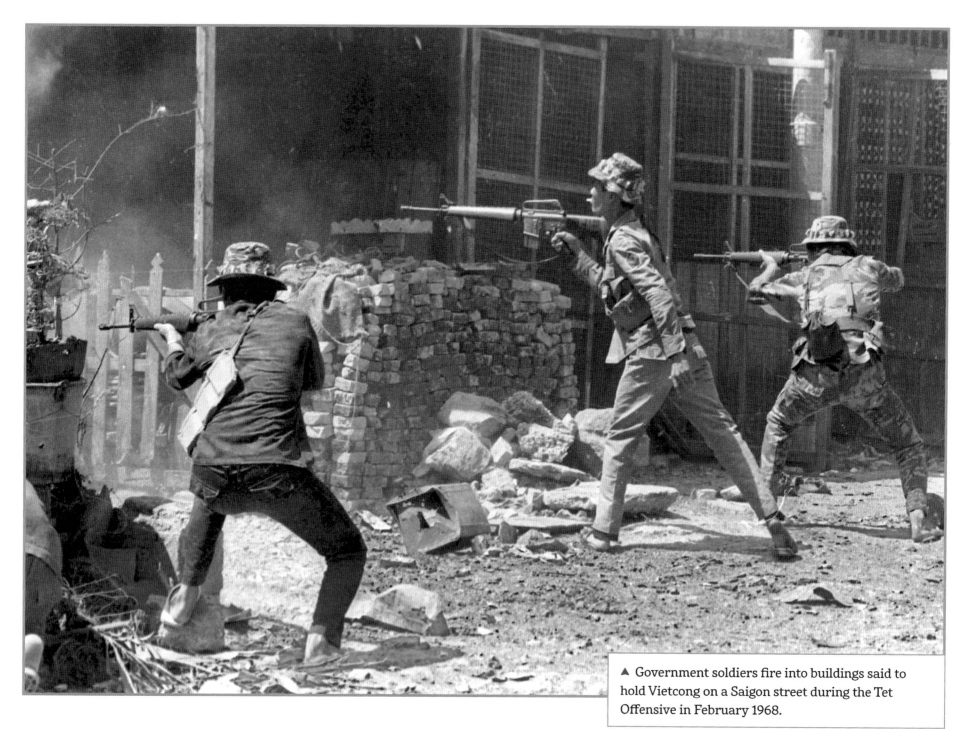

▲ Government soldiers fire into buildings said to hold Vietcong on a Saigon street during the Tet Offensive in February 1968.

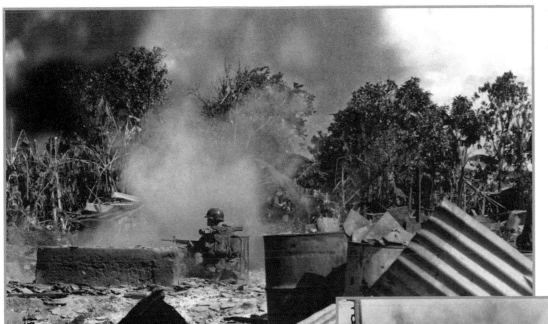

◀ Tet Offensive battle smoke and wreckage provide cover for a South Vietnamese soldier during fighting in Cholon, the Chinese section of Saigon.

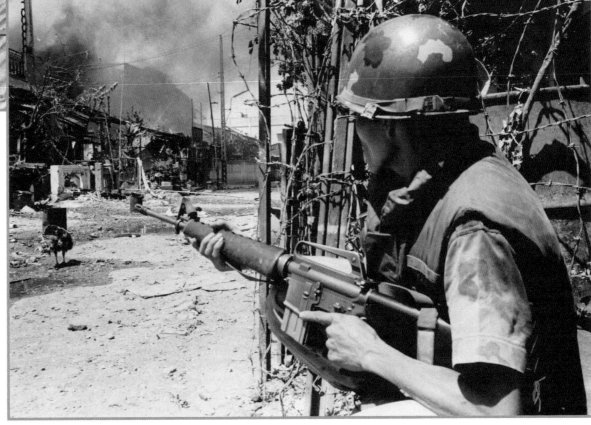

▶ A cautious South Vietnamese soldier surveys a street scene from his position during Tet Offensive in Saigon, February 1968.

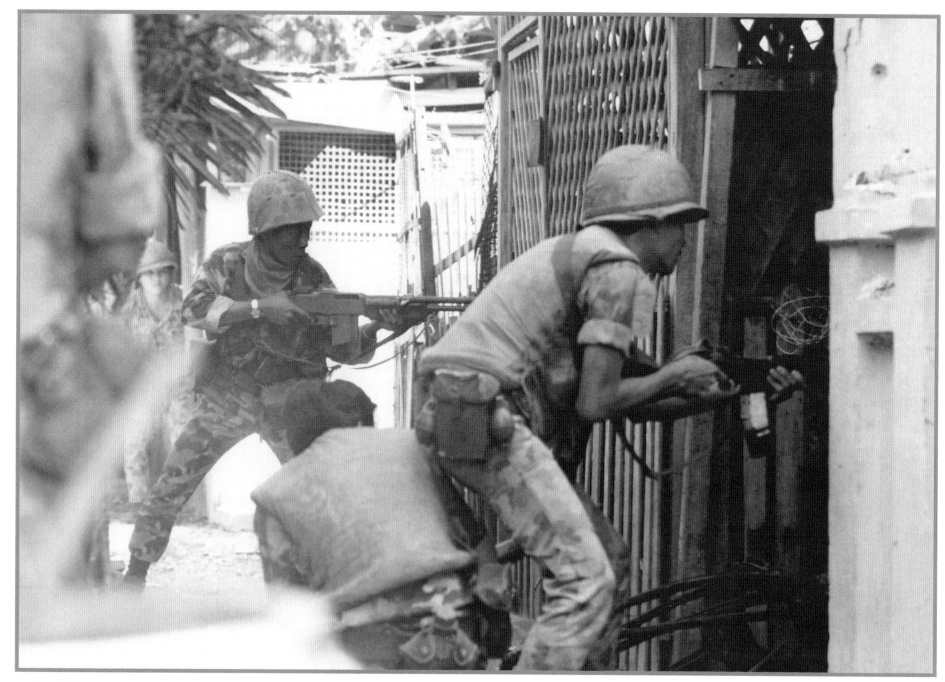

▲ South Vietnamese Rangers fighting VC house to house in Saigon batter down door during the Tet Offensive, February 1968.

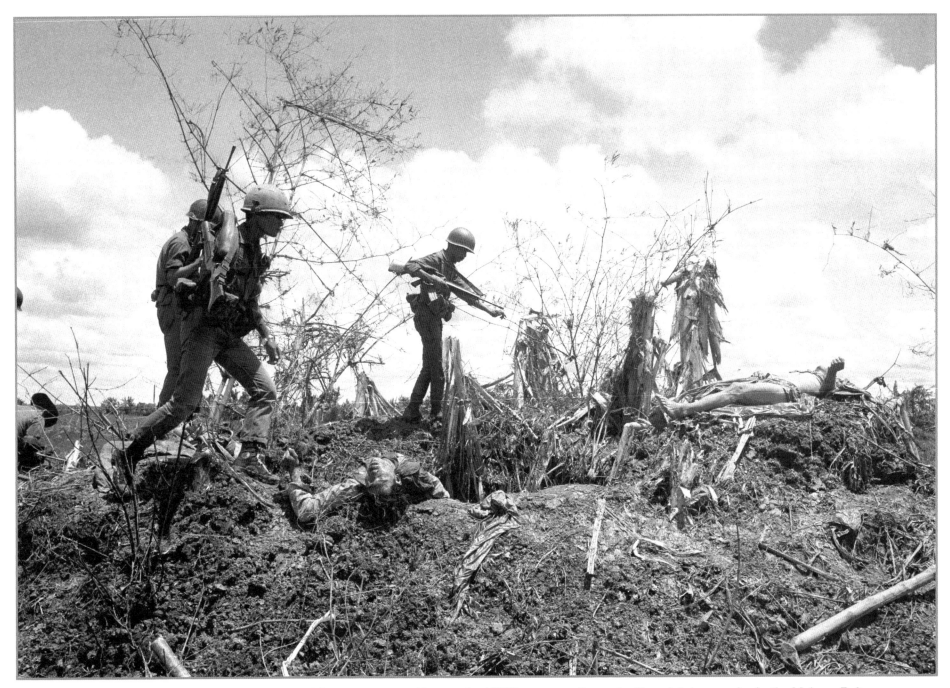

▲ By 1970 Nick accompanied South Vietnamese soldiers on countryside patrols. ARVN troops walk past bodies of slain enemies in the Mekong Delta.

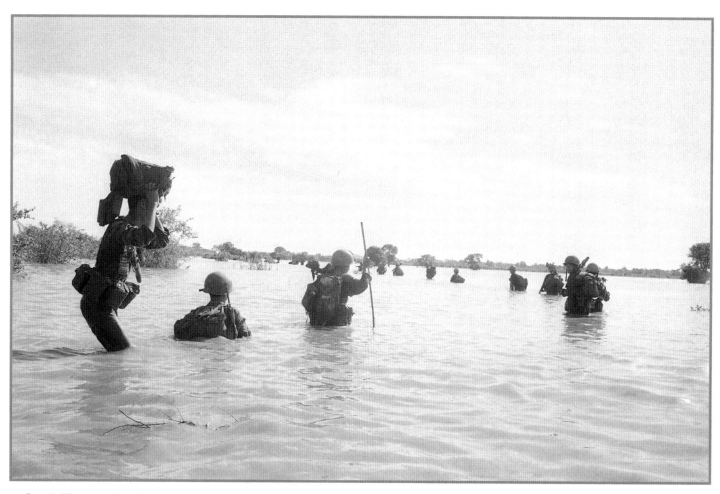

▲ South Vietnam Marines cross a shallow branch of the Mekong River on their way to an operation in Cambodia in 1970.

Chapter Three

An Intimate War

Photographing war in the countryside, Nick Ut would learn, was just as risky as photographing Tet's urban combat in Saigon. AP correspondent Peter Arnett described the risk photographers and reporters faced:

"For those whose daily job it is to capture and transmit the taste, the feel, the smell of battle, few wars have been as perilous as the nightmarish struggle in Vietnam.

"This is because it is a war without any front lines, without clearly marked friendly or enemy territory or clear lines between combatants. It is a war of treacherous ambushes and of swift hit-and-run attacks by a wily foe who materializes suddenly from the jungle, strikes viciously and vanishes.

"Reporters and photographers regularly venture to places where the action is, to record in words and on film the color, the flavor, the terror, the triumphs and the heartbreaks of a confused and confusing conflict."

Nick had a sense of the dangers so abundantly clear and deeply felt within the AP staff; three AP photographers were killed during the period before and after Tet. Nick's brother My died in the Mekong Delta in October 1965, just weeks after Bernard Kolenberg was killed in an air crash. Ollie Noonan died in a helicopter shot down in August 1969. Before the war ended, other photographers—friends from other organizations as well as AP staff—died either during action with the enemy or in aircraft crashes. Portraits of the AP photographers killed were on the walls of the office, memories of them and their fate permanently fixed in the fabric of the bureau and a reminder of the intimate experience with the war that all photographers shared. That intimacy resulted in combat photography not

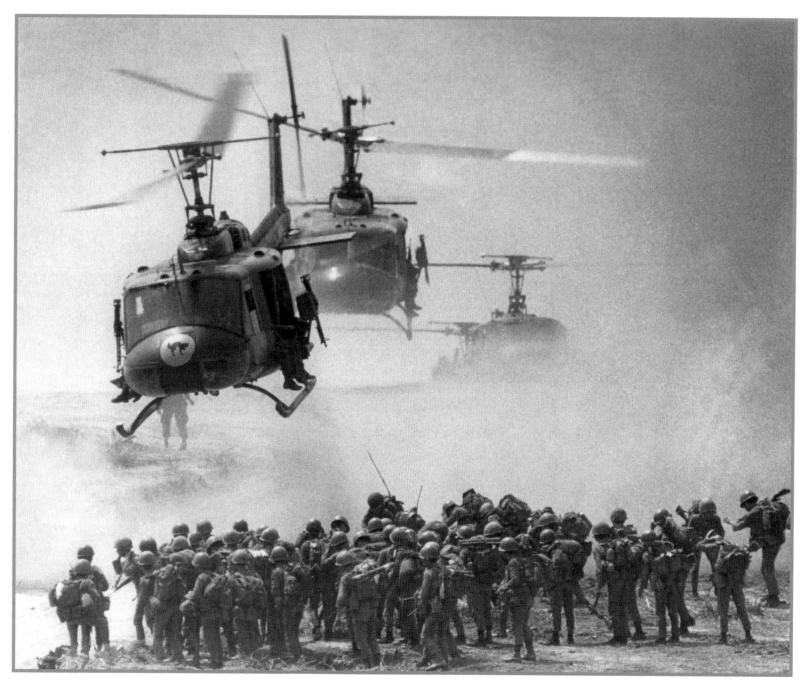

▲ Vietnam was a helicopter war. Choppers land near Khe Sanh to pickup troops that will attack enemy camps in Laos.
(AP Photo/Koichiro Morita)

seen previously and not likely to be seen in future wars. That intimacy encouraged photographers to move closer and closer to battle, which in turn contributed to the deaths and wounds of so many. It also resulted in unique, voluminous and remarkable photo coverage.

Unlike in World War II and Korea, there was no military censorship in Vietnam. Censorship would have been tricky, even burdensome, requiring censors with multiple language skills. And there was a political issue: How could the U.S. military override the Vietnamese government and justify control of dispatches, photos, film and communications, especially given the military's "invited" presence in Vietnam. The result: In World War II and in Korea, censorship to a great extent sanitized war. Even if a photographer could get to the scene of conflict, arrival at a battle site was often long after the fighting ended. In Vietnam, there was no barrier to the distribution of any photo regardless of content. There were guidelines that banned distribution of images or stories that would compromise operations, and violation of these guidelines would be considered a serious infraction. But the call on usage was left to the media.

Friendly relationships with media in those previous conflicts influenced the decision to make media coverage of combat in Vietnam easy. Press passes were simple to obtain. Transportation around Vietnam was available aboard military aircraft or helicopters carrying supplies and troops to the site of sudden conflicts. All a correspondent needed was a press pass and the pilot's OK to jump aboard a battle-bound helicopter. Photographers often landed while battles were underway.

In an interview with Newsweek magazine, Tim Page, one of the corps of Vietnam photographers, described the helicopter war this way:

"To be in and out of combat at the drop of a helmet was the convenience of the chopper. The ubiquitous Huey, proffered to a generation of shooters accustomed to taxis. Riding them. Shooting from them. Inserted (in and) out of them. Resupplied and rescued by them. A defining experience that made it a trademark of that distant conflict."

And dangerous. The lumbering, slow-moving, up-and-down take-off and landing made the chopper an easy target for Vietcong and North Vietnamese guns and rockets.

The nearly exclusive use of 35mm cameras and their various lenses opened opportunities for photography not possible in WWII and Korea where the cumbersome 4x5 Speed Graphic was the popular workhorse camera used by most war photographers. Sturdy and reliable as it was, the 4x5 lacked the versatility of the 35mm systems.

Nick Ut's daily camera equipment included at least three cameras hung around his neck and a spare in a pocket. One camera carried a 300mm lens, a second a 180mm lens and a third a 35mm lens. In his pocket, his spare camera had a 50mm lens.

Nick wore his cameras like his clothes. He never went anywhere without camera equipment. He explained why:

"I remember when I joined AP, I always had a camera. You know, go eat, go everywhere, lunch, dinner, you never know what happens. I remember one time, one day in Saigon, I take dinner at Saigon River. I hear rocket come and hit Mekong River, and so many people wounded. That's why I had a camera, shot right away. But today people carry iPhone for snapshot, you know. But me, I always carry camera all the time in my life. I never leave camera at home."

He mentioned the four cameras he always carried. "Four because you need short lens, long lens. Sometimes, you never know, the one camera's broken, you know. That's why you had to carry four, you had another camera still working. And you carry . . . over 50

rolls of film." AP photographers also carried a waterproof case filled with film and other bits of equipment of possible need in the field.

Helicopter access and the 35mm equipment gave photographers a new visual potential that became the hallmark of Vietnam war photography.

Most photos were shot in black-and-white. AP's Eddie Adams summed up the difference in combat between B&W and color film:

"I think war should be shot in B&W," he wrote. "It's more primitive. Color tends to make things look nice. It makes the jungle in Vietnam look lush, which it was. But it wasn't nice."

Nick would soon learn that the countryside landscape held its special dangers. The Delta area was flat. Tree lines formed a lush backdrop to rice paddies . . . but also ambush protection for Vietcong. Low level dikes separated the paddies and acted as convenient pathways across the muddy, water-soaked fields . . . and because of that, they were seeded with land mines.

In Vietnam's Central Highlands, rocky terrain created natural fortresses for enemy troops. Open fields offered growth of razor-sharp elephant grass that grew head high and could slash the face of the careless with a knife-like cut. The jungle was ominous at every turn. Trails were mined, or set with poisonous punji stakes that could puncture a boot. Hidden trip wires set off explosives. Dense undergrowth favored ambush.

Robert Capa was killed on a hillside when he stepped on a mine in May 1954, during the French War. Dickey Chapelle, the first woman photographer killed in Vietnam, was hit by shrapnel in 1964 when a nearby Marine set off a trip-wire mine. Her final moments were photographed by AP's Henri Huet who a few years later would himself die in a helicopter shot down over Laos. Capa and Chapelle, some 10 years apart, joined units at base camps that patrolled the countryside to search out the enemy. In Capa's case, these were the Vietminh that battled the French; in Chapelle's case, the Vietcong that battled the Saigon government.

Villages encountered on patrols were a gamble. Some were populated by friendly Vietnamese. Others were Vietcong hideouts or locations for the storage of Vietcong supplies.

In writing about war coverage for an in-house AP newsletter, Faas described the realities photographers encountered in Vietnam and by implication the risks of covering a war that was nowhere and everywhere:

"They (photographers) could crawl to the forward trenches of a besieged outpost, wait beside riflemen in night ambushes, witness brutal interrogations and executions and merciless street fighting. While the enemy—the Vietcong and the North Vietnamese—operated in secrecy, American and allied troops and government civilians performed almost always under the probing eyes and lenses of newsmen."

The intimacy photographers shared extended beyond the battlefield. After a day or several days with a patrol dodging snakes and other jungle critters, if not Vietcong traps, photographers would hop a flight from the overbearing humidity of the jungle to the pleasures of Saigon. Dinner followed in a plush or, at minimum, a comfortable French restaurant. Or for those so inclined, the company of the large corps of "bar girls."

And the next morning, they would rush to the airport once again and, amid swirling dust and the deafening wap-wap-wap of rotor blades, locate a Huey headed for the latest attack. Or perhaps a second round of the previous day's clash. David Halberstam, the New York Times Pulitzer-winning reporter, described the mixed mindset of a rushee as being, "Terrified we might NOT get there in time to get aboard, terrified we might get there in time to get aboard."

Terrified or not, once at the takeoff zone a press card accompanied by a request to the pilot to board the chopper usually prompted a thumbs-up signal. The photographer hopped aboard and stared at crates of ammunition and bandages during the flight to war.

A special word about the pictures: In most cases the photographs were of events described in the stories, but in some cases the pictures were of other similar actions. In many ways the war, except for increasing violence, changed very little over the years. Faas, who covered the war for most of its long duration, described his first battle coverage in June 1962 this way:

"Three days of wading through swamps, paddies and mangrove thickets, long hot walks in the sun followed . . . On the third day I walked back into a government post and was trucked out with the troops, eventually reaching Saigon to tell my story and transmit the photos from day one . . . a pattern that did not change until the last day of the war."

A pattern that did not change. To many, writers and photographers alike, that was the frustration. Patrols in one week would encounter nothing but the unchanging landscape; a week later, ambushes caught troops on either side unaware. Towns and cities changed hands—for a time in Vietcong control, then government control, then Vietcong again. Battles were fought anywhere at anytime, then fought once again in the same places a week or a month later. Even parts of Saigon suffered a similar fate as the war neared conclusion.

So there was similarity from story to story, and from picture to picture. Yet each story and each photo wove its special thread in a tapestry of war and destruction stitched together for more than a decade (longer if one considers the French conflict after World War II).

Six photographers won Pulitzer Prizes for their picures. Hundreds of other photographers were at a time and place where drama set their images apart, each a nuance that showed the war in personal terms.

Taken together these factors enabled photographers to produce a remarkable record of the conflict, a record not likely to be repeated.

This was the war Nick Ut would photograph, the war he wanted to photograph, as his brother, Anh Bay, No. 7, did before him.

GALLERY

The Vietnam countryside created a deadly challenge for ARVN and American patrols seeking and engaging Vietcong and North Vietnamese units.

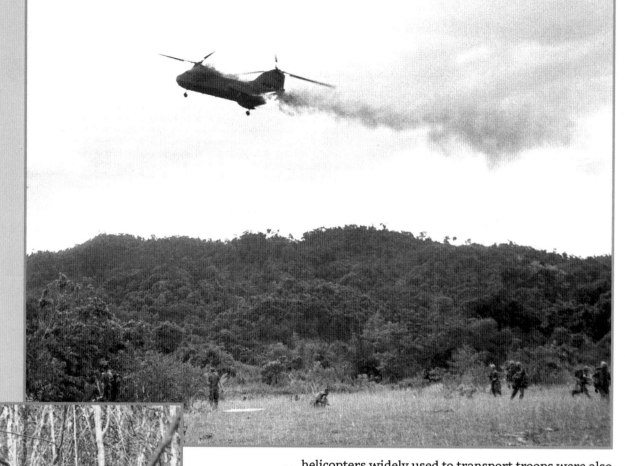

... helicopters widely used to transport troops were also easy targets for enemy rockets. (AP Photo/Horst Faas)

30

... dense jungle offers excellent cover for ambush.

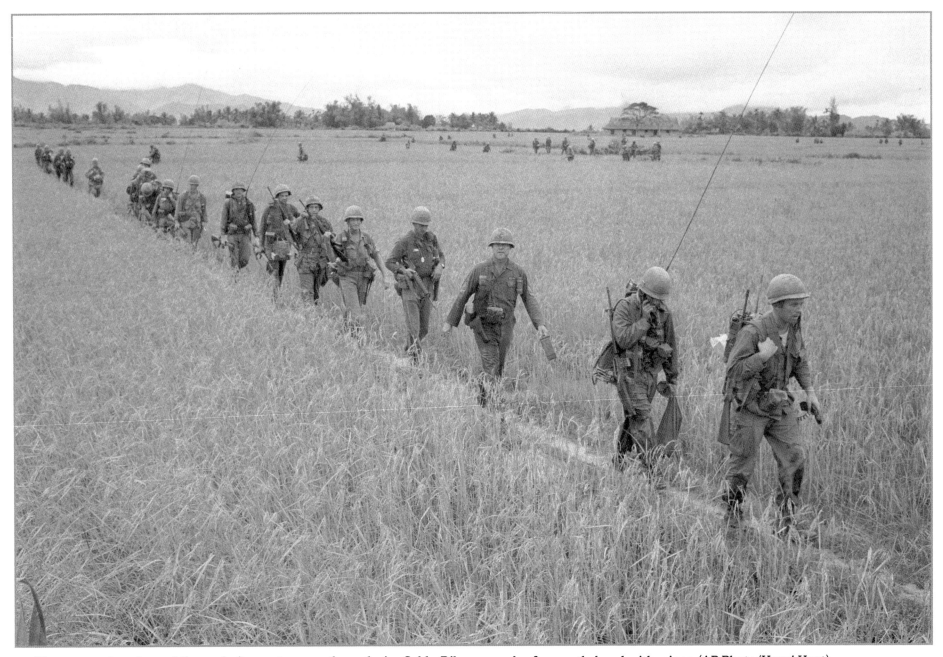

... dikes separating rice paddies make it easy to move through rice fields. Dikes were also frequently laced with mines. (AP Photo/Henri Huet)

. . . distant tree lines provide cover for VC ambushes. (AP Photo/Rick Merron)

... elephant grass hamper easy, swift movement for troops penetrating enemy positions.

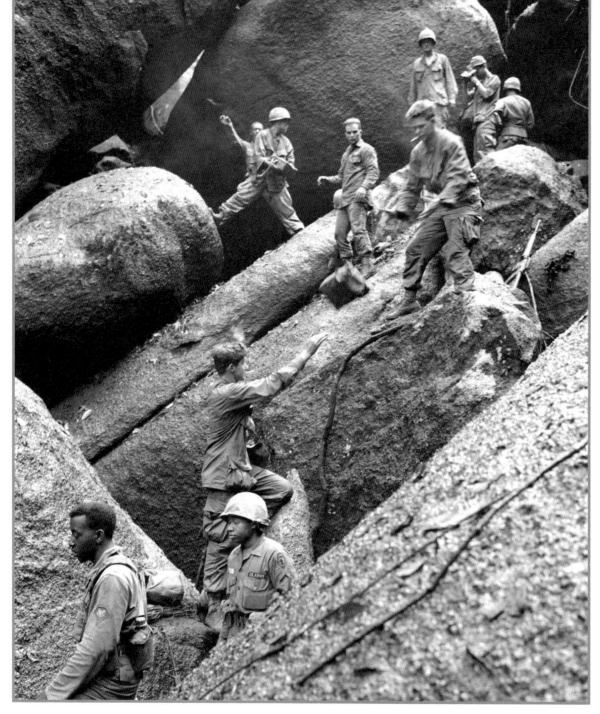

. . . rocky areas provide natural fortifications
for Vietcong and North Vietnamese troops.
(AP Photo/Henri Huet)

34

Chapter Four

Combat Photography in the Countryside

Now working full-time with a camera, Nick Ut rode his scooter from one flashpoint to the next as Tet Offensive battles flared throughout Vietnam for weeks.

His tried-and-true system—"follow the smoke"—guided him to both urban and countryside combat locations, some as far as 30 miles into the Delta. Or north along Vietnam's coast. Or close to the Cambodian border, where infiltrators from the Ho Chi Minh trail entered South Vietnam.

Chasing battles kept him busy until fighting eased up as February slipped into March and as battered Vietcong forces backed off to recuperate. But the respite was temporary.

On an evening in early May, a typewriter in the AP newsroom clacked away as an editor prepared the daily story summarizing war activity. Before the first sentence was complete, a bone-shaking blast blew open the AP's office door. Renewed heavy attacks hit Saigon and other cities with full force, signaling resumption of countrywide warfare soon named the Mini-Tet Offensive.

Again, Nick leaped into action. Weeks turned to months before ARVN and American troops put down the enemy force. Mostly Nick spent time with Vietnamese troops. It was a natural choice. Language was not a problem and there was always an abundant supply of American C-rations in the field. Sometimes even a treat in

the form of a Vietnamese meal cooked up by ARVN personnel with locally obtained chickens or ducks and rice.

And there was an added benefit to AP. For several years the media face of the war was American. Now Nick's steady coverage of ARVN units provided added images of the Vietnamese role in the war.

In 1969, a third photographer fatality renewed the always present but muted understanding of the risks war coverage presented equally to photographers and reporters. In August of that year, Oliver Noonan was killed when the helicopter taking him back to Danang after photographing American troops was shot down. All aboard perished. Noonan had been a successful photographer on the staff of the Boston Globe but, like so many of his colleagues, he was driven to cover the war. He paid his own way to Vietnam where he joined AP locally. He rarely smoked, never drank and calmed his nerves by writing poetry. His portrait became the third on the bureau wall, placed alongside those of Huynh Thanh My and Bernie Kolenberg.

Fighting ground on, and Nick's coverage took a new turn in 1970. President Richard Nixon authorized military action to disrupt and destroy enemy camps along the Ho Chi Minh trail in Cambodia. North Vietnamese trucks, small vehicles and even bicycles effectively moved manpower and supplies from North Vietnam through Laos and Cambodia and eventually to enemy troops in South Vietnam.

Vietnamese patrols for the first time officially entered Cambodia at several points, including one via an area called the Parrot's Beak located not far from Saigon. The border area was long an entry point for NVA and VC crossing into South Vietnam from the trail. Nick joined ARVN units that entered Cambodia to locate enemy camps.

American troops were involved, but for the most part Nick stayed with ARVN; day to day, he accompanied one or another Vietnamese patrol. Most patrols were dreary affairs, riding overcrowded personnel carriers through high grass and jungle growth. For the most part, there was little or no contact with enemy forces. When exceptions came they were sudden and violent.

One of Nick's forays took him into Cambodia just over the border not far from the South Vietnamese provincial capital of Tay Ninh. He joined a platoon crowded aboard one of several armored personnel carriers. They moved slowly and cautiously toward the Cambodian town of Kampong Chuk, their passage hampered by the usual narrow trails and heavy growth that reached the top of the vehicle.

Suddenly, across a small clearing, a North Vietnamese regular armed with a Russian B-40 rocket stepped out of man-high grass, raised his weapon, aimed and fired at the personnel carrier. In the instant before the blast, Nick saw the B-40 and then the fiery launch. In that same instant, several ARVN soldiers shouted, "Jump . . . , Jump!" Nick leaped over the side of the vehicle. Cameras hanging from his neck thrust upward and smashed into his face. The rocket hit the personnel carrier and killed or wounded 15 of the ARVN troops. Shrapnel spread widely, a piece of hot metal hitting Nick in the belly and ripping painfully through his stomach. In severe pain but conscious, he was quickly evacuated to South Vietnam and a hospital near Tay Ninh.

A blonde American nurse approached the wounded photographer and started her procedure; the first step was to pull off his pants so she could get at the wound. Nick objected—vigorously. A Vietnamese nurse removing his pants? That would be OK. But a foreign woman? No way! But battlefield nurses faced bloody wounds every day, all day, and there was little time for gentle negotiations

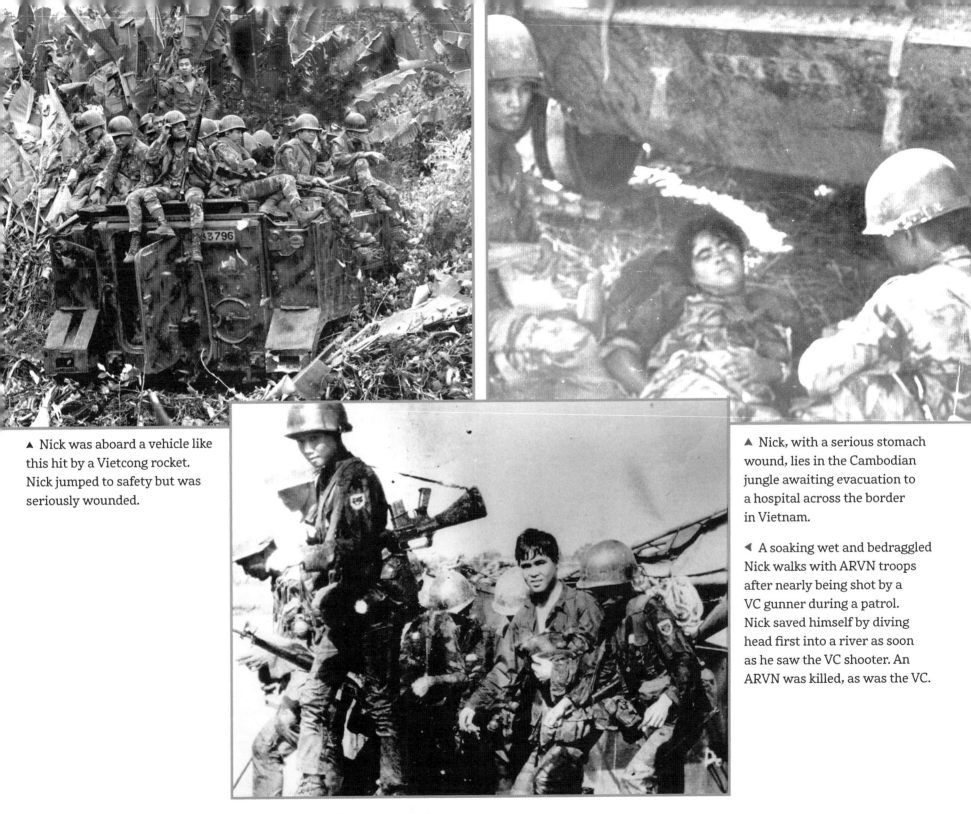

▲ Nick was aboard a vehicle like this hit by a Vietcong rocket. Nick jumped to safety but was seriously wounded.

▲ Nick, with a serious stomach wound, lies in the Cambodian jungle awaiting evacuation to a hospital across the border in Vietnam.

◀ A soaking wet and bedraggled Nick walks with ARVN troops after nearly being shot by a VC gunner during a patrol. Nick saved himself by diving head first into a river as soon as he saw the VC shooter. An ARVN was killed, as was the VC.

over modesty or other niceties. She pulled off Nick's pants. Up went his hands, hiding his face to cover his embarrassment. The nurse quickly found the shrapnel, removed it from his stomach and showed it to Nick. "Why are you worried about this? That guy over there lost a leg," she said.

Nick remained in hospital care for a week, followed by three weeks at home recuperating. There was time—and reason—to rethink the dangers of combat photography. Even before he was wounded, he considered the ample evidence confirming just how risky it could be. Three AP photographers died, his mentors Horst and Henri were seriously wounded and Eddie barely escaped death when trapped between enemy and friendly crossfire. Nick's friend Phouc lost count of the times he was wounded.

Nick himself had had a previous close call. He was with a patrol of Vietnamese Rangers in the Delta as they advanced along a river and across a watery stretch of the countryside. A Vietcong soldier jumped from his hiding place among the reeds and opened fire with an automatic weapon. Nick dove headlong into the river. A Ranger behind him fell dead even as the quick reaction of another Ranger dispatched the Vietcong. Nick's most serious damage was a soaked uniform, loss of film shot earlier in the day and cameras that needed to be sent to Tokyo for cleaning and repair.

Nick knew he was lucky. There was no other way to explain his close call that saved him from death or loss of a limb. Now he was seriously wounded, laid up in a hospital bed, waiting for his wound to heal and wondering: What am I doing here? Is it worth it?

He considered the options. If he left AP he would be drafted, and he considered the high mortality rate of the ARVN forces. He enjoyed his work. He lived better than any ARVN soldier. He liked his colleagues. He pretty much could come and go as he pleased. And however much his belly wound hurt, he had survived. Nick concluded it was best to stay with combat photography; he knew that soon he would be back doing what he loved.

Later that year, another photographer friend would die covering the war in Cambodia. In October, Nick was in Phnom Penh where he met UPI's Kyoichi Sawada, winner of a Pulitzer Prize in 1966 for his Vietnam photography. Despite vigorous competition between AP and UPI, Nick and Kyoichi were friendly and had met several times on stories. Over breakfast they chatted and exchanged photographer gossip. A quick farewell and Nick headed back to Saigon with his pictures. Two days later he learned that Sawada and a UPI reporter were found executed along a Cambodian highway, both shot in the chest, their press credentials nearby in the dust.

Proper press ID was important but showing it could be informal in Vietnam. Consider how it worked when Nick needed transportation on military aircraft to cover stories beyond the reach of his scooter. At the airport outside Saigon, amid the chaos of helicopters taking off and landing, their rotor blades noisily stirring up clouds of dust, he would first locate the right Huey, the one his sources told him was headed for a spot he wanted to reach. His sources might have told him that an American and South Vietnamese patrol, ambushed and under attack by the Vietcong, was in need of supplies and medical assistance.

Locating the right helicopter, he would shout to the pilot, requesting permission to board. He would point to the inscription "Bao Chi" (Press) on his shirt pocket and to his name on the other shirt pocket. An AP Logo was imprinted on his cap. Could he get a ride to the battle? No special introduction was needed. Cameras around his neck, bag hanging from his shoulder, and the simple ID markers on his shirt made it obvious he was a photographer.

Besides, pilots came to know the photographers who turned up virtually every day to hitch a ride to the war wherever it was being fought.

A thumbs-up signal from the pilot, and Nick would climb aboard. The chopper would rise and he would be off to the battle scene, sitting alongside boxes of ammunition, medical supplies and rations. Returning to Saigon after reversing this process, he would ride with the dead in body bags and the wounded.

Nick's Bao Chi accreditation also allowed him to hitch a ride on any C-130, the larger aircraft that flew longer distances and with greater loads of supplies and personnel to units far from Saigon.

In February 1971, a C-130 took Nick to Quang Tri where he planned coverage of a major ARVN thrust into Laos, called Lam Son 719. The ARVN assembled some 17,000 troops, making it the largest Laos invasion of the war and greater in scale than the Cambodian incursions of a year earlier. The ARVN force was to interrupt enemy shipments and encampments along the Ho Chi Minh trail.

South Vietnamese authorities banned news coverage of the attack but then made arrangements to include four newsmen on an inspection of invasion sites inside Laos. Journalists were booked to join a three-helicopter group scheduled to visit several ARVN units battling combined Vietcong and North Vietnamese regulars. Nick, early on the scene, was assured one of the four seats for AP. Life magazine's Larry Burrows, in India on another assignment, heard of the plan and rushed to the area to obtain another of the four seats. Kent Potter of UPI and Keisaburo Shimamoto, a freelancer for Newsweek, likewise were accredited. An ARVN photographer and several military officers completed the passenger list.

A week passed. As Nick waited in Dong Ha and nearby Khe Sanh, the inspection trip was delayed day after day by fog and rainy conditions. Finally, the weather lifted and the inspection was assured for the next day, February 10. At the last minute, Henri Huet turned up and told Nick he wanted to make the flight. Huet said he was scheduled for a rest trip to Hong Kong and wanted to get in a final operation before leaving Vietnam. Nick backed off in respect for Huet's seniority and in consideration of their close friendship. Three helicopters took off from their advanced position and headed for Laos. Nick made his way to Quang Tri and a C-130 return flight to Saigon.

As the helicopters flew across dense jungle and rugged mountain territory they drifted unknowingly over heavily fortified North Vietnamese positions. Two choppers were hit by ground fire and crashed into the remote Laotian terrain. One carried the four photographers and ARVN personnel.

Word of the crash reached AP reporter Mike Putzel who was in Quang Tri to relay news developments to Saigon, a report that included information about the helicopter crash. News in a situation like that almost always lacks detail, and Putzel's sources were vague. Still, what little was known at Quang Tri indicated that the four photographers were among the lost. Later details confirmed the disaster. Putzel managed a shaky, static-filled phone connection to Saigon where Chief of Bureau Richard Pyle took down the names of those aboard the lost helicopters. Other staffers watched the names spell out letter by letter on Pyle's typewriter— H . . . U . . . E . . . T. Huet's name appeared with shocking clarity.

Once in Saigon, Nick went directly to the AP bureau unaware of the helicopter crashes. Horst had just arrived from India where he had encountered Burrows before the two rushed back to Vietnam. Horst read the bureau story and learned of Huet's death. He and Huet were close, and Horst once again was shaken with grief. He

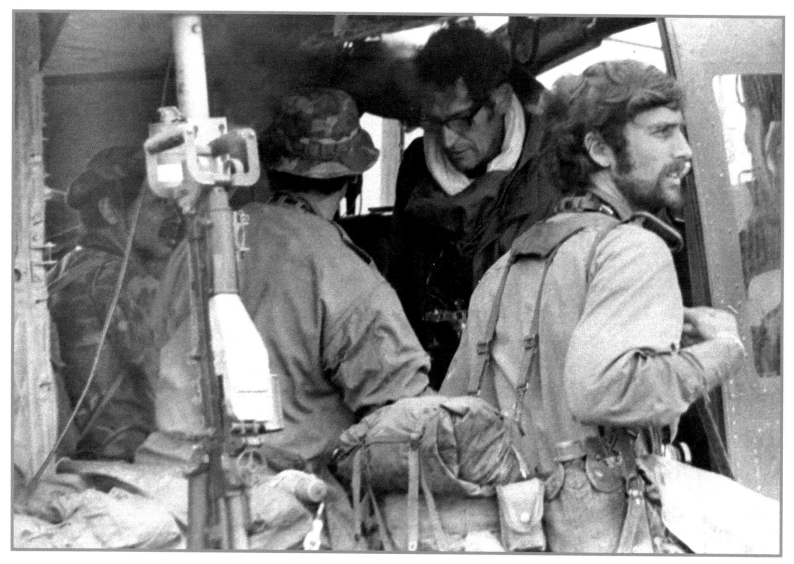

▲ Four photographers board a helicopter to cover a South Vietnamese inspection of ARVN operations in Laos. Kent Potter, UPI, at right; Larry Burrows, LIFE, background, wearing white collar; Henri Huet, AP, back to camera; Keisaburo Shimamoto, Newsweek, mostly hidden at left. All died when the helicopter was shot down by North Vietnamese ground fire February 10, 1971. (AP Photo/Sergio Ortez)

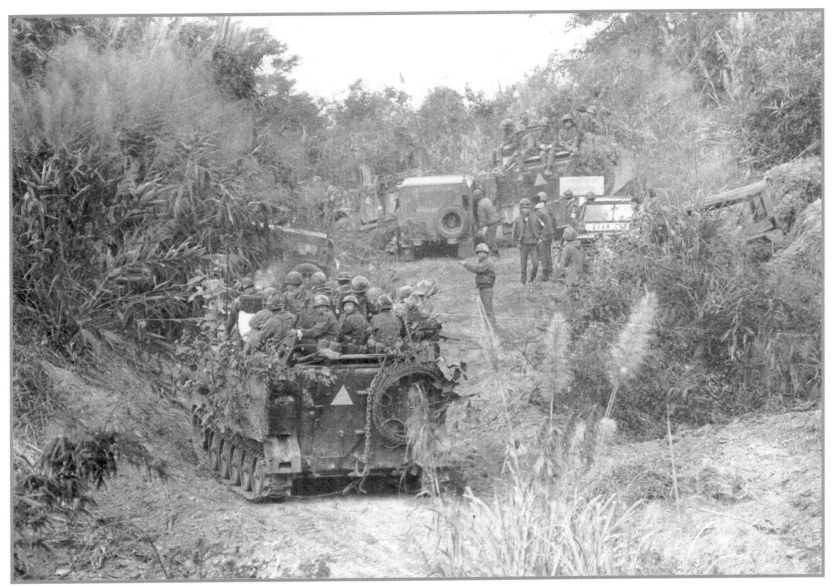

▲ This is one of the last photos made by Henri Huet the day before he boarded a helicopter shot down over Laos. (AP Photo/Henri Huet)

took upon himself the duty to inform Nick as soon as Nick arrived in the office.

"Did you see Henri," Horst asked in the futile hope that, after all, some error had delivered bad information. Nick told the story of the seat switch. Informing Nick then about the crash, Horst handed him a copy of the wire story.

Nick sat down, stunned and silent, his mind paralyzed by the death of his close friend, his cheeks streaked with tears. He was supposed to have been on that chopper. Instead, the friend who christened him "Nick," the man who mentored his photography when he worked in the darkroom, was dead. Gone. Like his brother, My, slain by Vietcong. Like Sawada who died in Cambodia, like Noonan who also perished in a helicopter crash. Nick stared at the bureau wall where Henri's portrait would soon be placed with the others.

Each of the photographers who died in Laos was respected by the foreign press corps in Vietnam, but Huet and Burrows were special personalities. Both were longtime correspondents who covered the war with distinction, whose photographs were recognized for their artistic content and for the bravery required to make their special kind of photojournalism.

AP colleagues admired Huet as a human being as well as for his work: a man always with a smile, always modest, and with a sense of humor that broke the tension in difficult situations. He had been seriously wounded in late 1967 and after his recovery was assigned to New York for a short time, and later to Tokyo; but his soul was in Vietnam, where he had covered the war since the French days. He insisted on reassignment to Vietnam, and AP accommodated his wishes. He had only recently returned to Vietnam when he boarded the flight into Laos.

Burrows, a longtime friend of Faas, was equally respected by his colleagues. Tall and lean, he always wore large-frame glasses, and his British accent underscored his classic, gentlemanly conduct. His photos regularly appeared in major war layouts in LIFE.

Early on the morning after the crash Nick and another AP staffer returned to Dong Ha to learn what they could of the previous day's events. A rescue attempt was made to the remote, untamed area, in hopes of recovering anything possible. Searchers, however, could not locate the crash site, and enemy troops nearby threatened their efforts. The danger was great; the Lam Son 719 invasion was in trouble, and eventually ARVN troops were forced to evacuate. For the time being, a recovery of photographer remains was put off.

GALLERY

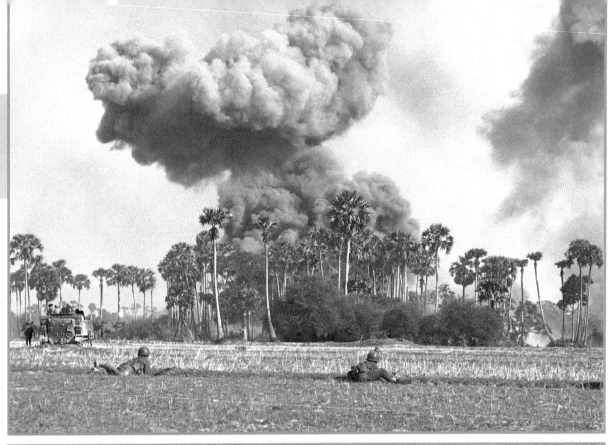

▶ South Vietnamese Rangers seek cover behind rice paddy dikes as an air strike provides cover for personnel carriers and troops moving toward Vietcong positions, May 1970, near Parrot's Beak.

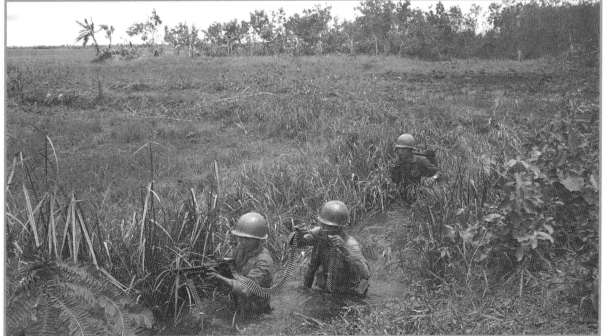

▶ ARVN machine gunners slog through a swampy area of border.

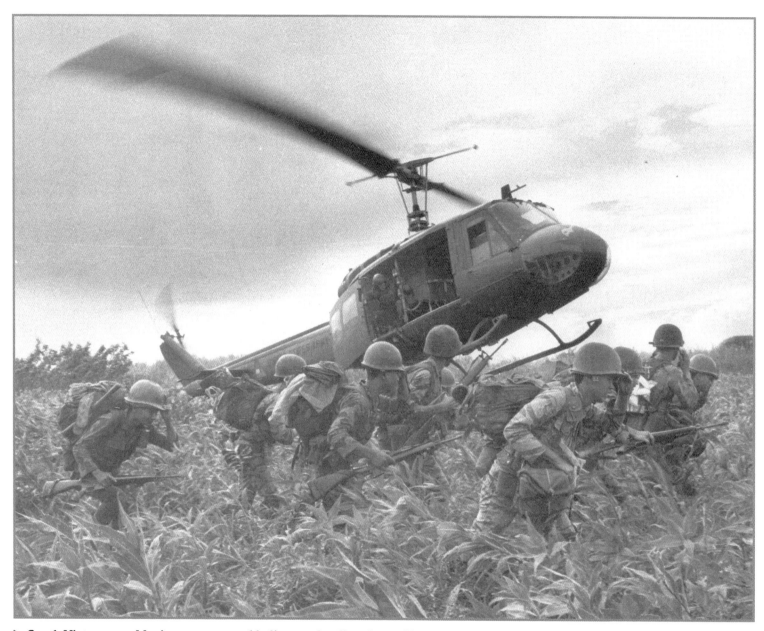

▶ South Vietnamese Marines run toward helicopter landing that will take them back to base after a June 1970, sweep for North Vietnamese troops near the Ho Chi Minh Trail.

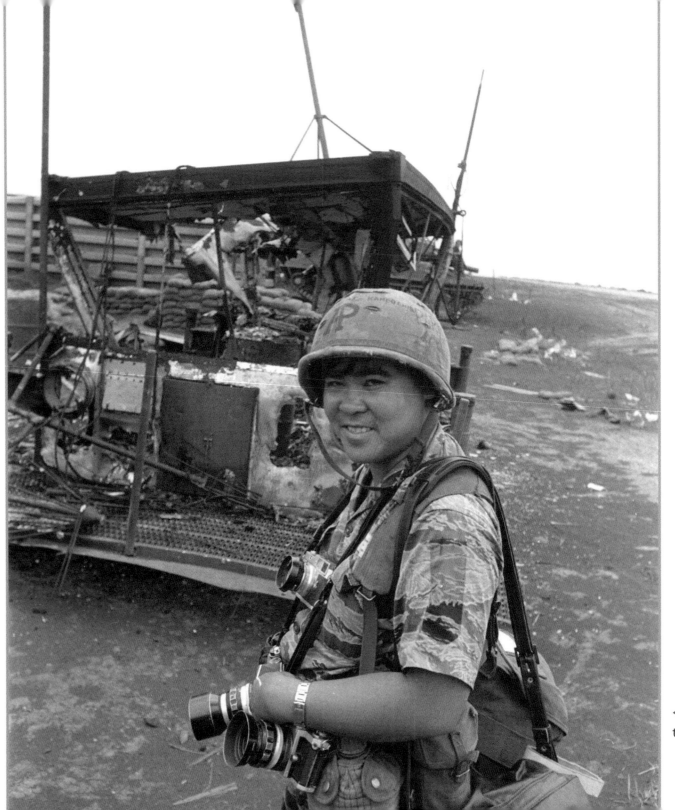

◄ Nick Ut in the field.

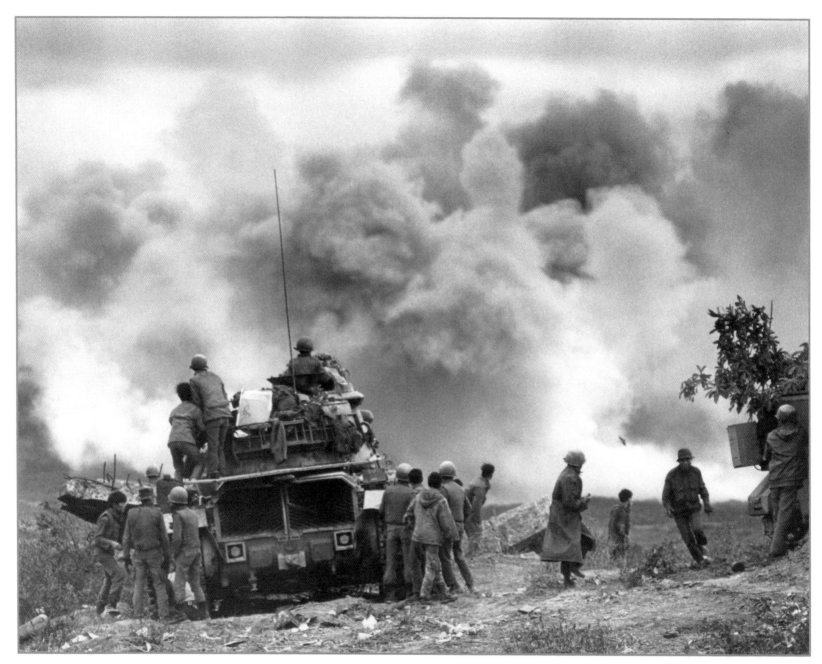

▲ Near Dong Ha ARVN soldiers view the strike area hit by bombs from U.S. aircraft. The air attack was aimed at a North Vietnamese tank column threatening ARVN positions.

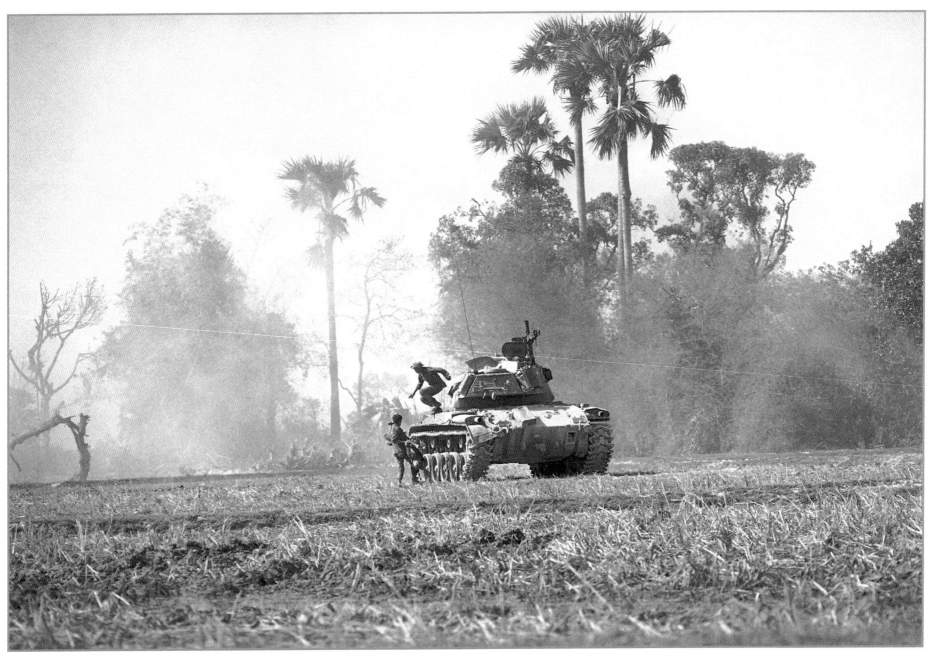

▲ A South Vietnamese tank is hit by enemy rockets. A gunner is killed on the ground as others jump from the burning vehicle. Action took place in Cambodia May 1970.

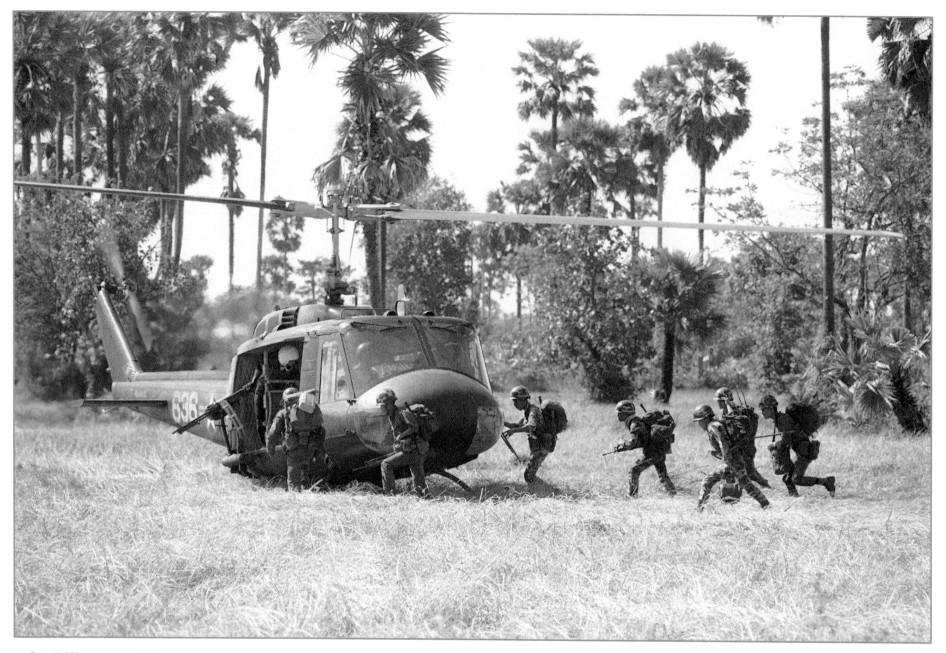

▲ South Vietnamese Airborne troops rush toward their pickup helicopter after an attack on North Vietnamese positions near Phnom Penh, December 1970. Fighting in Cambodia continued despite cease-fire agreement that affected only Vietnam.

Chapter Five

A Change in the War

Just as the face of the war had changed from Vietnamese to American in the mid-1960s, it was changing back again as a new decade began. At the same time the tempo of the conflict was changing.

Beginning in 1970, ARVN troops entered Cambodia, and in 1971 they invaded Laos, operations in each country aimed at interrupting enemy use of the Ho Chi Minh trail. Some operations included American troops; others, especially into Laos, did not. President Richard Nixon's plan to reduce the American presence in Vietnam moved forward, and by 1972 there remained some 70,000 U.S. troops in country, down from more than 550,000 in the late '60s. Most U.S. personnel still in Vietnam were advisors to ARVN units, while others were assigned to air support for ARVN troops.

As Americans departed, the North Vietnamese Army increased its numbers in South Vietnam. Their goal was to establish areas of control before the on-again, off-again Paris peace talks could end the war. NVA units used tanks and artillery in longer battles while at the same time Vietcong hit-and-run-tactics persisted.

Through it all, Nick Ut's life remained much the same. He still spent most of his time with the ARVN wherever the action took him in Vietnam and Cambodia—sometimes in the Delta, sometimes outside Danang, other times in the Central Highlands. Disappearing Americans did not reduce his assignments. His purpose to show the violence of the war to the world remained his driving motivation.

Still, now and then, there were times for a laugh, such as Nick's encounter with a fortune teller one spring evening in 1972. He and a few friends, relaxing over drinks at a sidewalk café, were approached by a man who offered to read palms. For a small consideration, of course. The group shrugged him off but then urged Nick, the war

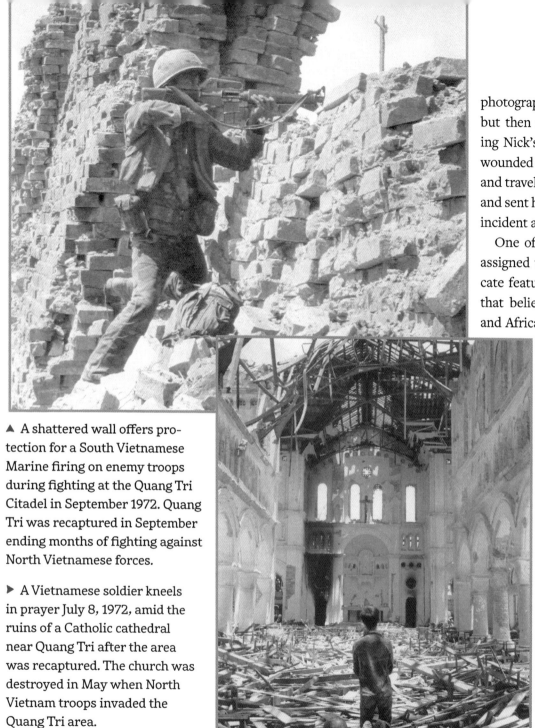

▲ A shattered wall offers protection for a South Vietnamese Marine firing on enemy troops during fighting at the Quang Tri Citadel in September 1972. Quang Tri was recaptured in September ending months of fighting against North Vietnamese forces.

▶ A Vietnamese soldier kneels in prayer July 8, 1972, amid the ruins of a Catholic cathedral near Quang Tri after the area was recaptured. The church was destroyed in May when North Vietnam troops invaded the Quang Tri area.

photographer, to get a glimpse of his future. At first, Nick refused but then relented and sat down with the clairvoyant. After studying Nick's palm lines, the fortune teller told him that he would be wounded again but would recover and that he would become famous and travel the world. Nick laughed at the prediction, paid him his fee and sent him on his way. Silly stuff, he told his friends, dismissing the incident as a joke.

One of Nick's pals was Michel Laurent, AP Paris photographer assigned temporarily to Saigon. Laurent, slight of build with delicate features and curly, long, light-colored hair, presented a figure that belied his several years of war coverage in the Middle East and Africa. The combination of riding side-saddle with Nick on his scooter and Michel's curls peeking out from his headgear resulted in Nick getting remarks from his neighbors about his "foreign girlfriend." Both Nick and Michel took the comments in stride and the story became part of their friendship.

These light interludes soon faded from Nick's life in Saigon, driven out by the 1972 Easter Offensive, North Vietnam's aggressive 120,000-man effort to seize territory before Paris peace talks could bring the war to a close. Two major Easter Offensive battles, each continuing for months, seized the attention of reporters and photographers. One centered on An Loc, a provincial capital some 60 miles north of Saigon near the Cambodia border. ARVN troops were besieged in the city but stubbornly refused to surrender. A separate attack was launched against Quang Tri, another provincial capital farther north, not far from where Nick met Henri Huet

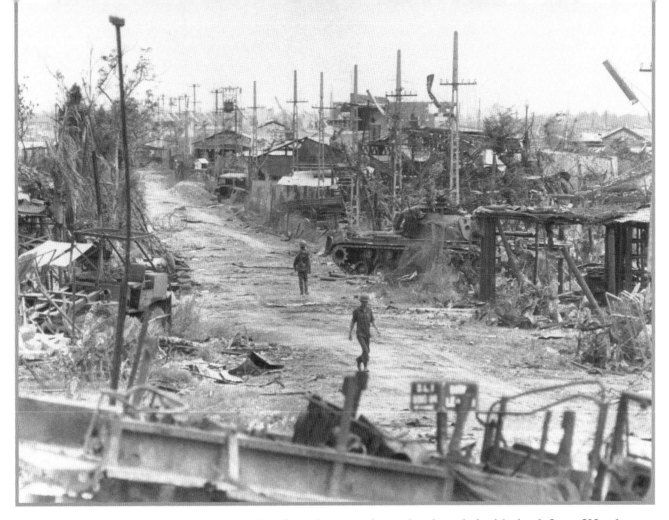

▲ ARVN troops patrol a section of Quang Tri after a house-to-house battle ended with the defeat of North Vietnamese troops. By July 1972, when this picture was made, Quang Tri was virtually destroyed. Fighting continued amid ruins until mid-September.

before his fatal flight over Laos. Easter offensive attacks kept Nick running back and forth making pictures at the two locations.

North Vietnamese planners saw An Loc as the northern end of a highway that would take them directly into Saigon. For weeks beginning in March, NVA tanks and troops tightened a circle around An Loc that eventually included portions of the city. Nick covered ARVN troops attempting to crack the circle and relieve the entrapped city, but most ARVN action involved artillery barrage and direction of U.S. air strikes. Nick photographed what military activity he could as well as the flood of refugees that somehow found their way

FROM HELL TO HOLLYWOOD

through enemy and ARVN lines. By early summer, the NVA forces were turned away, its siege of An Loc broken. Nick accompanied ARVN through the devastated streets of what was once the home of some 15,000 South Vietnamese. Scenes of shattered buildings were ubiquitous, peopled by survivors and returning refugees scratching through ruins to salvage some piece of their previous lives.

Attacks against Quang Tri, north of An Loc and close to the demilitarized zone, began in late March with NVA forces quickly overrunning the city. ARVN troops eventually retook the city, but it required several months of bitter urban fighting; Quang Tri would not be back in government hands until September. Making the long haul to the city, Nick covered some of the action especially around The Citadel, a Quang Tri historical landmark.

An Loc and Quang Tri's long-running battles continued into autumn ending finally in major victories for the ARVN. South Vietnamese success, without U.S. combat troops, was seen as a a positive omen for so-called "Vietnamization." Not noted was the role played by U.S. air support which would, like the American combat troops, disappear by 1973.

Significant as they were, the An Loc and Quang Tri battles did not overshadow Vietcong Easter Offensive attacks on outposts in the Highlands and in the Delta. Nick's knowledge of the Delta north of his hometown made the area one of his frequent coverage locations and often his jumping-off spot with ARVN patrols into Cambodia. Early in June, he planned to visit a town near the Parrot's Beak where NVA and VC had closed Highway 1, the major artery from Saigon to Cambodia.

Nick's destination: Trang Bang, a small town on Highway 1, 25 miles northwest of Saigon. His assignment was an appointment with destiny.

▼ A wounded South Vietnamese Marine is helped by his buddy near a make shift hospital a half mile from the center of Quang Tri in August 1972. Fierce fighting flared across the area near the city's ancient Citadel, center of North Vietnamese resistance.

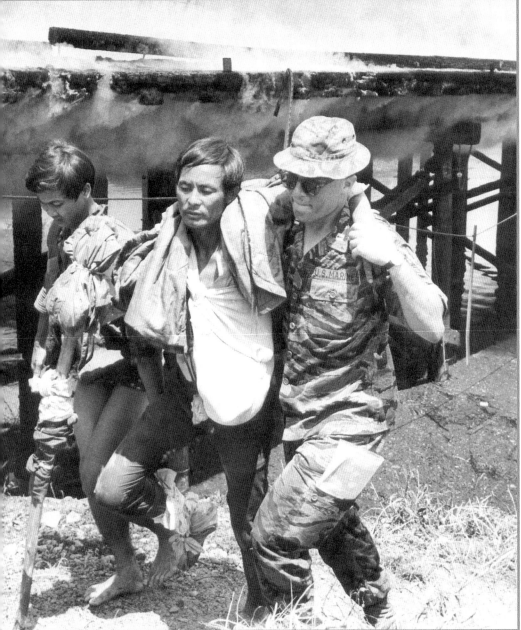

▲ An American advisor helps a wounded straggler who escaped North Vietnamese attackers near Quang Tri in May 1972.

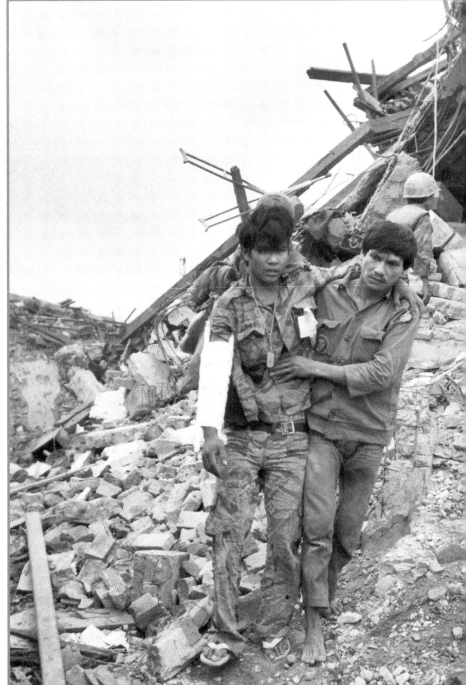

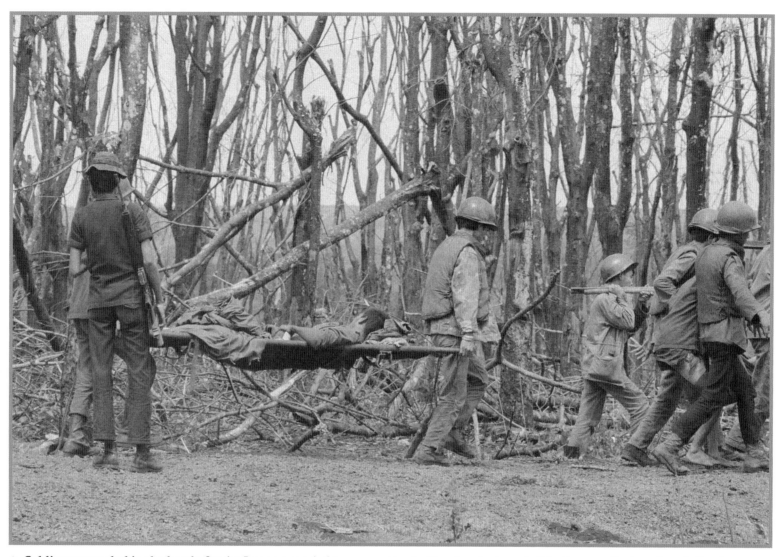

▲ Soldiers wounded in the battle for An Loc are carried to evacuation helicopter during a lull in the months long battle for the provincial capital.

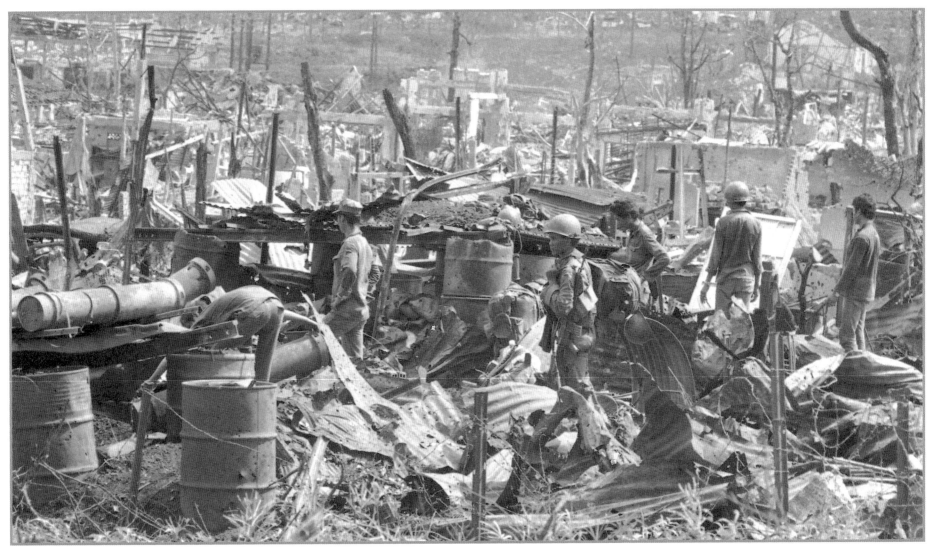

▲ ARVN troops survey damage in An Loc during a lull in the long, Easter Offensive battle for the provincial capital. The City was virtually destroyed before the North Vietnamese forces were defeated.

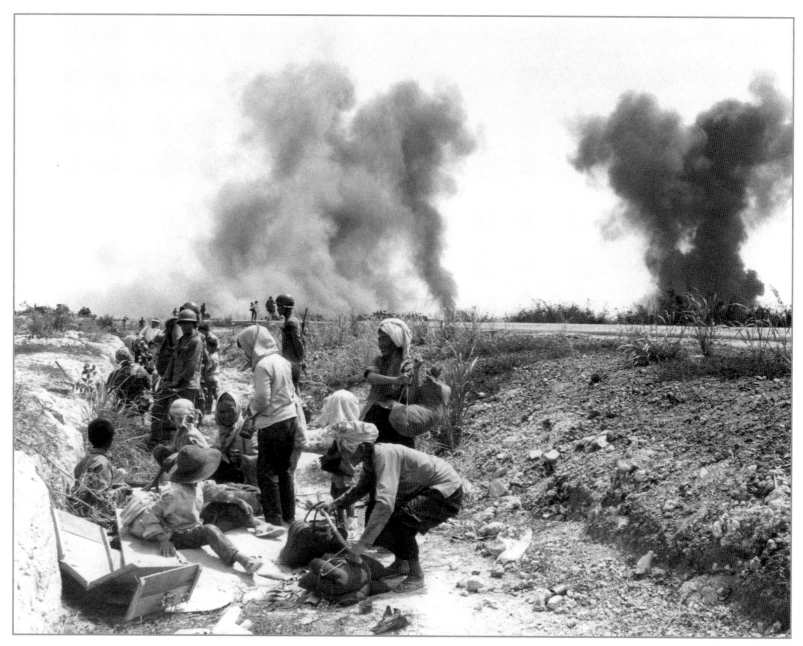

▲ Refugees rest in a ditch not far from An Loc in June 1972. The city was under heavy attack during the Easter Offensive. Smoke in the background marks the site of U.S. and South Vietnamese air strikes.

▲ A South Vietnamese family— parents and five children—flee An Loc, one of the major cities under attack during the Easter Offensive that began in May 1972.

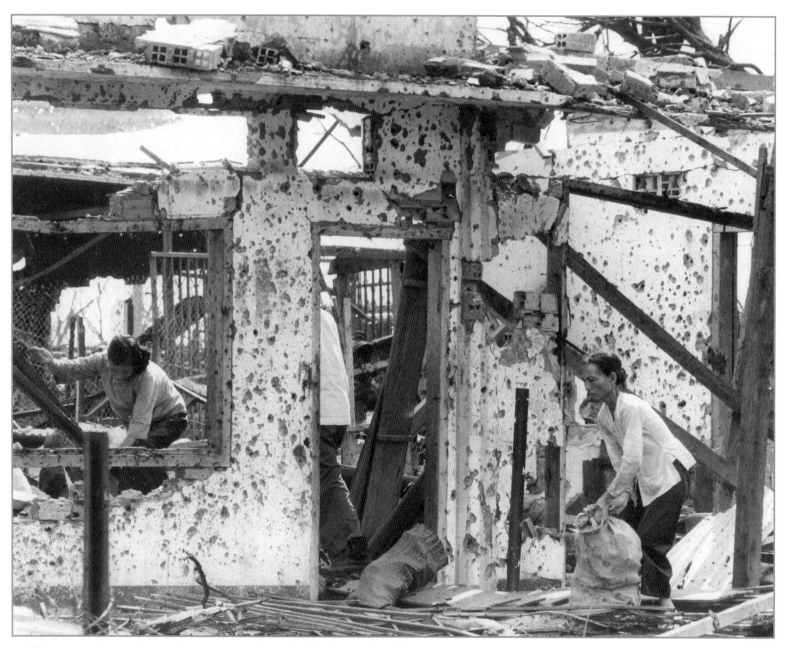

▲ Villagers seek to salvage what they can from their bullet and shell marked home in An Loc, June 1972.

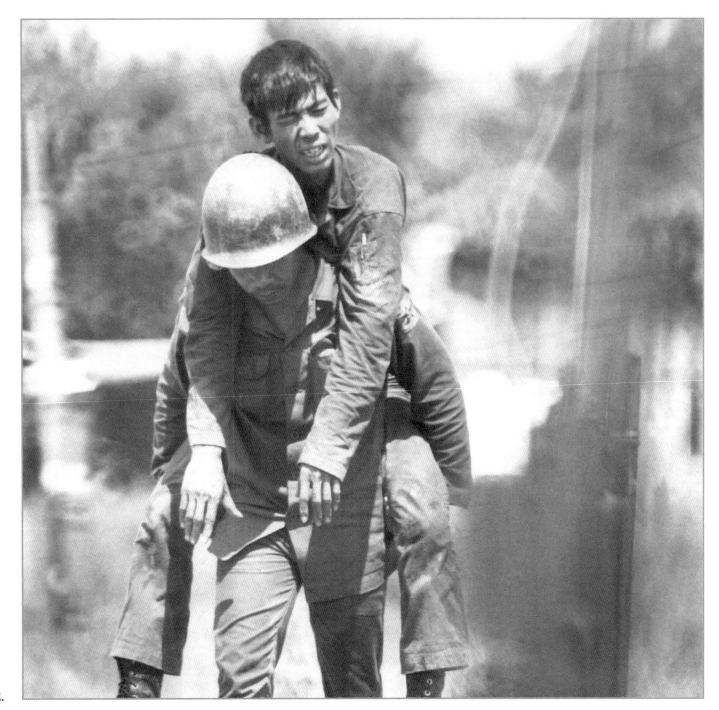

▶ Wounded are evacuated during the Easter Offensive, October 1972.

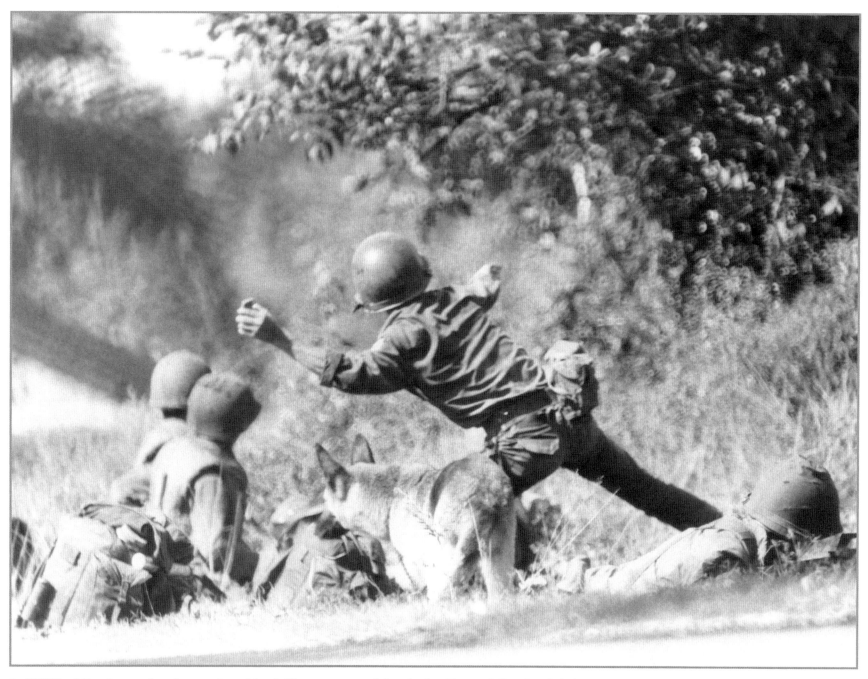

▲ ARVN soldier throws hand grenade at North Vietnamese position during Easter Offensive fighting at a hamlet near An Loc, October 1972

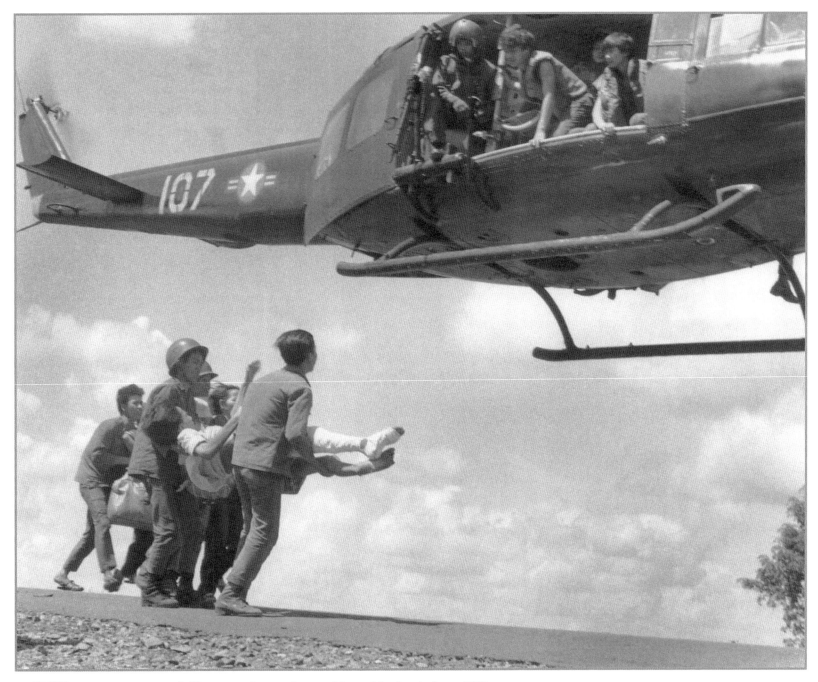

▲ ARVN troops evacuate a civilian casualty on the outskirts of An Loc in June 1972.

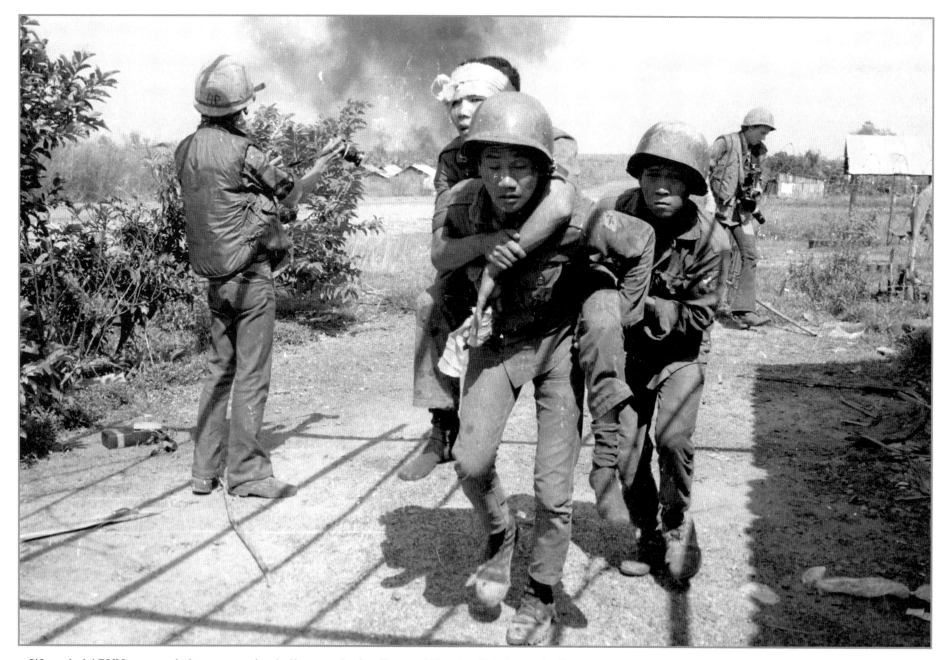

▲ Wounded ARVN are carried to evacuation helicopter during Easter Offensive fighting at An Loc.

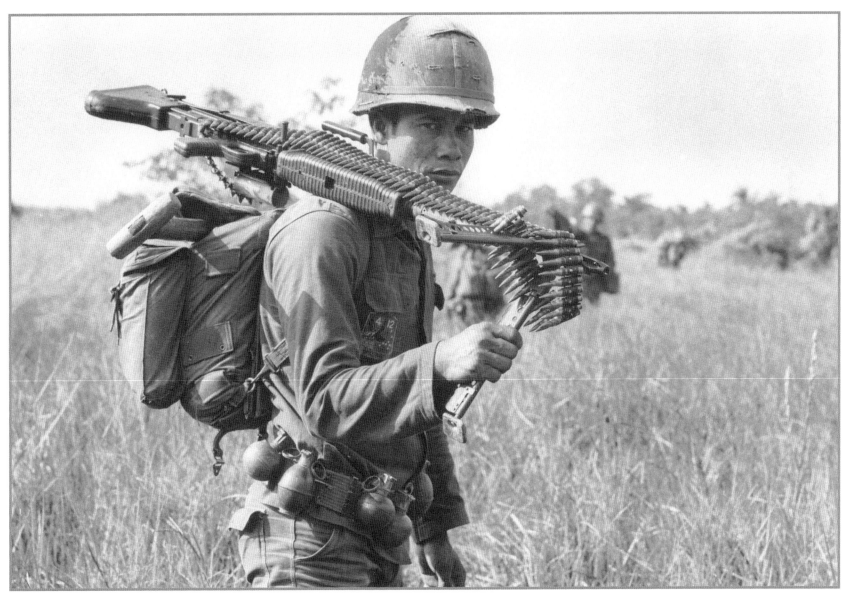

▲ A South Vietnamese machine gunner in the Mekong Delta, March 22, 1972.

► South Vietnamese troops fire on North Vietnamese positions in the Mekong Delta, August 1972.

64

◄ South Vietnamese personnel carrier makes its way through Mekong Delta waters in August 1972.

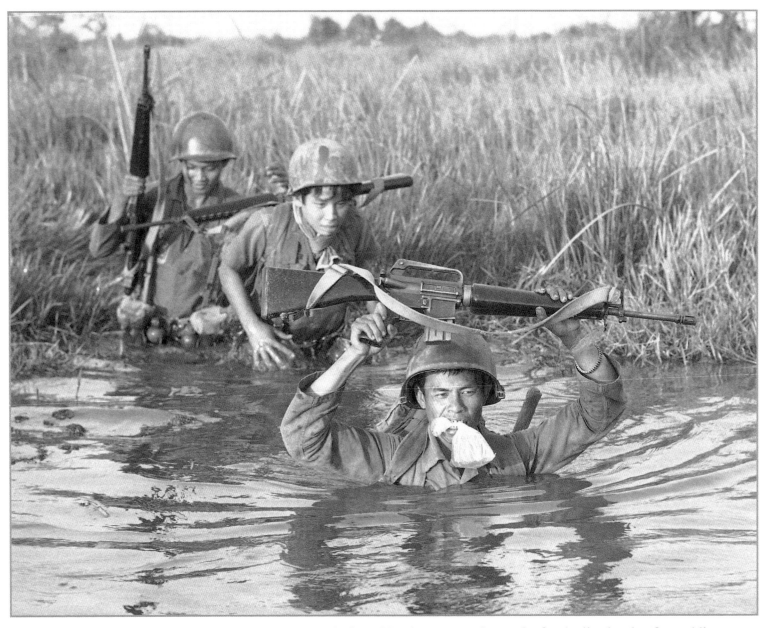

▲ ARVN soldiers cross a muddy Mekong Delta stream during a March 1972 patrol near the Cambodian border. One soldier holds a plastic bag containing his personal belongings in his teeth.

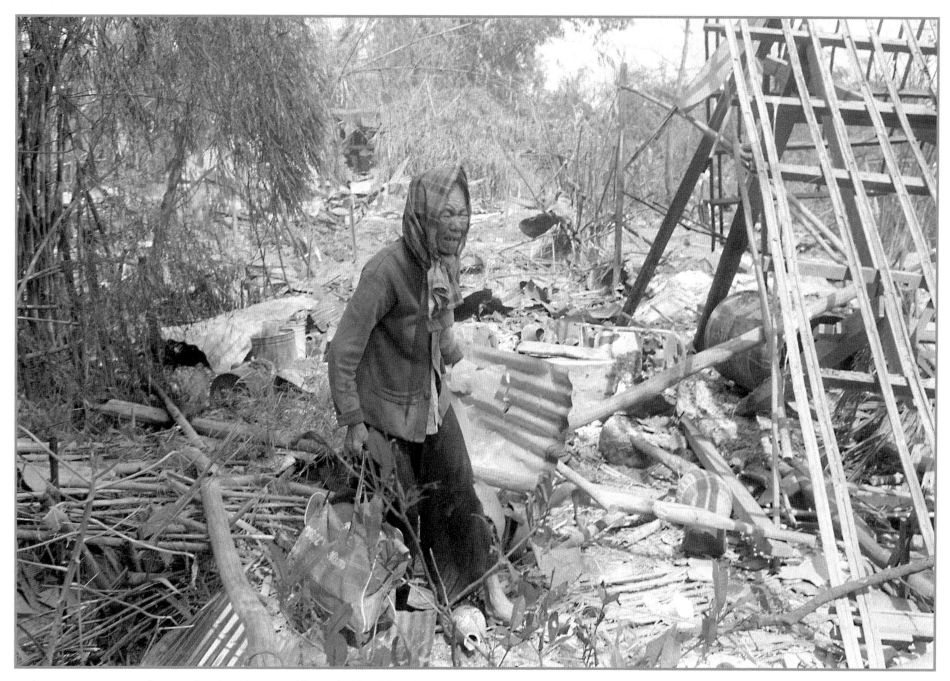

▲ A woman weeps as she searches her destroyed home in Tam Binh, just seven miles from Saigon. Her home was bombed during a attact to drive out North Vietnamese infiltrators.

Firestorm on Highway 1

Nick Ut's assignment started early that day, June 8, 1972.

It was 5:30 a.m., as he prepared to visit Trang Bang about 25 miles from Saigon and not far from the Cambodian border. He had heard reports that Vietcong and regular North Vietnamese troops partially occupied the village and closed Highway 1, a major artery for the transport of supplies. Several days of attacks by ARVN troops had failed to drive out enemy forces.

Fighting around Trang Bang was typical of many battles Nick had covered in the past four years, and he wondered about picture possibilities. Maybe, maybe not, he thought. He considered the risk involved in making pictures in the open countryside in the Trang Bang area. Snipers were always involved in these encounters. But because the fighting had lingered he decided it was worth a look.

Of course, he had not the slightest thought that before day's end he would experience the defining moment of his life, a moment captured in a photograph.

Horst Faas and Peter Arnett had told Nick they would join him on his trip, but Horst's previous injuries acted up and he cancelled out. Peter, likewise, decided not to go. Nick would travel alone to the village. Now a seasoned combat photographer despite his youth, he checked his gear. Flak jacket. Cameras. Lenses. Film. Snacks. Proper uniform to match that of South Vietnamese troops. Everything was in order.

The days of quick helicopter rides to battle sites were gone along with the massive presence of American troops. By 1972 U.S. forces were sharply reduced, their choppers and heavy military equipment

for the most part disappeared. So, Nick would travel the 25 miles to Trang Bang with a driver in the AP's van.

Early morning light, dimmed by an overcast sky that promised monsoon rains, filtered through the trees of Saigon streets. The overnight curfew was now lifted. Loaded down with gear, Nick climbed into the van waiting outside AP's Saigon bureau. Telling the driver to head toward National Highway 1, he settled in, appreciative of the air-conditioning that eased the muggy heat of a Vietnamese spring turning to summer.

For Nick, the ride along Highway 1 was routine. He had traveled the road many times on his way to battle sites near Saigon, always observing rules of thumb necessary for survival. Vietcong owned the night, making after-dark highway travel foolhardy. Still, risk remained, reduced but not eliminated during daylight. Even close to the capital, snipers were always about.

As the van rolled along the highway, Nick's thoughts turned to remembrance of his brother Huynh Than My, Anh Bay, No. 7. He had photographed war in the Delta, and his knowledge of the area—like Nick's current knowledge—helped My move quickly to ever-changing battle sites. Knowledge offered only limited protection, however. Vietcong had overpowered a Vietnamese army unit My was photographing, and My had been killed while awaiting evacuation. Recollections continued to flood Nick's mind as the van picked its way through the early morning traffic. The passage of seven years since My's death had not diminished Nick's memory of his older brother, their life together during his teenage years, the lessons he learned about photography and the powerful admiration he held for his mentor.

It was 7:30 a.m., and Nick's reverie ended as the van slowed down, encountering stacked-up traffic near Trang Bang. Stalled cars, carts, buses, bicycles, trucks, military vehicles and refugees clogged the highway. Some had been there for three days while fighting continued near the village. Refugees and travelers alike lived along the highway, sleeping out of doors while hoping that government troops would prevail and make possible their return home. Leaving the van and driver, Nick shouldered his equipment and hiked toward Trang Bang under a grey sky. A gentle mist was falling.

After a short walk, Nick approached a barrier of concertina wire across the road. He checked in with the Vietnamese military commander, then joined fellow journalists, a dozen or so of whom gathered along the wire. Photographer David Burnett, a rising star for Time and LIFE, greeted him. Nick spotted freelancer Hoang Van Danh. Fox Butterfield of the New York Times waved. Television cameramen from ABC, NBC, CBS, ITN and others stood nearby chatting. As the journalists spoke, their conversations were often interrupted by gunfire near towers of a Cao Dai temple that they could see above the distant tree line.

It was a bizarre scene, this encounter in a strange war. The bystanders huddled together, watching across the wire barrier. The Cao Dai towers were flanked by wooded areas on either side. It was a peaceful landscape until disturbed by automatic weapons chatter or the explosion of a grenade. But no one ducked or sought cover at the sounds of gunfire.

War was over there; correspondents were over here, the two groups separated by a length of highway. Watchers heard the action in which unseen soldiers played a deadly game: On one side of the highway North Vietnamese troops and their VC allies held a position that faced South Vietnamese government troops on the highway's opposite side.

Nick joined South Vietnamese troops in fields surrounding the temple. He made pictures of soldiers cautiously surveying the scene and slowly advancing toward the Cao Dai buildings. Then he returned to the highway, rejoining the media group.

Like Nick Ut, 9-year-old Phan Thi Phuc Kim had no idea that June 8 would also provide her life's defining moment. She lived in the shadow of the temple in the semi-rural outskirts of Trang Bang's business district. Her life was made up of schooling, playing with her siblings, helping with chores at the family's noodle shop and caring for their few barnyard animals.

Just as in Nick's hometown of Ky Son, life in Trang Bang felt the bite of the war. Trang Bang was close to the Cambodian border at a spot where Vietcong and North Vietnamese troops left the Ho Chi Minh trail and entered South Vietnam. In recent weeks, Vietcong agents had turned up at night and forced villagers under threat of death to carry messages for them to their local operatives.

When Highway 1 was closed, ARVN troops moved in and firefights became frequent in the woods as the VC edged closer to the main part of the village. Sounds of rockets and heavy machine-gun fire confirmed to the villagers that North Vietnamese troops were involved.

Townspeople and nearby residents fled to other communities and to Saigon, but Kim's family remained to protect their business and to care for their animals. On June 5, ARVN soldiers advised them to take shelter in the Cao Dai temple. For three days, they heard the war edge closer as increased government action drove the North Vietnamese out of the town and into a wooded area behind the temple. Assembled villagers—about 30 men, women and children—felt protected by soldiers and believed that North Vietnamese and Vietcong would not attack a religious site.

It was 1:00 p.m. Still watching and listening to the gunfire near the temple, Nick and the other journalists considered options—stay a bit longer or return to Saigon to meet deadlines. That's when an ARVN officer told them that Skyraiders of the 518th Vietnamese Air Force Squadron had been called in for an air strike to precede a major assault.

Soon, South Vietnamese planes streaked in, firing phosphorous rockets at the North Vietnamese position to mark it with white smoke. Instantly, colored smoke rose from the South Vietnamese, indicating their location near the temple.

Planes skimmed over the treetops in the direction of the smoke-marked locations. The first Skyraiders dropped bombs, but some failed to explode. Nick and the other journalists noticed that the duds and some of the exploding bombs fell closer to the government positions than to the North Vietnamese.

Their experience told them a napalm attack would follow, and within seconds, a plane followed a similar pattern and dropped its deadly package.

Through the long lens of his camera, Nick watched the drop; he photographed tumbling canisters hitting the highway close to the temple and the South Vietnamese position. The napalm exploded, its fiery orange splashing across the highway. Dense smoke billowed upward. Nick held his camera steady and with its 300mm lens captured the full scene. A wave of intense heat washed over him despite the distance from the site of the explosion. For years afterward, he would recall the heat and the vivid colors of the napalm attack.

South Vietnamese troops joined the villagers in the temple. Although they knew an aerial attack was imminent, they believed anyone close to the Cao Dai buildings was safe because their location was marked by the colored smoke. But when the first plane appeared, its bombs landed closer than expected to the temple towers.

Soldiers realized something was amiss. Immediately, they shouted to the villagers to get away: "Run . . . Now!"

The villagers, Kim Phuc and some of her family dashed down the highway as the second plane swooped in low and dropped its

package. Nick's lens followed it as flame swept across the landscape, creating what can only be called the fires of hell.

Several soldiers and villagers were swallowed by the inferno, and others along the perimeter of the fire were burned as they ran.

Kim Phuc felt the greasy, burning napalm hit her left shoulder and back. Her clothes burst into flames. She tore them off, then ran naked along the highway, trying in vain to escape the firestorm.

Nick and his fellow correspondents on the highway saw the children, men, women and soldiers emerge from the smoke. The journalists moved toward them. Nick photographed an elderly grandmother holding a burned baby that would die in her arms.

He saw a young naked girl. "Too hot, too hot," she cried out as she ran toward him, her arms outstretched, with other crying children fleeing alongside her.

Nick had used the film in three of his cameras to make pictures. Reaching into his side pocket, he pulled out his reserve camera with a shorter lens and photographed the harrowing scene. As he made more pictures of Kim Phuc and the others, she dashed past and he saw her severe burns.

In an interview, Nick recalled the scene:

"I keep shooting. Shooting pictures of Kim running. Then when she passed my camera, I see her body burned so badly. I said, 'Oh, my God, I don't want no more pictures.' She was screaming and crying. She just said, 'I'm dying, I'm dying. I'm dying, and I need some water. Bring water.'"

He ran, got water and started to pour it on her burns, hoping this would help. But she cried out, "No water on my body. Need water to drink." He gave her a drink from his canteen.

Nick and other photographers and correspondents tried to aid the badly burned girl, from whose shoulder and arm flaps of skin were peeling off. When someone tried to cover her with a poncho she screamed in pain. A relative pleaded for help, and Nick carried Kim to the AP van. Several family members, some burned, got in the vehicle, and the group headed for a hospital in Cu Chi.

Nick described the trip in an oral history interview:

"I sit with my driver. She sit in the back, but she couldn't sit down. She had to sit on the floor, her skin so bad. 'I'm dying, my brother, I'm dying, I'm dying,' screaming all the time, like over 40 minutes. Every kid in the car is screaming and crying, in the van. I look Kim all the time. I tell her we will be in hospital soon, soon, soon. I told driver drive faster, faster . . ."

Back on Highway I, correspondents remained for a short time as fighting around the temple continued, then made their way toward Saigon to meet deadlines. Among them was LIFE'S David Burnett, who made many pictures that day but was changing film at the brief moment when Kim Phuc ran past. Burnett's recollections, recorded in an AP Corporate Archive oral history interview conducted by AP's Chuck Zoeller, provide insight into how a photographer responds in such chaotic situations:

"Civilians and soldiers came running out of the smoke soon after the napalm blast, and you're a photographer and you are aware of what the physicality is to make a picture, and you realize that in a way it's an active, aggressive act but you do it in a passive way. You're just waiting for life. You're putting yourself in a place that whatever the life is around you, you're

ready to shoot it. It's not like there are trumpets heralding the moment. You take the picture and then take another picture, then you wind it on, you take a third picture. And that's how it all unfolded. And within minutes or so I was shooting pictures. The kids had run up to where the TV cameramen were.

"And the thing about it is the camera stops time for that moment, but what we were living in that moment continued; it was a continuum,

it didn't stop. Just because a picture was taken or film was rolled didn't mean that it stopped. It was a moment building on a moment and another moment. And I remember shooting these pictures of the sister and the brothers. I don't know if she's the sister—she might be a cousin. The older girl, her brother, and then like 10 yards away, Chris Wain (ITN television correspondent) is pouring his canteen over Kim's burns just trying to help, give a little bit of a break. And then very quickly within another minute or so they rounded up the kids and got them running toward where the cars were.

"It was all happening so quickly. If there was going to be a picture made that day it was probably meant to be that moment in Nick's camera on Nick's roll of Tri-X."

Highway congestion slowed the ride to the hospital which took 40 minutes despite Nick's urging the driver to hurry. Screaming in pain at each bump in the road, Kim fainted several times. She told her relatives repeatedly that she was certain she would die.

When they finally reached Cu Chi hospital, staff experienced with serious burn victims told Nick that Kim's chances for survival were slim. They would assign her to a section of the hospital for patients seriously wounded and not expected to live. Nick took a doctor aside, showed him his media credentials and told him the child had been photographed and her picture would probably be published in newspapers worldwide. Surely, he told the doctor, they did not want to have Kim die in their facility. Treatment was expedited and elevated. Kim was reassigned to an area for life-saving treatment.

Nick made one more check of the family, then headed for Saigon and the AP.

Now came the wondering. In the 21st century, photographers see digital images on their camera screens immediately after exposure. But this was 1972, and Nick had to wait until the film was developed at the AP bureau before he could see what he had. As the van sped back to Saigon, Nick mentally reviewed his photography of little more than an hour earlier. He knew he had the possibility of great pictures. But . . .

Was his focus good? Was the exposure accurate? Did mist collect and create water drops on his lens? The scene was lit by an overcast sky that dimmed the usual sunlight of early afternoon; was his shutter speed fast enough to stop the action? It all happened quickly. Napalm explosion. Smoke. People running toward the journalists, many of them screaming. Some dying. Chaos.

When the van reached the AP bureau, Nick was greeted by Yuichi "Jackson" Ishizaki, Tokyo veteran photographer and all-around technician temporarily assigned to Saigon. The bureau staff was not aware of the incident at Trang Bang, but Ishizaki, who had seen it all over the years beginning with World War II, could read Nick's expression. It told him Nick was excited about the pictures in his cameras.

"What have you got, Nick?" he asked.

"Good pictures," Nick replied, dumping eight rolls of 35mm Tri-X , black-and-white film on the table.

The two entered the darkroom, ran the film onto spools and passed the rolls through the developing process, then into heat-rigged cabinets. Drying was carefully monitored to avoid swelling or other film damage. Nick struggled with impatience.

Finally, Ishizaki examined the developed frames on a light table. He was the first of many to ask: "What's this, Nick? . . . You have pictures here of a naked girl running on the highway? What's wrong with the girl?"

Nick looked at the image with a magnifying device.

It was there.

The crying boy on the left, children and smoke in the background. In the center of the 35mm frame was the screaming girl, her arms outstretched. Nick recalled Kim's screams, "Help, me. Help me. Too Hot. Too hot." He examined other images across the rolls of film—an elderly woman holding a burned young child, obviously dead, others running and walking away from the Cao Dai temple still partially obscured in acrid smoke.

Nick and Jackson re-entered the darkroom and made a series of 5x7-inch prints, the size used for radiophoto transmission. Laid out on a table, the photos told the story of the napalm attack at Trang Bang in searing detail.

Now Ed White, former chief of bureau in Saigon who had been called back to help out with coverage during the Easter Offensive, hurried to put that story into words for the international wire. As Nick supplemented the prints' images with his own descriptions, White tapped out the news story:

TRANG BANG, Vietnam (AP)—A South Vietnamese A1 Skyraider accidentally dropped four canisters of napalm close to a temple Thursday, setting off a searing inferno in which about 20 civilians and soldiers were killed or injured.

Sheets of flame ripped across the district town on Highway 1 about 25 miles northwest of Saigon. Scores of women, children and soldiers ran down the road, horror etched on their faces.

Some could not escape the burning jellied gasoline that clung to their bodies.

One small girl ripped off all her clothing and ran naked with several other children, crying and screaming. The skin was burned off her back. An old woman screamed hysterically that her four children had burned to death. Another old woman clutched a charred child seeking help.

Medics treated youngsters who had been seared when the napalm exploded, and other government troops aided the injured.

Government soldiers, burned by the attack lay along the road. A South Vietnamese man hobbled along the highway carrying his wife piggyback style. She had been sprayed by the napalm.

The propeller-driven bomber accidentally dropped the napalm on both sides of the highway, near a Cao Dai temple while trying to flush out enemy troops surrounding Trang Bang. The jellied gasoline fell into the position of a government infantry company and civilians trying to escape the crossfire.

Meanwhile, as editors in the Saigon newsroom viewed the prints, there were questions. A discussion began over the nudity and AP's longtime policy of not transmitting full length frontal nude photos.

Would the child's nudity create problems? Were the pictures too dreadful to transmit? Would these factors combine to prohibit publication? Would Nick's pictures not be distributed beyond AP private circuits because of this policy? Should the picture be retouched to obscure the nudity? The first thought was that the photos would never be published.

The Associated Press had never carried a picture like this.

In the midst of this conversation, Faas and Arnett returned to the bureau from lunch. In an interview later, Faas recalled his reaction on seeing the prints: "Looking at all the film, I could reconstruct what happened. And there was no question that the main picture was great."

"Who made the pictures?" he asked.

"Nicky," Ishizaki replied.

Though well aware of the nudity policy, Faas believed strongly that the pictures should be distributed and ordered them transmitted to New York. No retouching, no special darkroom alterations. The prints were rushed to AP's transmitter location at the Saigon cable office and sent by radio circuit to Tokyo and from there automatically relaycd to AP New York.

Each photo took about 20 minutes to reach Tokyo and New York simultaneously.

Radio transmission was the only way to immediately send photos from Saigon, but technical problems frequently threatened picture quality. Fluctuating atmospheric conditions could blur, eliminate or otherwise damage large sections of the photographic image. This day, however, radio circuits were clear to Tokyo where AP's full-time cable relay to New York was reliable. Nick's pictures arrived in good shape at the 50 Rockefeller Plaza photo desk, the gateway to worldwide distribution of the photo.

The New York photo desk atmosphere in 1972 was a cacophony of noisy wire service equipment. Six or eight editors were always on duty managing the flow of news photos that covered subjects in Manhattan, domestic locales, and foreign posts of every size and language, including the war in Vietnam. The chatter of editors across the desk complex mixed with ringing telephones, teletype printers click-clacking out stories and wirephoto transmitters squealing as they scanned photos or recorded incoming pictures. Even at its quietest, the atmosphere was highly charged and electric.

As soon as Nick's picture landed in New York, it was obvious that its brutal content, combined with nudity, would require careful attention. This photo—unlike any image previously transmitted on the AP network—communicated the pain of the burned children.

Experience told me that particularly harsh pictures often resulted in vigorous reader response. As the head of AP Photos then, I had to consider whether the sheer horror of the photo and the pain it communicated would offend newspaper editors and—if it was actually published—their readers.

While the brutality of the picture in itself was controversial, the nudity would surely create a greater level of scrutiny and comment. The image of the naked child clearly conflicted with AP guidelines—guidelines I helped create—that banned distributing photographs of frontal nudity. The purpose of that guideline was to keep photos of sexual content off the network. I remembered the reaction to photos of the My Lai massacre, with some readers saying the images of naked children were obscene.

The photo would certainly have a political impact, drawing comment from both pro and con partisans on the Vietnam War.

At the same time the powerful impact of the photo was undeniable. It was a quintessential image of war, the horror of war. All war.

The composition of the image was nearly perfect: a screaming child on the left enhanced the agony and chaos, as did the hand-holding youngsters on the right; the naked child, her arms widespread in an impossible plea to ease the pain, was at the center of attention—and in the center of the image. A curtain of napalm smoke clouded the background.

Despite the nudity, I did not believe that the photo was prurient in any sense of that concept.

And so, a final set of questions needed answers: Was this photograph good enough to override content objections? Was this a great photo? Was it really visually superior? Was its appeal universal? Or was its appeal limited to the individual "eye of the beholder"? Was it

an image of the moment? Or was it a photographic icon that would inspire memories in a distant future?

Despite the guidelines that it clearly crossed, did these assessments justify its distribution?

AP, of course, would be the distributor of the photo, not the publisher. The pictures would, and did, require similar considerations by editors at newspapers. Each paper would reach its own decision to print or not print. Still, I could not disregard that distribution of the photo on the AP network would lend a tone of legitimacy to the image.

In the end, these questions were just that. They were serious checkpoints to be considered—but to be set aside when news photos were truly transcendent.

These considerations were not checked off one-by-one on a list, imaginary or real. They morphed quickly toward a conclusion as the picture was viewed and discussed with editors. It was obvious to me that this was a photo—a series of photos—that had to be seen.

We transmitted Nick Ut's picture worldwide.

Earlier, as the photos were being set up for transmission from Saigon, Faas had messaged New York to advise that they were on the way and to provide an alert about the subject matter. Then he decided to make a backup phone call, to be certain that editors knew the photos were coming. Telephone voice contact between Saigon and New York via radio circuits was always chancy, but somehow Faas made the connection.

"I got one of those rare telephone calls through to Hal Buell in New York, who was in charge of AP photos at that time," Faas recalled. "I told him the pictures would become icons of all time."

By the time the call came through, the first picture had arrived. I told Horst that Nick's photo was already on the wire and to expedite any others that would tell the story.

Once the prints were out and on their way to the world, Faas put his hand on Nick's shoulder and told him, "You did good work today, Nick Ut." The 21-year-old photographer glowed.

Before leaving the bureau, Nick took another look at the film. That's when it hit him.

There, in the lower left-hand corner of the 35mm frame, was the frame number recorded automatically at the time of exposure: Frame No. 7.

No. 7. Anh Bay. Nick's name for his brother, My. For Nick, the conclusion was inescapable. In some mysterious way, his brother had helped Nick make the photo, an image that showed the violence of war and its tragic impact on children.

It was My's lesson of years ago. He had told Nick that photographing the war would help tell the world of Vietnam's devastation, would help end the war. My hoped Nick would have the opportunity to make such photos, and Nick knew he would carry his brother's role at Trang Bang with him forever.

As Nick left the bureau, the hyper-excitement of the day ebbed. He stopped for a bite to eat, food having been forgotten since the hours on Highway 1 . . . , the rush to Cu Chi . . . , then to the AP bureau . . . , then film and prints . . . , the impact of the photos on the staff and especially on Nick . . . , the discovery of Frame No. 7. Now he was alone. No Henri. No My. Images flashed through his mind: Burned skin, a screaming child and her pain. Then recollection of his own wound, earlier, and that pain. Then the older woman and dead child. Nick had seen the dead on other assignments, but here was a child close to dying.

"So bad, so sad . . . ," he recalled later, "to see dying, crying, bleeding . . . that I don't want to see anymore."

Firestorm on Highway 1

Afterward at home, still alone and seeking to find sleep, Nick knew he would photograph the war again another day. My came to mind again, and My's lessons of photography and the need to show the world what the war was like. Sleep came finally, but it was brief. Nick awoke, seized by a sense of gloom. He remembered those late-night thoughts:

"I felt so sad. But I told myself, this is my job . . . , it's what I do. It was the same for many photographers . . . at least ones I knew . . . , they were driven. That meant I would see the same things again . . . suffering . . . , shot people . . . , bleeding people . . . But the day after that, who knew, maybe something happy would happen, and I could photograph that. We never know."

Publication of the Highway 1 photo was sensational; it appeared on newspaper front pages around the world. There is no record of complaint from media editors or readers about nudity. The picture captured the horror of war in an intensely visceral way, its naked, seared figure communicating pain with unmistakable clarity.

AP Saigon received a stack of messages overnight congratulating Nick for his picture. Horst and Peter Arnett told Nick it had a good chance at winning a Pulitzer. That bewildered Nick. He did not know what Pulitzer was or what it meant despite the several Pulitzers won by AP staff and the staff celebrations that followed. Nick would understand all that months later when news of prizes and worldwide acclaim were delivered to the bureau.

That morning, June 9th, Nick, Horst and Peter drove to the Cu Chi hospital to visit Kim. Doctors told them she was alive but too ill to see visitors. They went on to Trang Bang where they discovered that the military action was over, the enemy force disappeared. Thin acrid smoke drifted over the village and its wreckage.

For Nick the sounds of battle were absent, replaced by muted weeping at the loss of loved ones and the sight of shattered homes on a scarred landscape.

Arnett wrote:

"The sun rose on tired and rain-soaked families walking back to the town. Some found their homes and shops in smoldering ruins.

"Soldiers were packing their gear, climbing on armored vehicles and striking out of town ignoring the refugees.

"Another nasty little battle was over."

GALLERY

Nick Ut's photos tell the story of the napalm attack at Trang Bang, June 8, 1972, that left Kim Phuc seriously burned. The pictures are numbered in the sequence they were made.

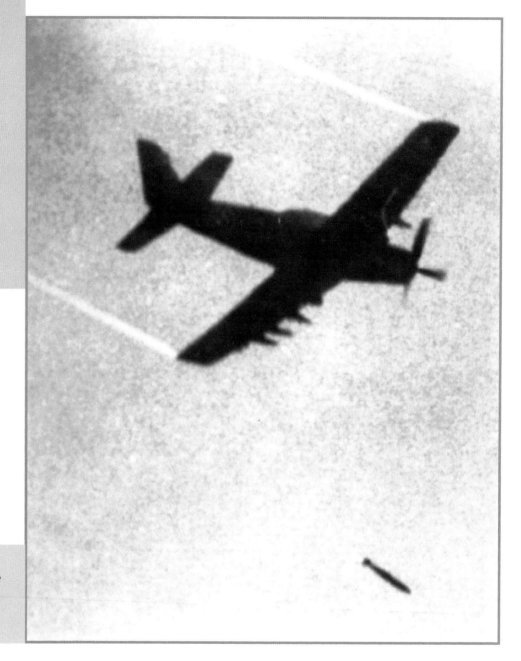

1. South Vietnamese Air Force plane drops bombs and napalm explosives near the Cao Dai temple.

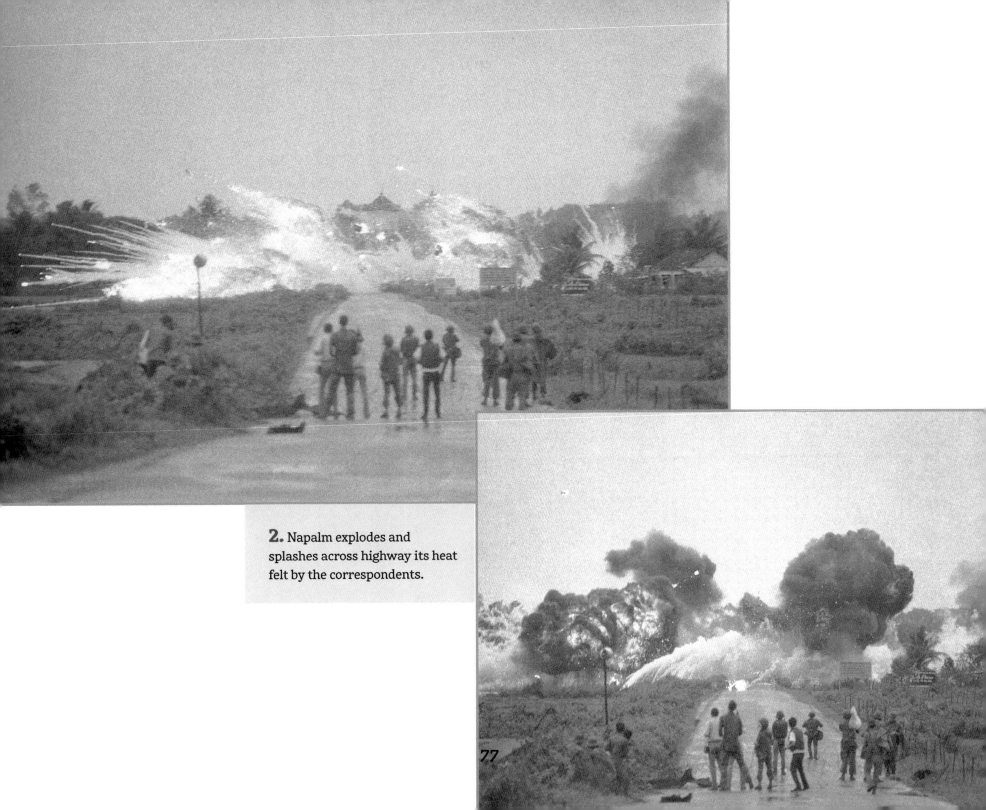

2. Napalm explodes and splashes across highway its heat felt by the correspondents.

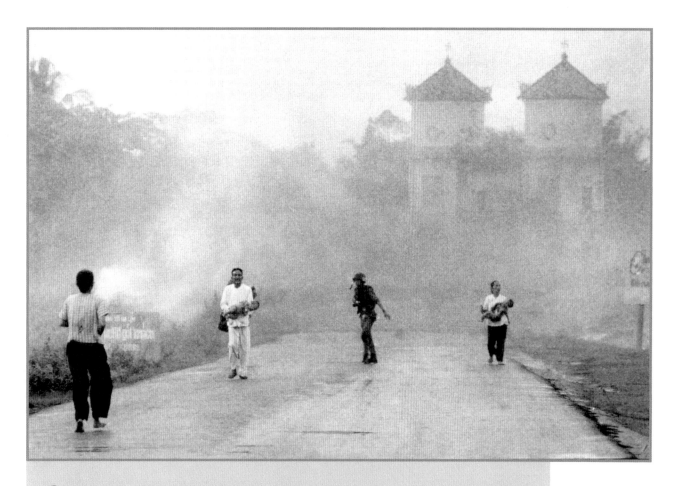

3. First Trang Bang villagers to flee the bombing appear in smoke of the explosion.

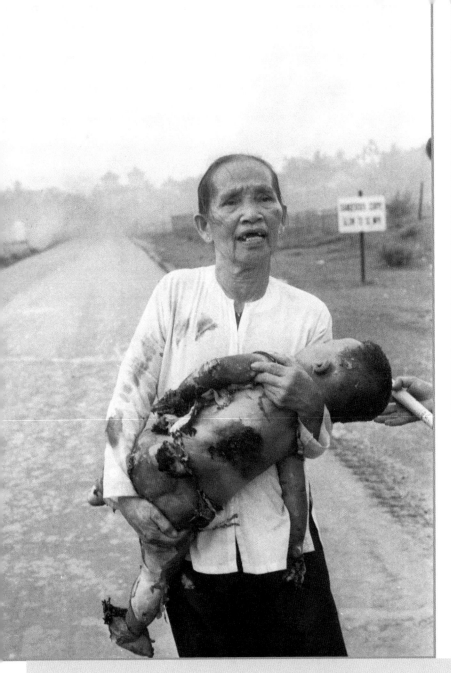

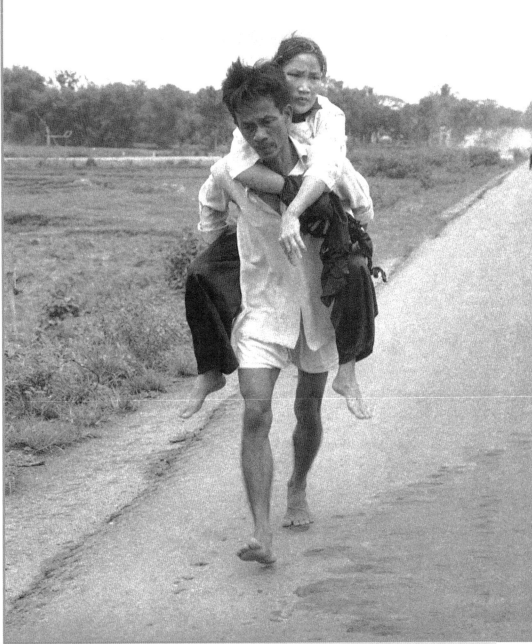

4. (*left*) Ly Thi Tho, grandmother of Kim Phuc, carries severely burned three-year-old Phan Van Danh. The child, a relative of Kim, dies in the grandmother's arms as she approaches the correspondents.

5. (*right*) Man carries a wounded villager away from the explosion.

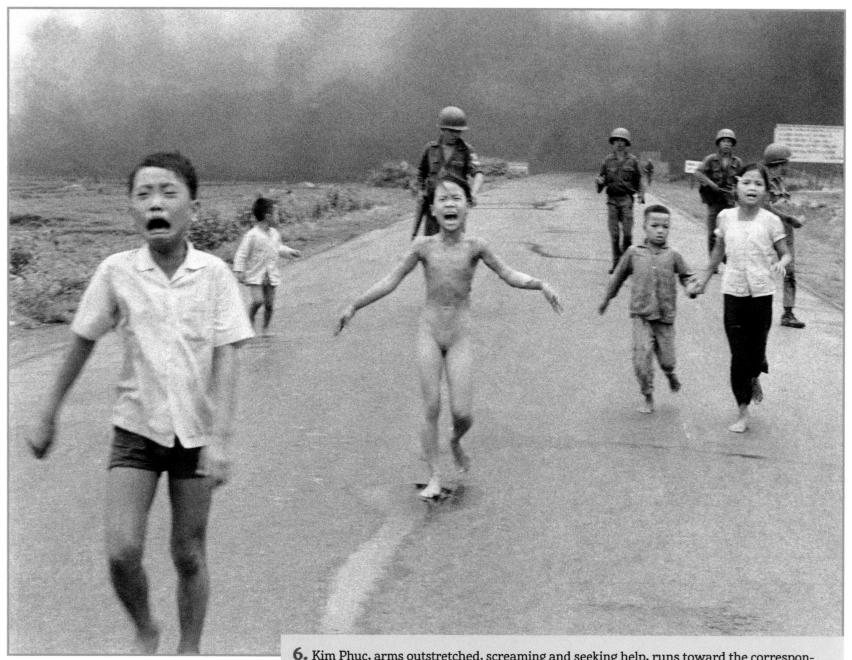

6. Kim Phuc, arms outstretched, screaming and seeking help, runs toward the correspondents. At left is her brother, Phan Thanh Tam, age 12, screaming in agony from an eye wound. Behind Tam is Pham Thanh Phouc, Kim's younger brother. Two children holding hands are Kim's cousins, a boy Ho Van Bo and a girl, Ho Thi Ting.

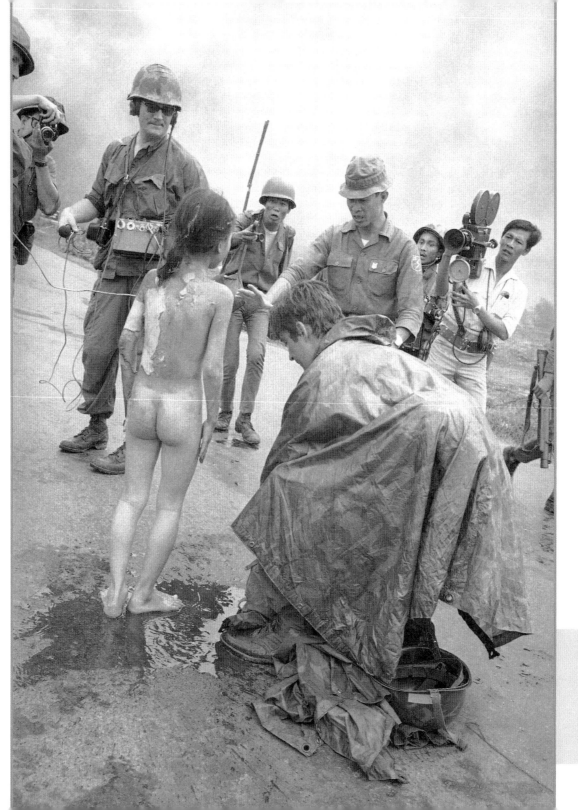

7. Correspondent Christopher Wain brings water to Kim Phuc who stands naked in the group.

8. Smoke drifts over the Cao Dai temple.

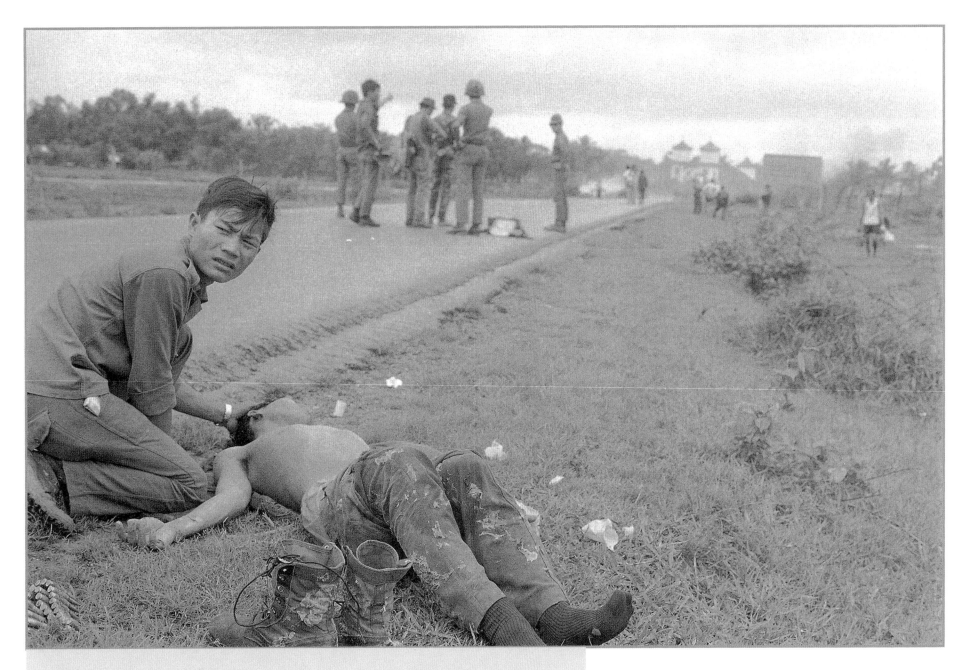

9. Vietnamese soldier helps his fellow ARVN who was seriously burned in the bombing.

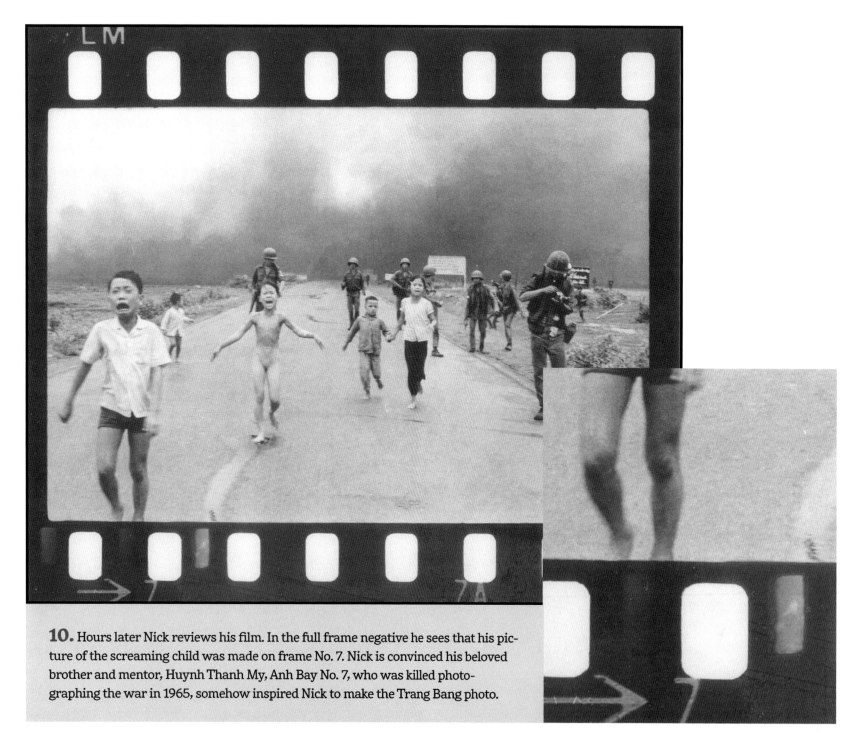

10. Hours later Nick reviews his film. In the full frame negative he sees that his picture of the screaming child was made on frame No. 7. Nick is convinced his beloved brother and mentor, Huynh Thanh My, Anh Bay No. 7, who was killed photographing the war in 1965, somehow inspired Nick to make the Trang Bang photo.

Chapter Seven

"It Is a Picture That Doesn't Rest"

A full spectrum of opinion followed Nick Ut's photograph from that day on Highway 1 and into the 21st century. Some believe the photo was and remains the ultimate anti-war symbol. Others say the photo ended the Vietnam War. Still others were and are convinced the photo provided the enemy with an effective propaganda tool.

Like the blind men who touched an elephant and then described the animal's appearance, each was partly in the right though all were in the wrong.

Photographs do not appear in a vacuum. They fall into a time and place and are affected by the times as much as, or possibly more than they affect the times. Iconic images seize upon a split second. They capture in that instant recollections of what has gone before, what exists in the present and, if we are smart enough, they may enable us to see into the future. Nick Ut's photo captured what happened that day at Trang Bang; it also brought to mind other horrific images from past battles. And it reminds us that if war continues, more such horrors will occur.

In their enthusiasm for Nick's photo and its impact, some commentators frequently credited—and continue to credit—the image with inspiring the American withdrawal from Vietnam and ending the war or at least contributing to its conclusion. Over the years, many

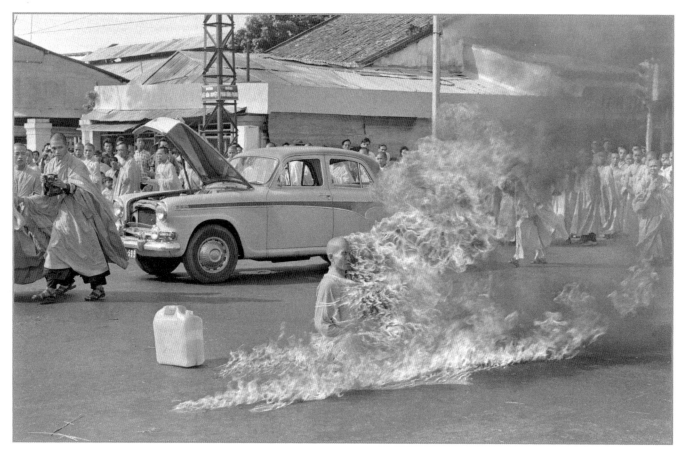

▲ The ultimate protest (AP Photo/Malcolm Browne)

American veterans thanked Nick for his picture, saying it helped bring the war to a close and got them home sooner. Potential draftees told Nick the picture eliminated their assignment to Vietnam.

Long before the photo appeared, the U.S. military presence in Vietnam had been reduced. By June of 1972, American military personnel numbered about 70,000, down from more than 550,000 just a few years before. U.S. personnel in '72 were involved in the administrative detail of withdrawal, were assigned as advisors or were part of air support for ARVN units. By January 1973, just months after Nick made his picture, the two Vietnam governments and the United States signed a formal peace agreement and the last U.S. military personnel soon left Vietnam. For the ARVN and for the civilian population of Vietnam, the war continued for nearly three years after the photo appeared.

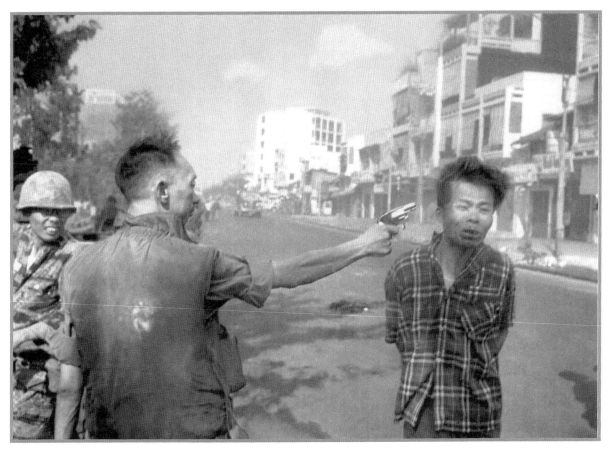

▲ Saigon street execution (AP Photo/Eddie Adams)

Nick's photo is not the only image credited with ending the war. Eddie Adams's famous Saigon execution photo prompted the same observation. Actually, the war lasted longer after Adams' picture appeared than before the photo flashed around the world in February 1968. Mal Browne's famous 1963 photo of a Buddhist monk's self-immolation put Vietnam's back-alley war on newspaper front pages where it remained for more than 10 years. The immolation created a greater appreciation for abuses suffered by Vietnam's Buddhist majority, but demonstrations continued and there were more immolations protesting the treatment of Buddhists.

That does not mean these photos are without influence on public opinion. They compare to notebook entries, their powerful visual phrases inspiring recollections of other powerful images, other

places, other incidents. They serve as windows to conversation and debate that transcend the special moment in time that a photographer captured. In that context, iconic photographs—and especially Nick Ut's photograph—made significant contributions to the anti-war attitudes of the '60s and '70s by tipping those who were undecided about the war off the fence. In the broader context, pictures of this kind act as historic reminders of incidents and events, providing lessons for contemporary decisions. These images bump history either by justifying existing opinions or contributing to the changing of opinions and become enduring symbols.

Amid the public discourse created by Nick's photo, some raised challenges to its credibility, either to create false impressions or to weaken authentic reactions.

Captions and commentary sometimes portrayed the photo as a symbol of unacceptable U.S. actions in Vietnam. The napalm, it was said, was dropped by Americans in support of ARVN ground troops. The photo is sometimes introduced with that description, explicitly stated or implied. But it is not true. The South Vietnamese military called for the air strike at Trang Bang. Vietnamese pilots flew the aircraft. Asked about these inaccurate descriptions, Nick is philosophical.

"Propagandists say what they want to say. I know that when I make photos I want show the truth," he says

Listeners to tapes of President Richard Nixon's staff meetings on Vietnam withdrawal hear Nixon ask his aide H.R. Haldeman about the picture.

"Do you think it could have been fixed?" Nixon inquires.

"It's possible," Haldeman responds. Nothing more came of the discussion.

At a later date, retired Gen. William Westmoreland, who had served as U.S. commander in Vietnam, said the girl was not burned by napalm but by an accident around a cooking fire. Nothing to document that claim was ever produced, and Nick's other photos of the preceding moments clearly show the napalm bombs falling and exploding.

Decades after it first appeared, the photo continues to resonate as an effective anti-war symbol in national and world cultures. When Nick retired from AP in the spring of 2017, after 51 years of shooting news pictures, he was feted by both AP friends and his journalistic competitors. Always the Vietnam photo was mentioned.

Nick heard many reasons for the misplaced napalm drop, but a definitive explanation remained a mystery. Some say it was a mistake, plain and simple; others believe the pilot saw personnel fleeing on the highway, assumed they were Vietcong and dropped the napalm on a perceived enemy. Vietnamese military officials said the napalm attack was targeted for the North Vietnamese foxholes dug in around the edge of the Cao Dai towers but was some 100 yards off-course. Later napalm drops hit the target with indications that the North Vietnamese were killed. In all, 20 South Vietnamese children, women, men and soldiers were killed or injured by the error.

In his recorded interview with AP, Burnett, the LIFE photographer, was asked whether chance, or luck, was a factor in making the picture.

"There is no doubt that there is chance involved. In French, it's almost a better word—in French, you would say 'par hasard' . . . by the hazard of the moment . . . by the accidental . . . tumblers falling into place, that these things come together.

"The difference probably between what happened at Trang Bang with these kids and many other places is that there was a photographer there. And people are fond of saying how hard it is to look at Nick's picture, and it definitely is a challenge to look at it and to just concentrate on that picture because you're looking at a picture of a lot of pain.

"But that picture is what saved her life, and that's something that people need to be reminded of, that if there hadn't been a picture she would have just been another casualty of which there were many in Vietnam . . . and Afghanistan and Iraq and Germany in World War II and France . . . There were hundreds of thousands of those moments when people were just inadvertently casualties of something that happened. And they died, and that was the story, but there was no story, there was no reporter, there was no photographer.

"In this particular case there is a picture, and the picture drew attention to this moment. And several days later everybody wanted to know who the girl was.

"Maybe I can think of a dozen pictures that you can just give a very short verbal description of and people know what you're talking about. And this picture, Eddie's picture of General Loan is probably another, and maybe John Filo's picture at Kent State. If you go through the list of pictures, particularly wire service or newspaper pictures, which have won either World Press or the Pulitzer in one of those big contests, they've become so iconic in the public eye.

"It's just these pictures remain. Still pictures remain a very powerful tool for telling a story and for getting people's attention. It's a way of boiling down a situation or a place or a moment that video can't do. Video treats every moment with the same sense of importance. And the still picture, the really successful ones, I think they distill it into a really pure photographic moment.

"But let's not get crazy about it trying to artificially create these moments that don't get there on their own. Nobody had to push Nick Ut's picture. Every picture editor in the world in every newspaper in every language looked at it when it came over the wire machine and said, 'Well, we probably ought to run this on page one.' The picture individually builds that momentum. It's not something you can will on it by being a photo critic or a columnist or something. The picture has to attain that place."

Horst Faas best summed up the comments, criticisms and conversations:

"It is a picture that doesn't rest."

Widespread attention in the weeks and months after he photographed Kim did not change Nick's routine. The Easter Offensive continued, and Nick made pictures of fighting north of Saigon and in the Delta south of the city.

On October 26th Nick and AP staffer Neal Ulevich visited Trang Bang to check reports of renewed fighting in the area. Also, there was the possibility Nick could check in with Kim's family.

Nick was at the Cao Dai temple when he and ARVN troops were hit with rocket and mortar blasts as they moved along a temple wall. One mortar blast landed near Nick and he took a piece of shrapnel in his upper left leg. An ARVN soldier grabbed him by his arm and dragged him into the relative safety of the temple. A medic patched up his leg but the wound required further hospital treatment.

Ulevich described the incident in a letter to his parents dated Oct. 27, 1972:

"It was a curious thing. Nick and I became separated inside the city where a terribly hot battle was raging. Later I went back to a place where we'd agreed to meet—it was a graveyard 100 yards south—and waited. A house began to burn in the city, and I sat there in the hot sun waiting for flame to engulf it, waiting to take pictures. By that time (I didn't know it) Nick had been caught in a mortar blast. He was treated on the spot and made his way to our jeep where he met a friend, a freelancer. The freelance drove and they picked me up. Then we raced to the hospital.

"Nick was wounded not far from where he'd taken that searing picture of the girl burned in the napalm strike a few months ago, the little girl running down the highway.

"The doctor let him go the same day with instructions to keep off his feet for a few days. The chip of metal is an inch from his thigh (according to x-rays) and will remain there the rest of his life."

It does remain there still. Nick feels it in the cold weather and when he walks longer distances. It is a reminder of his stomach wound two years earlier in Cambodia as well as other close calls. He knows that, as lucky as he was, luck can be a fickle companion.

Around the time of Nick's October 1972 wounding, there was historic news from the Paris peace talks. Following the decisive battles at An Loc and Quang Tri, it was announced that North and South Vietnam and the United States had reached agreement on a peace treaty. Formal signing was scheduled for early 1973.

The prospect of peace at hand would be contradicted during the following months by renewed battles that made peace seem just a distant possibility. The October announcement, however, inspired immediate hopeful visions throughout Vietnam. Ulevich, in the same October 1972 letter describing Nick's wound, wrote to his parents:

"At any rate, I wouldn't tell you all this (Nick's wound), I know it worries you, but for the fact it's over. I won't be covering combat any more and I am, to speak the truth, as happy about that as you are.

"There are many cables on the desk this morning. It's about 8:30 a.m. right now. Faas is being pulled out of the Mideast and sent straight away. Jackson Ishizaki, whom we surely can use, has applied for a visa in Tokyo. On news side there is no doubt our bureau (and Saigon generally) will be deluged.

"I am fascinated by the prospect of covering the peace. It is at this moment the biggest story in the world and will remain so for months. It's quite a thing, the end of the war. There is no place I'd rather be right now."

But war didn't end. Nick and Neal and the other AP photographers covered combat for two more years.

War ended for Neal in the last moments of the day before the war's final day. He photographed desperate Vietnamese fighting to scale a wall at the U.S. embassy hoping to escape the oncoming North Vietnamese Army. Moments later, he was aboard a Marine Corps helicopter that lifted off the embassy roof April 29, 1975. The chopper took him to an aircraft carrier so crowded with refugees that helicopters were pushed overboard to make room for the flood of newcomers.

GALLERY

Nick Ut was wounded during an ARVN clash with North Vietnamese near the Trang Bang Cao Dai temple, the same temple involved in the napalm bombing that injured Kim Phuc. Nick and fellow AP photographer Neal Ulevich went to Trang Bang, October, 26, 1972, hoping to visit Kim but ran into a battle in the highly contested area.

◄ ARVN soldiers spot North Vietnamese positions from their lookout on a tower of the Cao Dai temple.

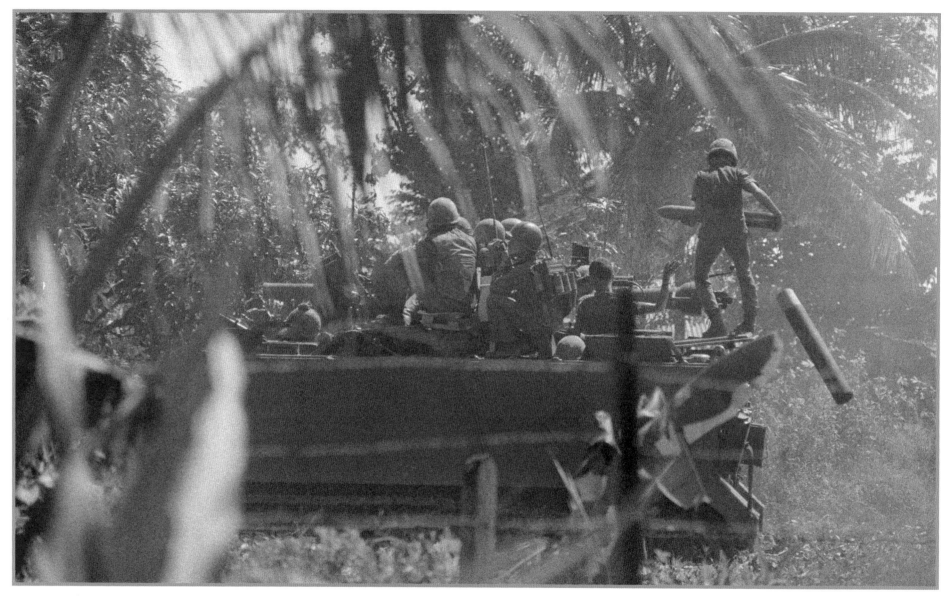

▲ Government soldiers fire recoilless rifle at enemy positions, October 26, 1972.

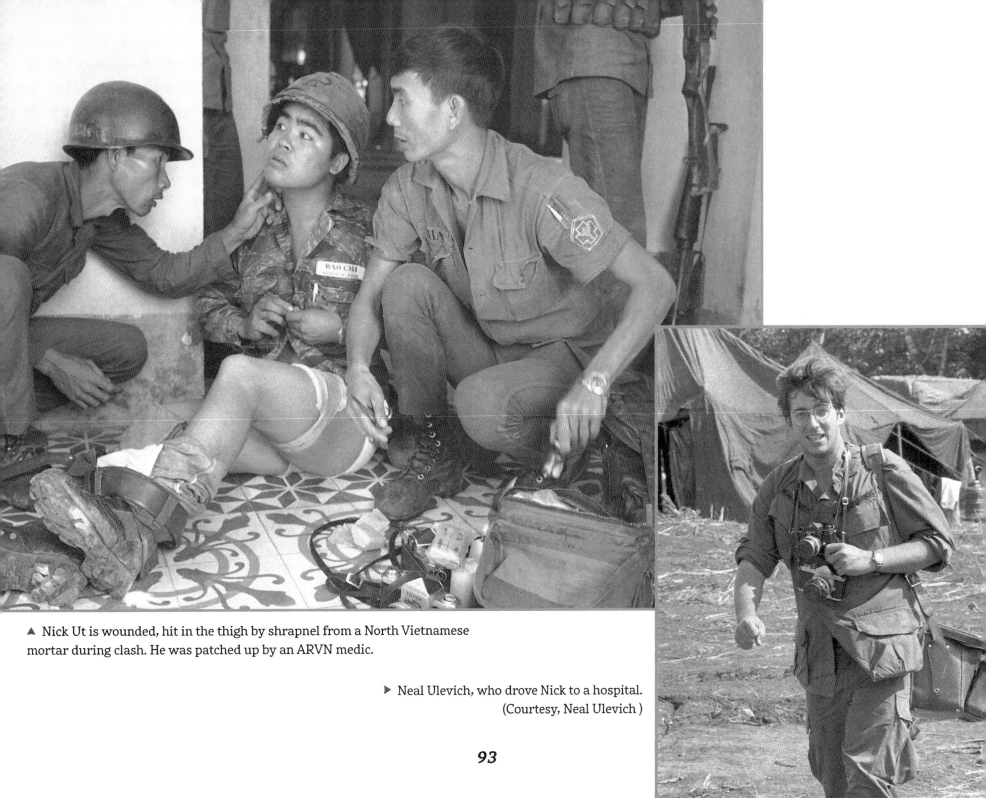

▲ Nick Ut is wounded, hit in the thigh by shrapnel from a North Vietnamese mortar during clash. He was patched up by an ARVN medic.

▶ Neal Ulevich, who drove Nick to a hospital.
(Courtesy, Neal Ulevich)

93

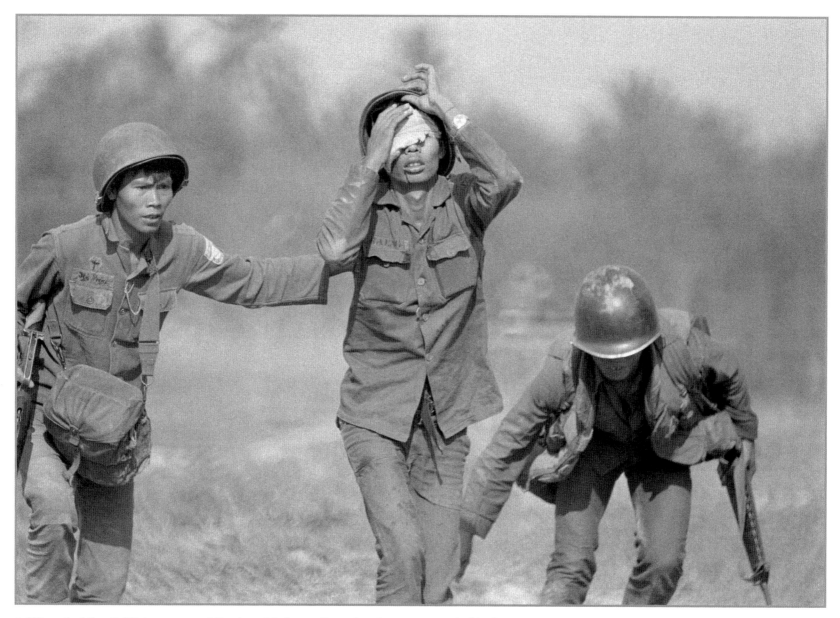

▲ Wounded South Vietnamese soldier is guided to safety after he was wounded in fire fight at Trang Bang, January 28, 1973.

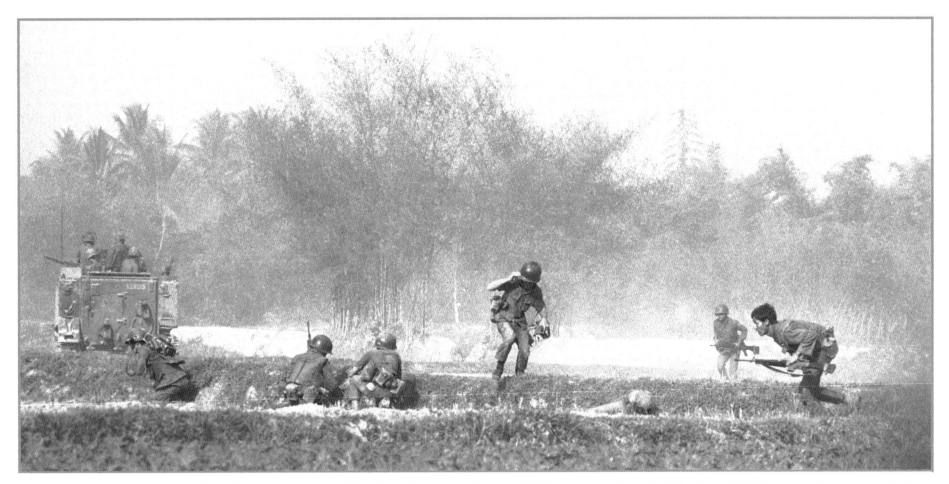

▲ Fighting continued despite a Peace Treaty in January 1973, signed by South, North and U.S. representatives. In this photo ARVN troops take cover as North Vietnamese launch mortar attack near Trang Bang, January 28, 1973.

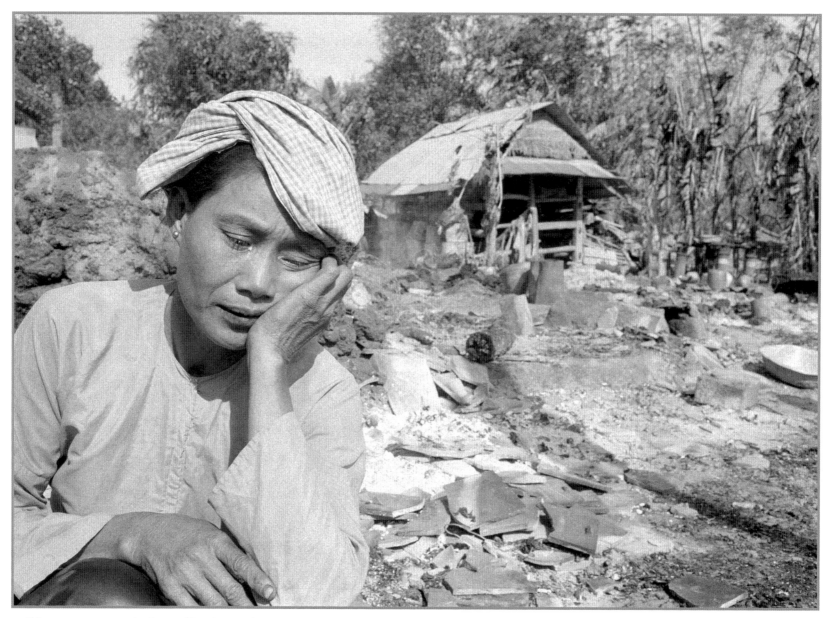

▲ Woman weeps at the loss of her home destroyed in a battle near Tay Ninh, not far from Trang Bang, January 29, 1973.

Chapter Eight

A New World for Nick and Kim

A party atmosphere greeted Nick Ut at the AP bureau one bright Saigon morning in April 1973: Champagne and cake, hugs and kisses, handshakes and backslaps. Amid shouts of "Congratulations!" Nick learned he had been awarded the Pulitzer Prize for News Photography, photojournalism's most coveted recognition for work of excellence. For days afterward, colleagues and competitors alike greeted him with best wishes for his achievement, which at 22 made him the youngest photographer ever to win the award.

New York headquarters called to add its accolades to the many he heard at the party. Local newspapers played up the story with emphasis on the fact that Nick was the first Vietnamese to win a Pulitzer. AP's Edie Lederer interviewed Nick for a story and Faas made a photo for transmission.

"I'm so happy," Nick is quoted as saying. "Everywhere I go newspaper friends shout and tell me congratulations. Everybody wants to know how much money I won—tell me I'll be a millionaire now. My family though, doesn't know what it's about, just that I won something, and it's good."

The Pulitzer Prize includes an invitation to attend the annual awards luncheon with other Pulitzer winners at Columbia

▲ AP colleagues celebrate the announcement of the Pulitzer Prize award to Nick, April 1973, in the AP Saigon bureau. From left: Edie Lederer, Chick Harrity, Horst Faas, Dang Van Huan (rear), Richard Pyle, Carl Robinson, Nick Ut, Toby Pyle, Lynn Newland, Dang Van Phouc, Hugh Mulligan, and George Esper.

University in New York. Vietnamese authorities, however, refused to grant Nick an exit visa in the belief that he would not return to Vietnam.

Disappointed, Nick told his tale of woe to his correspondent friends. Pham Xuan An, a reporter for Time magazine and dean of the Vietnamese correspondents corps, was among those who heard his story. An, who later admitted to being a Vietcong agent, was well connected in government circles. He made a few calls, then told Nick to reapply for the visa. An's intercession overcame administrative blindness, but too late. Delay in obtaining the visa meant that Nick would miss the award ceremony.

No matter, AP said. Come anyway. Nick was soon on a plane that took him far beyond Vietnam for the first time in his life. First-class accommodations were a new, exhilarating experience. He was aboard a real airline, so different from the crowded cargo planes that flew missions across Vietnam or the noisy helicopters loaded with ammunition, and so much safer than driving dangerous roads through sniper territory.

Stewardesses, aoi dai-garbed and sometimes flirtatious, served him drinks and meals on the hop from Saigon to Hong Kong. A Pan Am jetliner carried him to Los Angeles, a long ride with movies, fine meals, champagne and a cool atmosphere where he could snooze undisturbed until it was time to eat and drink again.

It seemed the future that the sidewalk fortune teller had found in Nick's palm had come true, after all: As he recalled the clairvoyant's promise of awards and travel and wounds, which he'd dismissed, he considered for a moment whether he should look the man up to give him a bonus.

At the LA airport, Nick wandered through the duty-free shops, surprised by the supply of every possible want, and at the rack of

▲ Nick receives his World Press Photo trophy in Amsterdam in April 1973. At left is Henk Kersting, AP Amsterdam Chief of Bureau. WPP representative at right.

more magazines than he had ever seen. So entranced was he by the sights and sounds that he missed his connection for Washington, D.C. Pan Am worked out a later flight and shuffled him off to a hotel for several hours rest.

His late arrival upset Richard Pyle, who was AP chief of bureau in Saigon when Nick made his picture and was now assigned to AP's Washington bureau. He expected a call from Nick and when

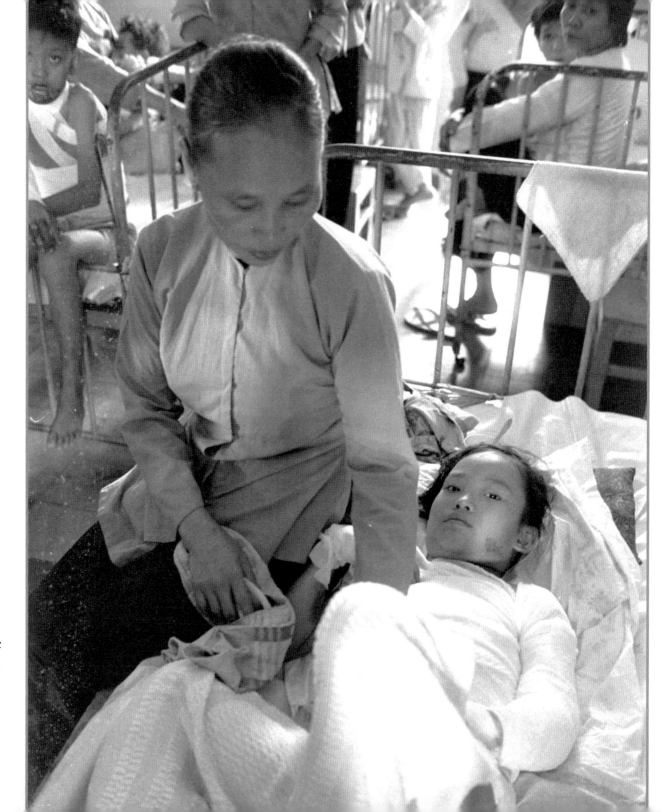

▶ Her mother attends to Kim Phuc in a hospital several days after she was burned. (AP Photo/Carl Robinson)

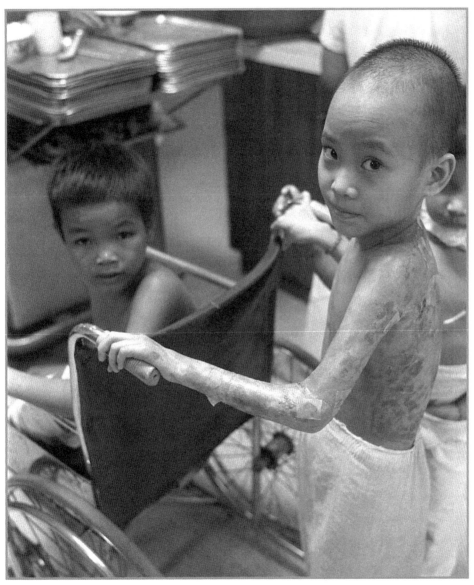

▲ Kim Phuc at Saigon's Basky Center for special burn victims where she spent several months. (AP Photo/Michelle Laurent)

he didn't show up, Pyle sent messages: What happened to Ut? Arriving in Washington, safe but late, Nick called Pyle and they met for dinner.

Next day, Nick was off to New York, where AP General Manager Wes Gallagher greeted him warmly. A World War II foreign correspondent, Gallagher kept a heavy hand on AP's coverage of Vietnam and was proud of the staff's six Pulitzer Prizes, of which Nick's was the latest. At the Rockefeller Plaza headquarters, Nick was treated to fancy lunches and introductions to editors throughout AP's central news system. He picked up his Pulitzer award and prize money at Columbia University.

On the final day of his New York visit, he strolled through the streets around AP's midtown Manhattan headquarters and marveled at the skyscrapers. Then he was off to Amsterdam and the offices of World Press Photo. The WPP's prestigious News Picture of the Year Award was among the many honors he received. With it came another plaque and check.

One of his Vietnamese friends, a resident of Paris, met Nick in Amsterdam, rented a car and drove to Belgium and then to Paris, where Nick enjoyed the sights. That's where he finally boarded a flight to Bangkok for a two-day stopover en route to Saigon and home.

After four weeks in a world he never knew existed, the young man from the Mekong Delta headed back to war.

Kim Phuc's world also changed—but to a life of painful operations in Saigon hospitals.

Christopher Wain, a television correspondent who helped Kim on Highway 1, used his influence to have her transferred to the Barsky Burn Center, a hospital dedicated to treating serious burn injuries received mostly in combat. Kim remained there for the better part

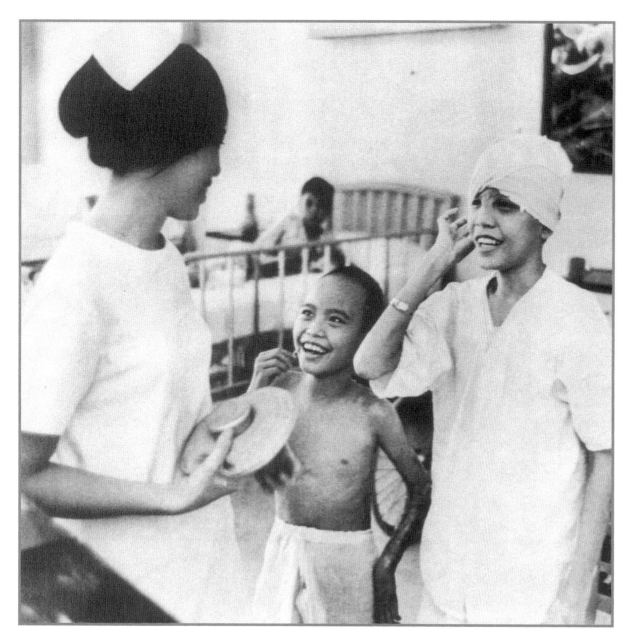

◄ Kim Phuc chats with a fellow patient and a nurse at the Saigon Brasky Center for Plastic and Reconstructive Surgery where she spent many months of treatment, August 1972. (AP Photo/Michelle Laurent)

of a year undergoing operations to repair damage done by the napalm.

Kim recalled those early days after June 8:

"I had no idea where I was or what happened to me," she said. "I woke up and I was in the hospital with so much pain, and then the nurses were around me. I woke up with a terrible fear.

"Every morning at 8 o'clock the nurses put me in the burn bath to cut all my dead skin off. I just cried, and when I could not stand it any longer I just passed out."

Her treatments were performed by doctors expert in dealing with severe burns. Some of her injuries were bone deep. Early surgery on shoulder wounds repaired her chin, which was fused to her upper chest by scar tissue.

Nick visited Kim and he made arrangements for transfer to her parents of gifts and money sent to AP Saigon on her behalf. More pictures were distributed in which Nick, because of his boyish appearance, looked more like Kim's older

brother, not an experienced combat photographer who made one of the Vietnam War's most celebrated photo icons.

In an oral history interview with Valerie Komor, director of AP's Corporate Archive, Kim described how little of that day on Highway 1 she remembered:

"My conscious is out and in. I don't remember at all." At times when she realized she was awake, she said, "Oh, I wish I'm not [awake]. The nurse just put me in the burn bath."

During the months at Barsky, Kim was not aware of the photo that Nick made or of the international stir that the image created. She had no idea that her image was well known internationally for showing an innocent victim of war. It was 14 months later that her father showed her the picture when she returned home to Trang Bang.

In the Komor interview, Kim recalled seeing the photo for the first time:

". . . My dad gave to me that picture. And he say, 'Yes, Kim, that your picture.' And the first time I look at that, I say, 'Oh my goodness, why he did it, why he took that picture when I'm naked and agony and painful? It look ugly because around me other children with clothes on. And just only me in the center with agony. I felt as a little girl, I felt embarrassed.'"

Although Nick visited during her hospitalization, Kim told Komor her painful treatment blotted out any memory of that, too. "Unfortunately," she said of that time, "I don't remember his face."

The war that brought Kim and Nick together would finally end in two years. Nick, then 24 and his life changing dramatically, and Kim, only 12 and still distracted by pain, were destined to travel different roads.

They would meet again but not for 17 years. And the reunion would take place thousands of miles from their native Vietnam.

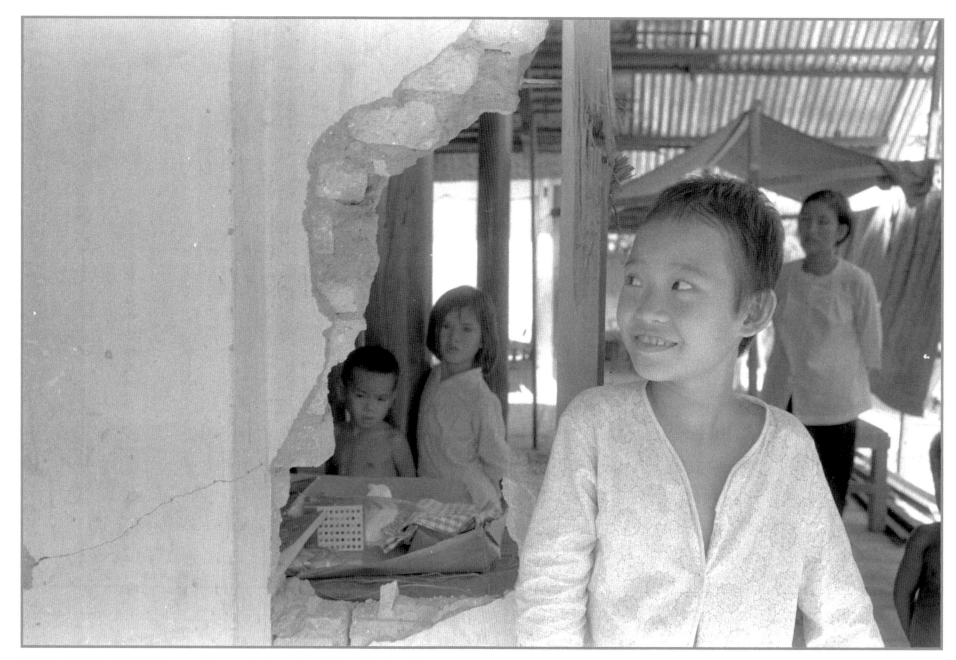

▲ Kim visits her badly damaged home during a break from her hospital treatment, November 1972.

Chapter Nine

Farewell to Vietnam

Hours of quiet time on international flights had given Nick Ut time to reflect on the passage of events since he photographed Kim Phuc on Highway 1. There was the picture itself and its impact on his life; there were frequent longer battles like An Loc and Quang Tri; he took a second hit, the leg wound at Trang Bang; the peace treaty signed in January that failed to end the fighting while at the same time it eliminated most American military support for South Vietnam. Then came the Pulitzer Prize and a trip abroad with insights into other lives and a world that contrasted dramatically with the decades of warfare he had lived through since childhood.

As a Pulitzer winner, Nick noted a new respect that colleagues, within AP and beyond, showed him in their daily exchanges, a bit of deference, a respect now easier to see and feel.

Still, back in Saigon now, Nick struggled with his return to photographing combat. Increasingly aware of both the daily risk and the personal effect of photographing war's violence, he told colleagues, "I didn't want see more blood, dead bodies, all people hurt and no homes left."

Through all the accolades and the soul-searching, he nonetheless remained the old Nick: The easy personality and boyish smile did not fade, and a scooter was still a regular mode of transportation. And in time, despite his qualms, he settled back into his role as photographer. He would soldier on, still inspired by the memory of My and the guidance his brother provided. He reset the message of Anh Bay, No. 7: Follow the smoke. Show war's reality to the world.

He visited Trang Bang with a gift for Kim Phuc obtained during his Pulitzer travels. Kim's family home suffered because of its

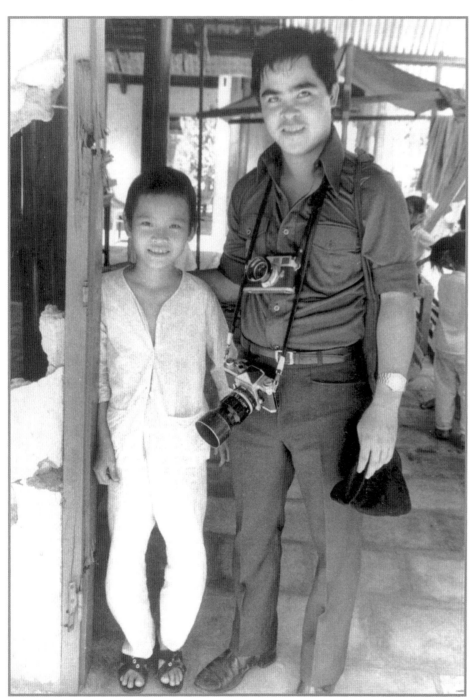

◄ Nick Ut visits Kim at her home in Trang Bang in 1973.

proximity to Cambodian border crossings and therefore constantly under attack. Where the family had lived Nick found only rubble and twisted metal, the debris of battle common to many other places he photographed.

Neighbors directed him to the family's new living arrangement, a ramshackle hut put together with concrete blocks, sheet metal, bamboo and whatever scraps they could use to construct a roof and walls. He saw that that the family was barely surviving. He learned that continued medical treatment for Kim, still crippled from the burns of napalm, was not possible due to a lack of money. He decided to organize help for the family.

This effort was interrupted, however, by an assignment to Phnom Penh to photograph sharply increased fighting between government troops and the communist Khmer Rouge.

Warfare in Cambodia was not addressed by the Paris Peace Treaty of January 1973, which called for a cessation of fighting by both sides but only in Vietnam, the return of POWs and the withdrawal of U.S. military by the end of March.

Travel to Phnom Penh was not easy. Nick drove to the Cambodian capital over mined roads and through areas where hidden snipers operated. On one road, his vehicle passed over a mine which failed to explode. Military observers guessed that the car apparently was not heavy enough to set off the mine.

Nick photographed Cambodian women and boys undergoing military exercises, some of the women carrying babies on their back as they trained to fight communist forces gradually taking over the country.

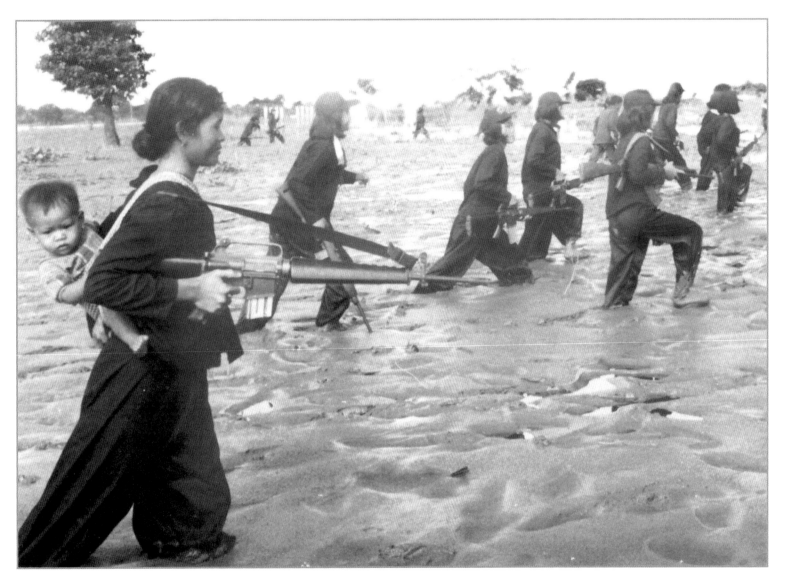

▲ Cambodian civilian soldiers train to halt progress of the Khmer Rouge, April 1973. A female soldier carries her infant child on her back.

The pictures were successful and won publication, but Nick began to see Cambodia as a place where bad luck outweighed good luck.

It was in Cambodia that his Japanese friend Kyoichi Sawada of UPI had been killed and where Nick himself had suffered his most serious wound, the shrapnel hit to his stomach that hospitalized him years earlier. Now, he was struck a second time while covering a Vietnamese Marine patrol in Cambodia.

The patrol camped overnight in a dangerous area, taking shelter in freshly dug bunkers fortified with sandbags and timbers. They were no sooner settled than North Vietnamese Army artillery in surrounding hills opened fire. Nick and the Marines retreated to safety and waited for the barrage to end. It finally did, encouraging the Marines to leave their fortification to check on possible wounded and to repair damage.

Instantly, more rockets poured in, one exploding near Nick and seriously wounding several Vietnamese soldiers. Nick felt a sting in his armpit but the nature of the hit was at first hidden by the darkness. Later, a medic patched him up with a bandage, and he spent two days under treatment at a Phnom Penh hospital before returning to Saigon.

Back in Vietnam, where fighting was now an all-Vietnamese affair, the withdrawal of Americans created a noticeable impact on AP news coverage. Fewer Vietnam pictures and stories were being printed in U.S. and other media. Lack of world attention, did not diminish the fighting, however.

Both North and South increased military operations, jockeying for position and territorial control. The absence of U.S. air support further encouraged NVA activity. Nick, Phouc, Cung and other Vietnamese photographers kept busy covering battles throughout 1973 and 1974.

Whenever Nick was in the Delta he visited his mother and other relatives who remained in Ty Son despite frequent fighting in the highly contested area. Many Vietnamese, including Nick, believed the war was in a kind of stalemate even in late 1974. Popular sentiment held that the stunning victory over the enemy during the Tet Offensive turned a tide against the North's forces that could not be reversed. These beliefs were encouraged by decisive ARVN victories at An Loc and Quang Tri. ARVN soldiers in great numbers strolled in the streets of Saigon, the city's outskirts were well protected and life continued pretty much as normal. Nick in a naïve way accepted the common belief that whatever else happened the capital could never fall to the communists.

A steady buildup of NVA units in central Vietnam from Laos and Cambodia was not seriously considered by the general Saigon population. Countryside battles saw the fall of villages to NVA, their recapture by ARVN, then their fall once again to NVA. Unnoticed was the incremental but steady expansion of territory under permanent NVA control. By the end of 1974, the NVA was in position to make a major assault.

Nick's pictures, largely unseen by the Saigon population, signaled the growing threat. From late 1974 and into 1975, his pictures told the story of refugees fleeing Vietnam's Central Highlands and moving toward coastal areas believed secure. Early photos captured refugees from a village, then refugees from several villages, then photos of highways crowded to capacity. Refugees walked, some traveled in and on overcrowded trucks and buses, others on bicycles. A fortunate few found air travel to escape from combat zones.

In March 1975, Nick visited Ban Me Thuot, the critical city in the Central Highlands not far from another major ARVN military installation at Pleiku. He learned that Pleiku was on the verge of

being overrun, and an ARVN officer he knew from previous battles told him with great urgency that Ban Me Thuot would soon collapse. Its capture would mean all of the Central Highlands would fall to the NVA.

He told Nick to get out, to obtain if he could a ticket aboard the final Air Vietnam flight out of the city. Taking his advice, Nick made his way to the airport. Days later, in mid-March, Ban Me Thuot was overrun. Nick heard that his friend shot himself rather than be captured. Retreating ARVN units and civilians with them were ambushed and destroyed on highways in what became a rout.

Nick's flight took him to Tuy Hoa, a coastal fishing village slightly north and east of Ban Me Thuot. There he found crowds of Cambodian and Vietnamese refugees who poured out of the mountains and hills. Riding with a rescue chopper, he photographed desperate families with their children trying to reach Danang and Saigon. He visited Cam Ranh Bay, once the huge American seaport base, where he saw shiploads of refugees and military who abandoned northern locations and awaited transportation to Saigon. His aerial views of highways showed them jammed with every conceivable form of vehicle, each loaded with refugees but unable to move.

At last Nick considered that, perhaps, even Saigon was in danger. That thought took on increased reality as NVA units moved north and south from Ban Me Thuot and by the end of March captured the ancient Vietnamese capital of Hue and then the northern city of Quang Tri close to the DMZ.

About that time, photographer Michel Laurent, Nick's AP friend from Paris and his motor scooter buddy from a few years past, showed up in Saigon. Laurent was now a winner of a Pulitzer Prize, shared with Faas, for their 1972 coverage of torture and executions in Bangladesh. He had left AP, joined the French agency Gamma,

and was assigned to photograph what appeared to be the final days of South Vietnam.

Laurent and Nick drove to Xuan Loc, about 25 miles from Saigon, where as elsewhere the story was refugees fleeing the oncoming NVA. As the two photographers approached the city, a rocket landed only 30 feet away. They were unhurt, but Nick knew that he used up another portion of his luck.

On the drive back to Saigon, now recognizing that the South Vietnamese capital was threatened, Nick told Laurent he should leave the country while he could. Laurent said he had decided to stay on, expecting great pictures to be made when Saigon fell.

Nick squeezed in another visit north, riding with NBC-TV in their chartered aircraft to Dalat, the city where his brother My was married back in the 1960s and where his sister-in-law's father had once been chief of police. Nick found Dalat, close to the perimeter of the highlands, fully staffed with ARVN personnel. There was no indication of Vietcong or NVA presence, and so the journalists went on their way. He learned that Dalat was captured the next day.

Developments tumbled one upon another through March and into April, and AP beefed up the staff to cover events that underscored the certainty of an assault on Saigon. With Hue, Ban Me Thuot and Quang Tri in NVA control, the obvious next target would be Danang, the once impregnable bastion of the U.S. Marine Corps and the location of huge stores of military equipment and supplies. As the NVA positioned for its attack, refugees fled to Danang, crowding the base with thousands of soldiers and civilians seeking rides to Saigon and out of Vietnam.

Hoping to photograph the chaos, Nick joined a Saigon rescue flight to Danang. Once on the ground crew members advised him to stay on the plane, warning him he probably would not be able to

get back on board in the refugee crush. He took their advice and the plane soon took off loaded with refugees as Nick attempted to make pictures from the aircraft's windows. On March 29, Danang fell to communist troops.

It was a bewildering time for Nick. Would he have to leave Vietnam in the near future? He had seen the good life in foreign cities, but Vietnam was his home and he loved its ways. He liked his job. Saigon, even as other cities fell, still appeared secure and fully staffed with ARVN. Despite NVA victories, many Vietnamese continued to believe Saigon was somehow immune to attack. But Nick wondered: If Saigon was captured, how would Vietnamese who worked for Americans be treated? There was no time to answer; the AP staff was operating at full speed around the clock.

On a Delta trip in March, Nick visited Kim and her family. He chatted with her parents and older siblings in what turned out to be their final visit in Vietnam. They would not meet again for many years.

George Esper, AP chief of bureau in 1974 and '75, could see that Saigon's days were numbered. His many years of experience covering the war and his wide circle of contacts were vital in deciding and then arranging how AP staff—American and Vietnamese—would be evacuated.

In April, Esper told Nick to visit the Japanese embassy in Saigon and obtain a visa. He would be transferred to Japan immediately. But that did not work out. Japanese embassy staff were closing the embassy and had no time to issue a visa. And Nick knew the Saigon government in its turmoil would not grant him an exit permit. He continued to cover the war, traveling deep into the Delta and stopped only by Vietcong road closures.

On April 27—Nick remembers the date precisely—Esper told him to stay in Saigon. Nick ran into Laurent and told him that he would probably leave Vietnam soon, and encouraged him to leave also. But Laurent stuck to his original decision to remain, repeating that there would be great picture possibilities when Saigon fell. Nick agreed but said AP told him he had to go and he planned to accept that decision.

On that day, Nick made a picture in a restaurant atop Saigon's Majestic Hotel, home to a popular bar frequented by correspondents. The room was destroyed by a rocket attack. A gaping hole in one wall provided a view of the Saigon River.

It was the last photo Nick made of the war.

The next day, April 28, Esper told Nick he had two hours to get his belongings together and to be back in the bureau ready to depart. AP journalists, American and Vietnamese, would leave for the airport and evacuation.

Heading home and gathering his camera equipment, a few shirts and other clothes, Nick told Arlette, My's widow, that she and her daughter Teena could leave with him. Arlette was originally a Northerner who fled south with her family and her father was an ardent anti-communist official in Dalat. Those considerations convinced her to accept Nick's suggestion and evacuate with AP.

Nick visited his mother, now living with another brother in Saigon, to say goodbye. She could come with him but she declined. It would be too much, she told Nick, for a woman her age to start a new life in a foreign country. She would remain in Saigon with her other children who also planned to stay. OK, Nick said, he would probably be back in Vietnam in a few weeks anyway. He returned to see his mother 14 years later.

The AP contingent gathered in a big room in the AP office building. Phouc, 10 years older than Nick, was there with his wife and

children. Cung decided to stay in Vietnam, as did George Esper, Matt Franjola who did both news and photos, and Peter Arnett, AP correspondent who had covered the war since its beginning and had returned six weeks earlier to report the final chapter.

Nick and the Vietnamese staff and their families –and Vietnamese from other news and commercial companies—boarded a bus for the trip to Saigon's Ton Son Nhut airport. Phouc and his family were with him, along with Arlette and Teena. Ton Son Nhut, scene of airlift evacuations for days, was now under bombardment by NVA artillery that had moved within range on the outskirts of the capital.

Flights halted for a time but finally resumed—and Nick and the others took off for the Philippines.

On April 29, Neal Ulevich and Ed White rode a bus with other correspondents through a chaotic Saigon seeking a route to the airport. Finally they learned the airport was in flames and headed for the U.S. Embassy. White headed for the chopper pickup area. Under an overcast sky and a drizzle of rain Neal photographed Vietnamese climbing the embassy walls in a desperate attempt to get aboard evacuation helicopters. When early darkness appeared Neal and White boarded one of the choppers and were flown to the aircraft carrier USS Okinawa.

On April 30, Saigon was in the hands of North Vietnamese Army troops. An AP driver who was secretly connected with the Vietcong escorted a small group of NVA officers and soldiers to the AP office. The AP trio remaining in Vietnam served the visitors warm Cokes and stale cake, all that was available in the cupboard. The NVA told the AP staff how they traveled through the South, finally ending up in Saigon. Weeks later Esper, Arnett and Franjola were told to leave what was now called Ho Chi Minh City.

Thirty years of war came to an end.

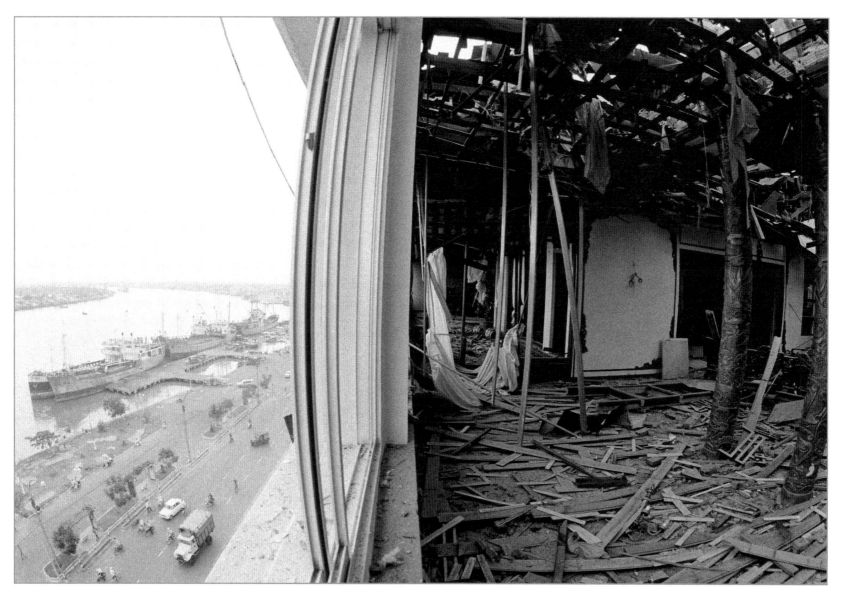

▲ Nick's last photo of the war, the roof garden and bar atop Saigon's famed Majestic Hotel was destroyed by a North Vietnamese rocket. At left view looks down on Saigon street scene and river. Nick made the photo, April 27, 1975, the day before he left Vietnam.

GALLERY

In the final months of the war Nick photographed battles throughout South Vietnam, from the northern provinces, to the central highlands, at coastal villages and in the Mekong Delta area. He travelled by commercial airline, Vietnamese army helicopter, rescue aircraft and in the AP's van.

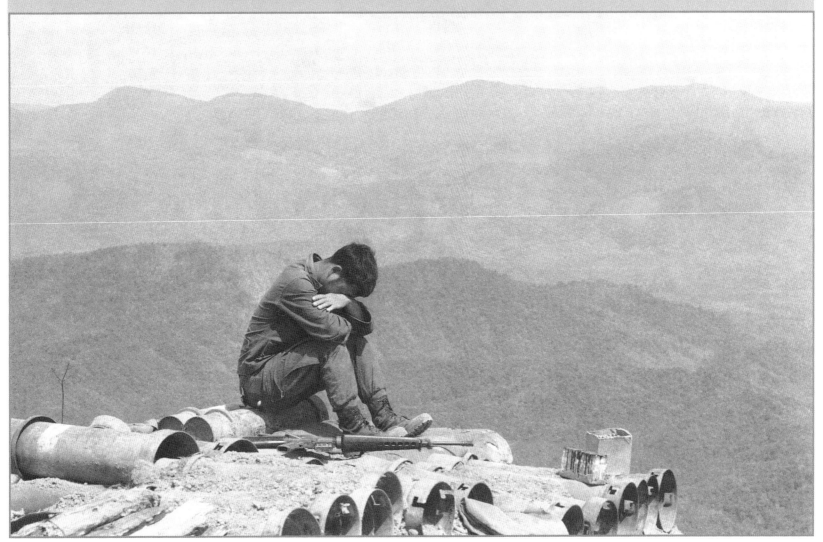

▲ ARVN soldier rests at an outlook point not far from Kontum in northeast South Vietnam, March 1974.

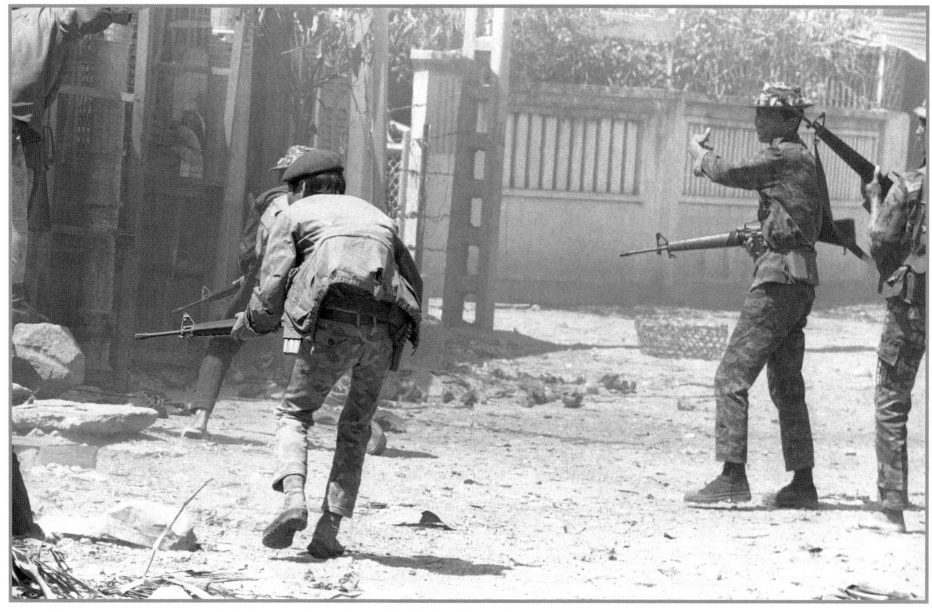

▲ South Vietnamese troops attack during house-to-house battle in Thu Thua, March 1975.

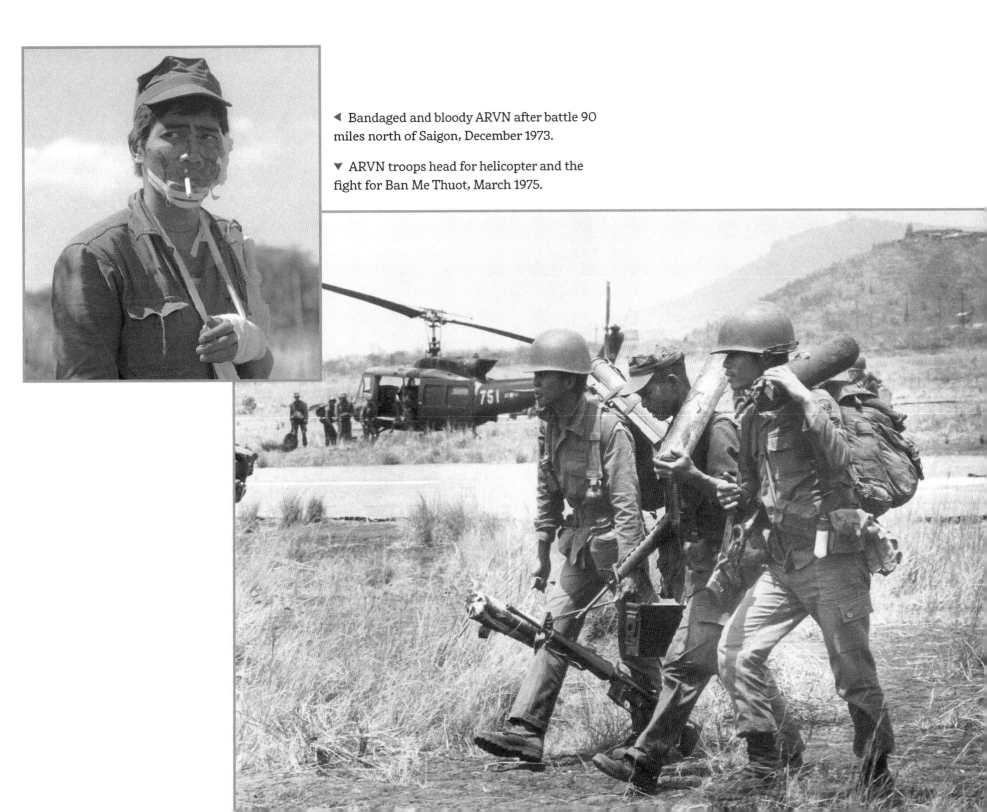

◀ Bandaged and bloody ARVN after battle 90 miles north of Saigon, December 1973.

▼ ARVN troops head for helicopter and the fight for Ban Me Thuot, March 1975.

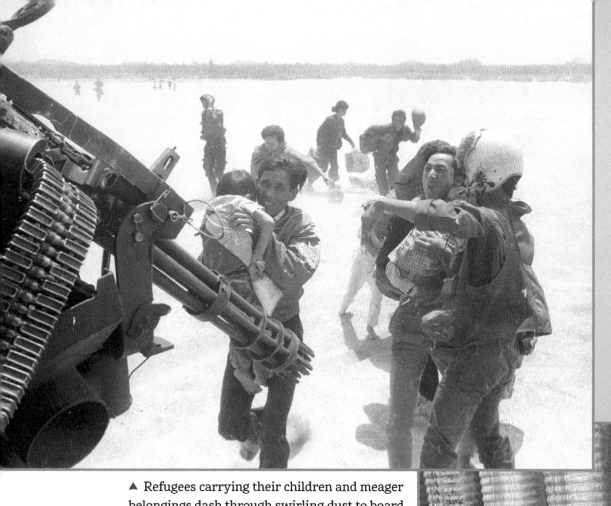

In March 1975, Nick flew from Ban Me Thout on the last Air Vietnam flight out of the besieged city and landed near Toy Hua Airfield, 235 miles southeast of Saigon. In Toy Hua assembled refugees awaited air transportation to safer areas of South Vietnam.

▲ Refugees carrying their children and meager belongings dash through swirling dust to board a South Vietnamese helicopter that will take them out of Toy Hua.

▶ A refugee family rests at Toy Hua Airfield, March 27, after arrival from the Central Highlands.

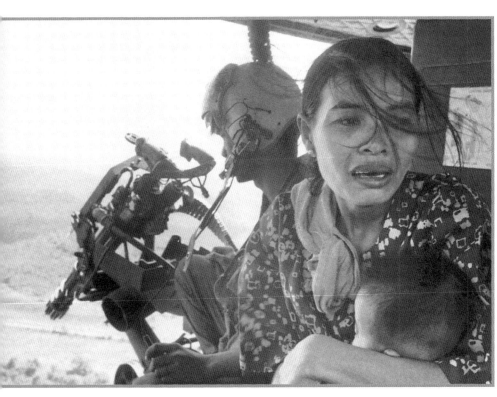

▲ Woman refugee and her child aboard a South Vietnamese rescue helicopter.

▶ South Vietnamese helicopter crewman holds a refugee child during rescue operations at Toy Hua.

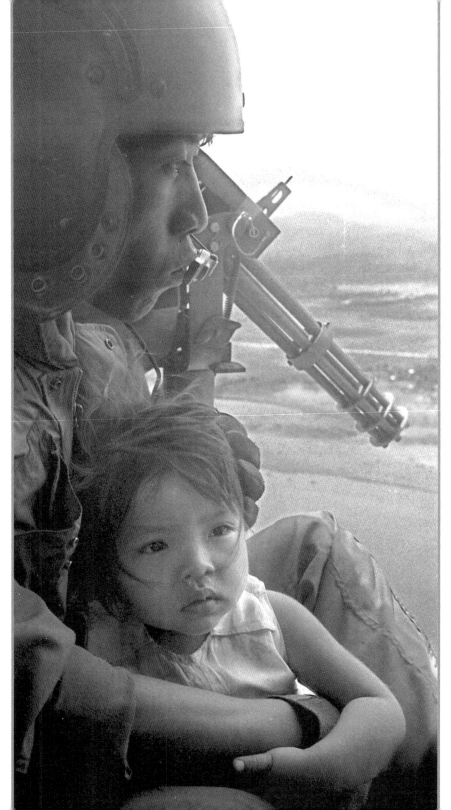

117

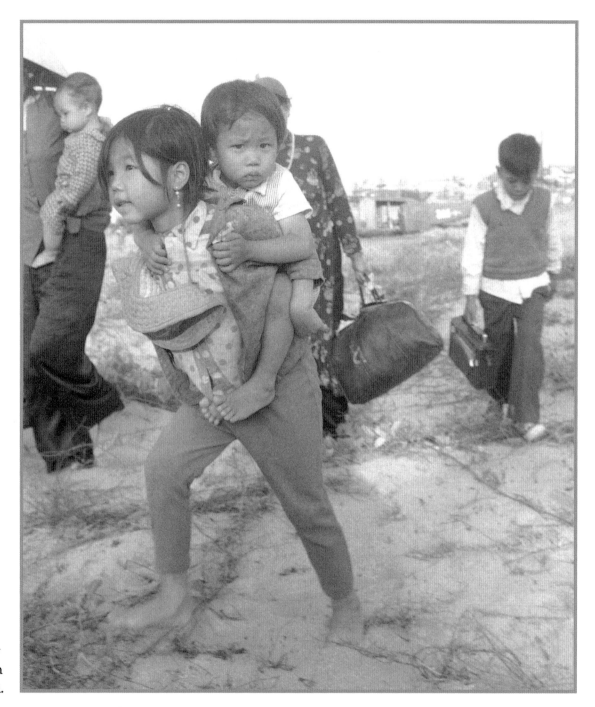

▶ Sister carries baby brother to evacuation helicopter at Toy Hua.

As Nick moved from area to area he encountered in creasing numbers of refugees fleeing the war. After a few weeks of safety the refugees would move again as North Vietnamese forces pressed closer capturing city after city. Highways were jammed; commercial transportation difficult to obtain. Government rescue operations expanded.

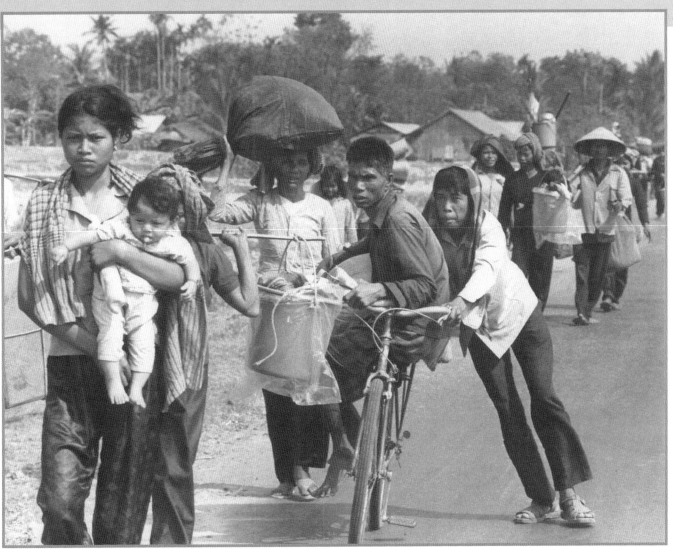

▲ In March 1975, just 35 miles from Saigon, Cambodians as well as Vietnamese headed toward South Vietnam's coastal areas believed safe.

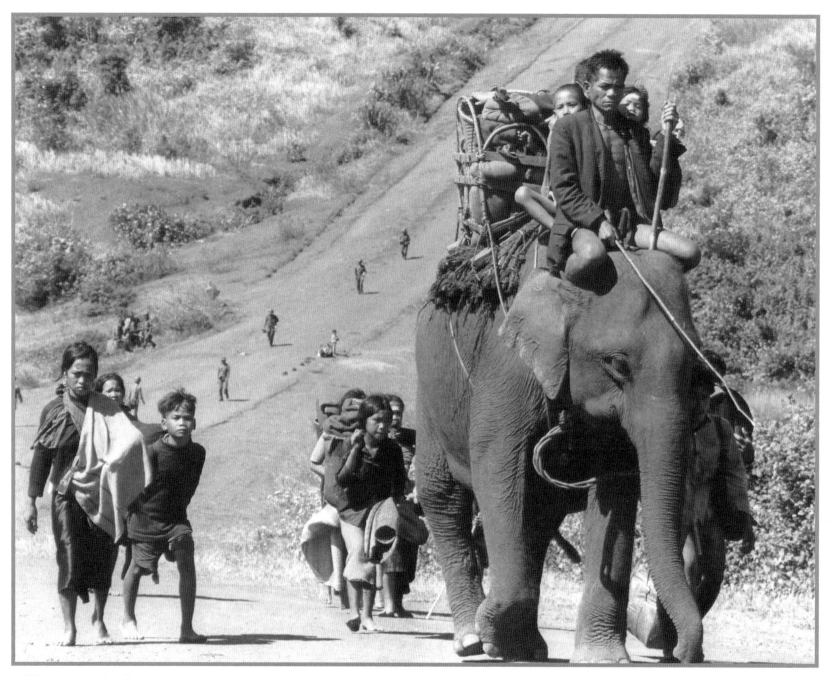

▲ Montagnard family astride their work elephant flee Vietcong attackers along a hilly road in the Central Highlands, December 1973.

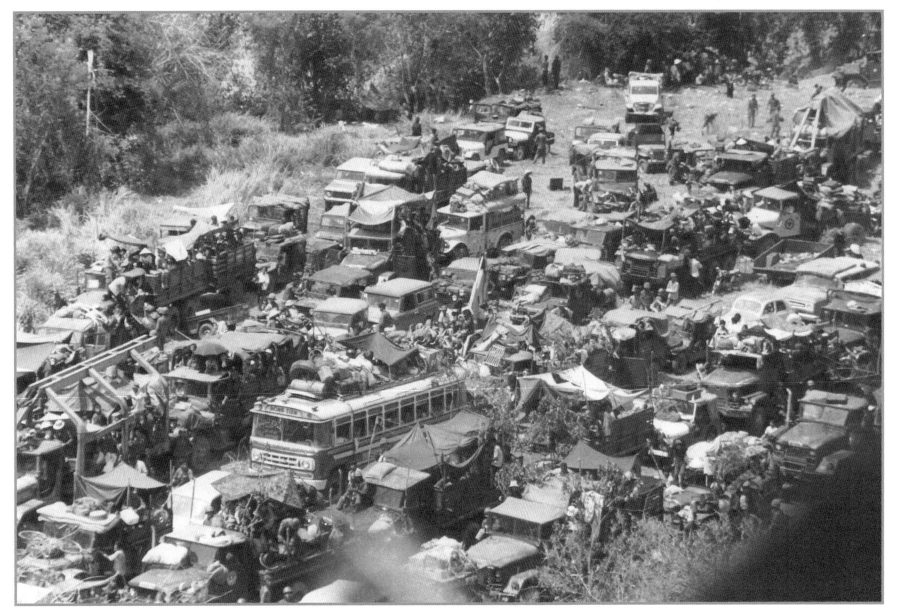

▲ A highway from northern provinces to South Vietnam's coastal area is deadlocked, March 1975.

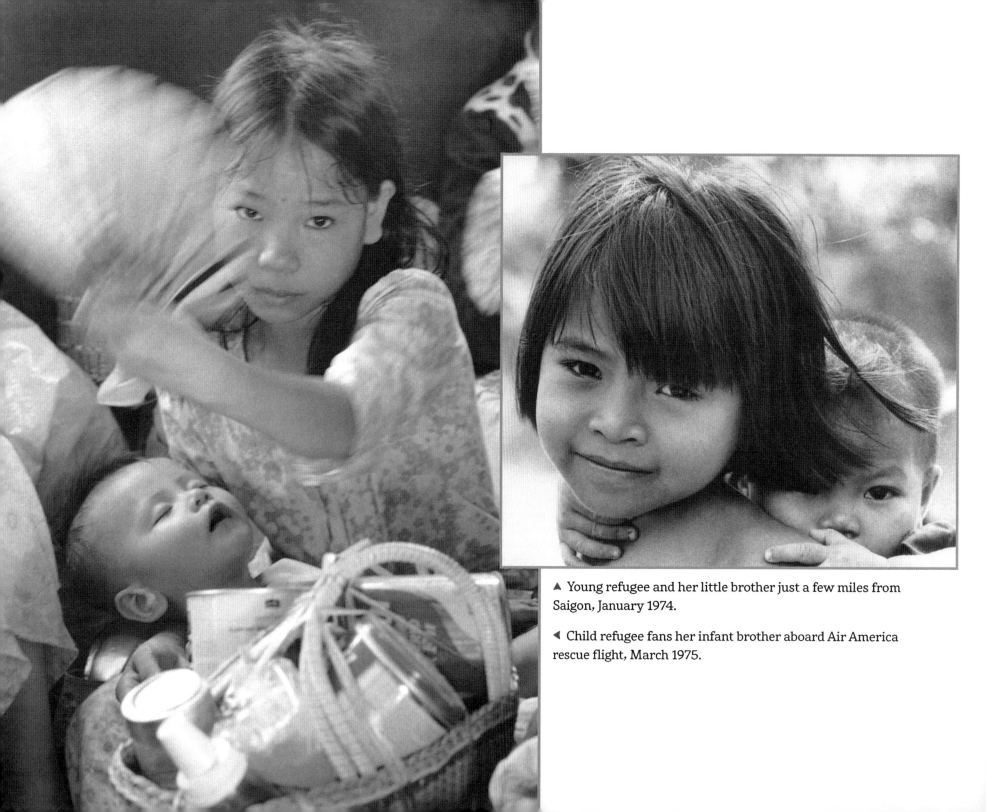

▲ Young refugee and her little brother just a few miles from Saigon, January 1974.

◀ Child refugee fans her infant brother aboard Air America rescue flight, March 1975.

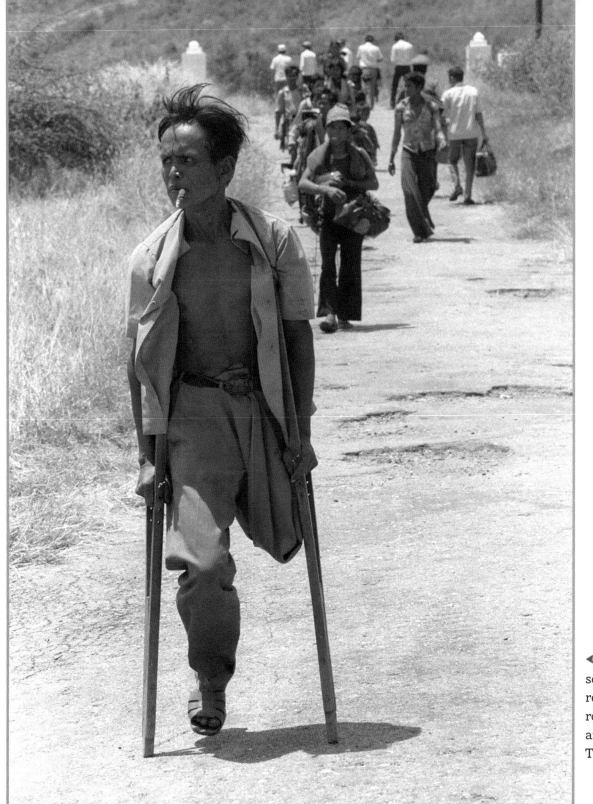

◄ A South Vietnamese soldier leads a group of refugees along a dirt road near Nha Trang and away from Ban Me Thout, March 21, 1975.

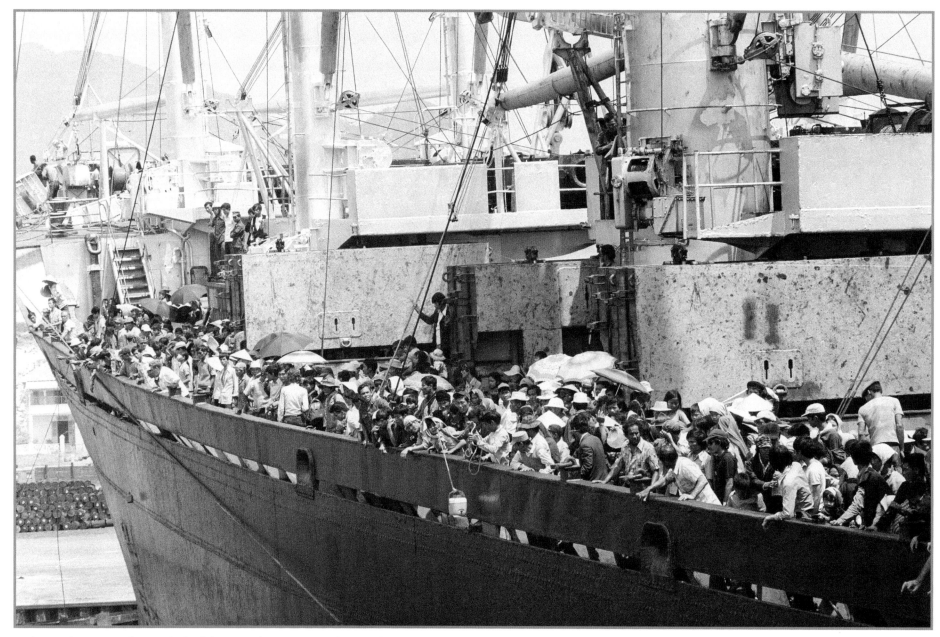

▲ A merchant vessel crowded with more than 5,000 refugees docks at Cam Ranh Bay at the end of a trip from besieged DaNang, which fell to North Vietnamese troops just days after the ship's departure, March 29, 1975.

Chapter Ten

Philippines, Guam, Japan

The long flight to the Philippines once again gave Nick time to think, time to wonder. What would happen now? Where would he live? Where would he work? How long would it be before he returned to Vietnam? Would there be renewed fighting to retake the country? Questions without answers added to Nick's forlorn exhaustion.

The single certainty was that there would be no combat assignments tomorrow, no nearby rocket explosions shattering earth and buildings, no dead bodies.

When he got off the plane in the Philippines he thought at first he was back in Danang. There were huge crowds, almost all Vietnamese, and signs in Vietnamese were posted everywhere. And everyone wondered what's next. Four days of idle time ended with a flight to Guam.

Unknown to Nick, AP sent Los Angeles staffer Linda Deutsch to Guam with a two-fold assignment. No.1, cover the mass arrival of Vietnamese refugees. No. 2, find the AP group and expedite their way out of Guam. Deutsch was a seasoned AP reporter, a mainstay of the Los Angeles staff and an expert in the coverage of the courts.

In an oral history interview she recalled her time in Guam:

Besides covering the story of some 50,000 refugees arriving in Guam, AP wanted me to locate the AP people—we had 42 people there—and arrange for the release of our staff who were evacuated from Vietnam.

The (refugee) story was incredible. It was probably one of the most emotional things I have ever covered in my life, to see all these people coming off boats in the middle of the

night, off ships, thousands upon thousands, bringing whatever they could take with them, a rice cooker or, you know, a baby's toy . . . something . . . Many of them had no papers. They had been taken out in helicopters. Some of them had been told to just throw their baggage away because there was no room in the helicopters. That's how they lost their papers.

▲ Young Vietnamese wear heavy oversized coats at Camp Pendleton, California's tent city, May 1975. Refugees from Southeast Asia's hot, humid climate found the coats a welcome defense against California's chilly nights.

And I was told that, in addition to covering the story by myself, I was to get our people out and get them to the United States . . . It was quite a challenge.

Deutsch wrote her copy about the general refugee situation and at the same time asked questions about AP people. But finding them in the mass of a hastily-built tent city was no easy chore. She recalled:

There were thousands of tents. And I finally asked somebody, and they said, 'Well, if you go down there and turn right at the water pipe and left at the outhouse, you'll see it, because they have a sign up' . . . So I followed the directions.

On this dusty road I came to this tent. And there's a sign up, hand lettered, and it says 'AP Tent.' And I knocked on the tent, and I said, 'Anybody there?' And this little face came and it was Nick. And he looked at me and said, 'You look like Edie.' (Nick referred to Edie Lederer, AP correspondent assigned to Saigon who was blonde and about the same height and bearing as Linda.) I said, 'She's my good friend.' And that was how I met Nick. And he was there, Dang Van Phouc was there, and Ed White was there. And others from AP.

Deutsch worked her magic with U.S. authorities to expedite paperwork, and soon the AP staffers and families were on their way to Camp Pendleton in California.

But not before one final loss left Nick speechless, numb, thrown back into the war. A BBC radio news broadcast reported that Michel Laurent was killed April 30, the last day of the war. Nick was stunned by the news that his friend had been killed in combat like Henri, like Noonan, like Sawada, like My. Nick believed the war followed him to Guam. He wondered whether the war would be with him forever?

The broadcast included details: Laurent attempted to rescue a fellow newsman who was wounded in a plantation firefight outside Saigon. A rocket blast took Laurent's life on a dusty roadway hours before the end of the war. He was the last journalist killed covering the 30 years of conflict in Vietnam.

Camp Pendleton in California was another city of tents, but many more, and there was more activity. The food was good and available 24 hours a day. The weather was warm like Southeast Asia, though the evening fog that rolled in off the Pacific Ocean brought an uncomfortable chill. Talk among the refugees centered on the unknown welfare of friends and relatives back in Vietnam. And about themselves and their undefined future as international refugees.

Refugee? Nick realized he was now a refugee—a fortunate one because AP was taking care of him, but a refugee nevertheless. He thanked his luck. He was not a refugee like those he photographed weeks before riding motorbikes or atop overcrowded trucks on highways under enemy fire. His fellow refugees at Pendleton struggled with uncertainty but they knew they were safe.

AP arranged trips into Los Angles to visit the AP office where Nick saw Linda again. He had a lunch or two with others in the bureau and even got a brief tour of LA with Wally Fong, longtime LA staffer. He felt comfortable in the familiar wire service atmosphere.

After several weeks, the U.S. issued passports listing the Vietnamese, Nick included, as refugees. He and Phouc officially rejoined AP. Phouc was assigned to Hong Kong and Nick to Tokyo. Nick's sister-in-law and her daughter made their way to Orange County to begin a new life with relatives. Nick and Phouc boarded

▶ Nick poses with Vietnamese refugees at Philippine Islands camp where he and others landed after departing Saigon, April 1975. (AP Photo/Dang Van Phouc)

◀ As in Vietnam, Nick often beat Tokyo's traffic by riding a motorcycle to assignments.

White and Jackson Ishizaki, another friend from Vietnam, helped Nick get settled. They rented an apartment in the building where White lived with his Vietnamese wife, Kim Phoung, and their daughter, Rachel. Nick spent time with them, often had a Vietnamese meal cooked by Kim and enjoyed 4-year-old Rachel, who reminded him of Teena. Vietnamese ties eased the adjustment to Japan.

Tokyo was a comfortable fit for Nick despite the issues presented by life in a foreign country. Little Vietnamese was spoken but the Japanese were friendly; many thought Nick was from Okinawa. He often took Rachel on walks in their neighborhood and soon learned, much to his delight, that Rachel's foreign appearance drew the attention of young Japanese

planes for their Asia bureaus. Although uncertainties did not vanish, the immediate future was now charted.

At Tokyo's Narita airport, Ed White welcomed Nick to Japan. White, now assigned to Tokyo as Asia news editor, had been Saigon bureau chief when Nick's brother My was killed. White escorted My's body from the Delta to Saigon for burial and he was there at My's funeral. White and Faas brought Nick into the AP. White tapped out the wire story on the day Nick photographed Kim Phuc. White was with Nick on that final, chaotic day in Vietnam, caught up with Nick in Guam and now greeted him as Nick walked into Narita's baggage claim.

women. Before long Nick dated some of them—a movie or chats in Tokyo's countless coffee shops.

Japan was hot and humid in the summer, much like Vietnam, but the frigid winter winds chilled Nick to the bone. Japan's cold irritated his leg wound where a piece of Trang Bang shrapnel still resided.

In 1975, not too long after he was settled in Tokyo, Nick received a telephone call from a Vietnamese woman, Tuyet Hong. Like Nick, she was from the Delta and had lived in Saigon, had been a neighbor to Arlette. A mutual friend noted Nick's photo in one of Tokyo's newspapers and suggested Hong might like to talk to Nick, perhaps get news of Saigon and her family.

Tuyet Hong lived abroad for several years in the late 1960s, received a French education, studied in Switzerland and lived in London for a year to perfect her English. Back in Saigon, her language capabilities helped her get a job with the Japanese embassy in 1972. Her colleagues urged her to visit Japan in April during cherry blossom time, which she did in 1975. Her mother told her the war was going badly and she should remain in Tokyo. After Saigon collapsed, Hong found herself in the same situation as Nick, a refugee.

She and Nick chatted on the phone and agreed to have lunch. Nick recalls it was a friendly lunch in which he learned that Hong would leave Japan in several days to take residence with a sister in Los Angeles. Nick saw her off at the airport. They exchanged holiday cards over the months but there was no further connection.

Assignments in Japan took Nick to sports and political events. He covered visiting Muhammad Ali, photographed Sumo wrestling matches, he made a quick trip to the DMZ in South Korea. International travel options, however, were limited. It took time for a refugee whose passport was stamped "No Country" to obtain a visa for other nations. That was a problem: Most AP international assignments required instant travel response to cover breaking news.

Return to Vietnam did not look promising, so after a couple of years Nick made a major decision. He would seek U.S. citizenship and get the "No Country" stamp removed from his passport. He asked AP for an assignment to the U.S. where he could settle down, begin naturalization and be a more useful wire service photographer. AP worked it out, discussing positions in either Washington or Los Angeles. He thought LA best—warm weather and a vibrant, growing Vietnamese community—and AP agreed.

Nick would soon be off to California, to face the challenge of change and find a place in yet another foreign land.

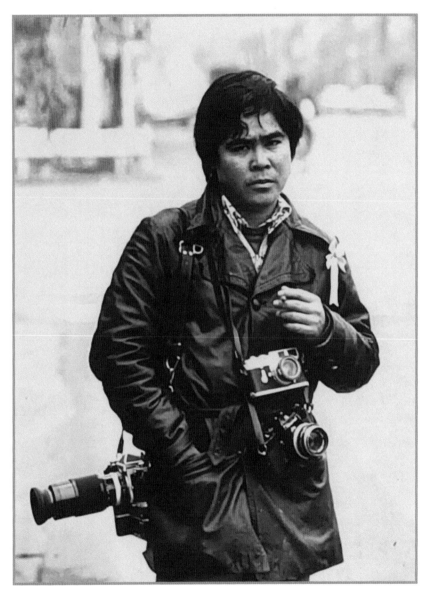

▲ Nick found Tokyo's chilly weather challenging as compared to the tropics of his homeland.

▲ Muhammad Ali works out on the heavy bag in a Tokyo gym during a June 1976, visit to Japan.

Chapter Eleven

Hollywood, Fires, Protests and Double-plays

Big cities were not new to Nick Ut. He had lived in Saigon, city-like despite its comparatively small size, and had spent two years in Tokyo, a metropolis as big as they come. He'd visited New York, Amsterdam, Paris and Bangkok.

Each had its big-city personality quirks. Los Angeles was no exception: a sprawling collection of communities laced together by crowded freeways on which it seemed everyone drove at least 15 mph above the speed limit. High-speed highways did not faze Nick until he was pulled over and issued a ticket for going 80 mph in a 50-mph zone. He quickly learned how far he could push regulations.

There were new-country challenges, however, that confronted the 26-year-old Vietnamese newcomer. The first, finding a place to live in LA's tangled maze, he solved with help from Vietnamese friends and AP bureau staff.

Next problem: Getting around in a city where even locals get lost. When Nick stopped for directions at gas stations in unfamiliar neighborhoods he was likely to encounter attendants who spoke only Spanish; even when sufficient English allowed a Vietnamese refugee to communicate with a Hispanic refugee it was a gamble as to whether he would receive useful directions. Nick soon learned that a photographer with a camera full of deadline-sensitive film

▲ One of Nick's first assignments in Los Angeles was helicopter crash that claimed the life of U-2 Spy plane pilot Francis Gary Powers, August 1977.

about overly aggressive photographers. Spencer and Nick discussed the unspoken niceties of police street coverage as compared to the free-wheeling ways of photographing battlefield action.

Then there was Hollywood. For an LA wire service photographer, the entertainment industry beckons—and Nick was soon immersed in glittery assignments.

In his first year, he photographed Roman Polansky, the director involved in a sex scandal, Jane Fonda, Pat Boone, Roy Rogers and Gene Autry, C-3PO, the Star Wars robot, President Gerald Ford and his wife Betty, Andy Griffith, Farrah Fawcett, Evel Knievel, the stunt master, singer Connie Stevens, California Gov. Jerry Brown, Jackie Cooper, Hugh Hefner, Joan Collins, Bette Midler, Muhammad Ali and a host of other celebrities. He was soon a regular at red carpet events, Hollywood sidewalk installations and one-on-one AP reporter interviews.

could make better time on side streets and boulevards than on the freeways. Eventually, LA became negotiable.

Among Nick's first Los Angeles assignments was a helicopter crash that claimed the life of Francis Gary Powers, the U2 spy pilot who was shot down over Russia in 1960 and had been freed from a Soviet prison. In mid-1977, Powers was a helicopter traffic reporter for a radio station. Covering the crash, Nick tried to make pictures of the recovered body in an ambulance. LA Photo Editor Spencer Jones later received a call from the sheriff's office with a warning

Covering LA's many college and professional sports teams was more challenging. Nick's Tokyo experience helped with basketball, hockey and boxing, but AP seldom covered Japanese baseball and the Japanese did not play American football. Double-plays and home runs? Punts and first-and-10s? These were mysteries to Nick. He told editors that baseball games reminded him of Vietcong running around in all directions.

He solved the problem by watching games on television, then checking photos printed in the morning newspapers. In time, he

▲ Paul Newman at Riverside Raceway, August 1979.

▲ Director Roman Polanski appears at a Santa Monica court in connection with sex crimes charges, October 1977. ▶ Farah Fawcett waits her turn on the set for TV tennis show, October 1977.

▲ Dick Van Dyke and Mary Tyler Moore on Television, March 1979.

◀ Jane Fonda speaks to a gathering of lawyers' wives in Beverly Hills, April 1978.

learned the rhythms and knew what to expect—be it a double-play or a goal line fumble.

The Los Angeles photographer community quickly accepted Nick. He never had a problem making friends. Even if he was a bit late for an assignment crowded with photographers, there was always a place for Nick.

"I was short," he once commented, smiling as he referred to his 5-foot-3 frame, "and they could shoot over me." He looked with disfavor on the paparazzi: "Too pushy," he said. "But I just push back."

Despite his professional friendships, Nick found himself lonely. That led him to call Tuyet Hong, the Vietnamese woman he'd briefly known in Tokyo, to suggest they get together for dinner. He learned that soon after arriving in LA, she had landed a job with an insurance company, thanks to her language skills, and was learning accounting.

A second dinner followed their first, then another and another—and Nick suggested they get married.

Marriage made sense to him. They were both refugees in a new land, both Vietnamese, both Buddhists, their ages were about the same and they lived in similar circumstances. The union would not be without differences: Hong was from Vietnam's North, Nick from the South; she was educated abroad and lived in big cities most of her life, he was a farm boy from the Delta; she was shy, reserved, whereas Nick was outgoing, friendly, easy to be with.

At first, Hong had reservations. She had not considered marriage and had lived a quiet life compared to Nick's adventures in the hectic world of news. On the other hand, he was reliable, he had a good job with a future and (she checked) he was not married

▲ Says Nick about jammed photographer sessions: "I'm short, they can shoot over me."

like some of the Vietnamese men who ended up in the U.S.

And so they decided to take the big step. After a short engagement they were married in January 1978. Nick remembers it was not a typical Buddhist ceremony. It lacked the traditional examination by astrologers and large family participation; most of their families were still in Vietnam. Some 100 people attended the ceremony, which had a definite American overlay.

The couple took up residence in Hong's apartment. Her office was near the AP bureau and for years Nick and his wife traveled together to and from work. They bought a house, and in time two children were born: Michael in 1979 and Bettina in 1982. And Nick and Hong became U.S. citizens.

Nick settled in to life in Los Angeles. He reported for work early each morning and was assigned to typical wire service stories. In LA, that meant considerable time spent in courthouses making pictures of celebrities and criminals.

He often joked: "Every star who has troubles . . . they will see me."

Actress Joan Collins, who passed through the courts in connection with both divorce and libel cases, saw Nick on her second court appearance and said: "What, you again?!" Later, at her home for an interview shoot as she celebrated a decision in her favor in a libel trial, Collins opened a bottle of champagne. She poured a flute of bubbly for Nick and offered a toast to her victory and to his photography.

Robert Blake, charged in 2005 with murdering his wife, recognized Nick and invited him to lunch on the day he was to hear the jury's verdict. They dined on eggs and toast, Nick recalled, and a few

hours later Nick made a dramatic photo of Blake with his head on the courtroom table as the jury pronounced him innocent.

Nick photographed O.J. Simpson at his 1994 murder trial, and the Menendez brothers, charged in 1990 with the shotgun murder of their parents.

After Michael Jackson was arraigned on child molestation charges, Nick photographed him in numerous poses coming and going from court, waving, face covered by hair, smiling, glum, full length, portrait. He even got a remarkable shot of Jackson dancing on the roof of his limo.

Trials partnered Nick with Linda Deutsch, and they became pals. Linda, the LA reporter who found Nick and other AP staff on Guam, was AP's star court reporter. She covered national and international stories that played on front pages.

Deutsch delighted in telling how, when she interviewed Daniel Ellsberg—who leaked the "Pentagon Papers," a secret study of U.S. decision-making in Vietnam—she introduced him to Nick who was assigned to do the pictures. When Linda told him Nick was the photographer of Kim Phuc, Ellsberg shouted amazement, hugged Nick and demanded to hear in detail the story of the photo. Nick, as always, obliged.

Marlon Brando, who held photographers in low esteem, wasn't happy when he saw Nick and an LA Times photographer shooting courthouse photos of him during a trial in Santa Monica. Brando had put on considerable weight and threw a nasty look at Nick every time Nick made a picture. Later Brando's lawyer introduced the actor to

▶ Nick and his bride Tuyet Hong at their wedding, January 1977.

▲ Nick poses for pictures behind the famous Hollywood sign during filming of a documentary about his life and career. (Photo/Scott Templeton)

Nick as the shooter of the napalm photo. Nick and Brando chatted for 10 minutes, and Brando said he was sorry he gave Nick a bad time.

Political celebrities were part of Nick's beat, too. He photographed Presidents Ronald Reagan, Bill Clinton, Gerald Ford, and, on the campaign trail, Barack Obama and later Donald Trump.

Only once in his career did anyone point a gun at him directly and threaten his life. And it was far from Southeast Asian combat zones. That happened in April 1992. Nick covered the Los Angeles riots connected to the police beatings of Rodney King. Those riots have been described as the worst of the 20th century. More than 60 people were killed, an estimated $1 billion in damage was done, freeways were closed and widespread looting paralyzed the city for days.

"Sometimes," Nick said, "it seemed as risky as Vietnam—maybe even worse—because you are all alone and in the open. It's like house-to-house street fighting, the worst of the war to cover.

"Many times I fear gunfire in Vietnam . . . sometimes soldiers killed near me and I wounded three times . . . but no one ever pointed a gun right at me, face-to-face, like on LA street during big rioting," Nick recalled.

The entire LA photographer staff covered the riots. One night, Nick saw demonstrators setting fires near a police station. As he moved forward to photograph the scene, a demonstrator pointed a pistol at him and threatened to kill him if he made photos. Reaction in a situation like that is visceral, instant. Faas early on told Nick

that no battlefield photo is worth your life. And Los Angeles was a battlefield: scores dead, fires out of control, looting, emotions running high, Korean business owners with rifles ready to protect their shops.

It wasn't that he considered every one of those factors separately but combined experience kicked in, and Nick immediately knew the best course was to back off. He decided to stay closer to National Guardsmen and police lines.

Rioters frequently made Koreans targets of their anger during the violence and often mistook Nick for Korean. He hollered, "No, No . . . I'm Vietnamese, AP news," and the moment passed. Years later, looking back over his assignments in Los Angeles, he said the 1992 riots and the killing and the burning of buildings were the closest thing to the war he photographed in Vietnam.

While not as risky as the riots, photographing California wildfires likewise presented dangers reminiscent of Vietnam. Suddenly trees exploded. "Whooom" is how Nick described the unexpected bursts of fire. Instead of following the smoke as in Vietnam, Nick followed the helicopters and larger aircraft that dropped fire repellent. At night the wap-wap-wap of choppers tracking the fire's progress passed over his house and woke him with flashed recollections of helicopters flying to and from battles in Vietnam.

Vietnam. Nick wondered whether he would ever return there, wondered about his family, wondered how his homeland had changed. When letters were again possible between Vietnam and the U.S., he learned that his mother and his siblings were well, but he wished he could see for himself the world he left behind in 1975.

His reflections on Vietnam included thoughts about Kim Phuc. He had not heard from her or about her except for a single reference to medical treatments in Germany. That was not surprising; there

▲ Nick covers Los Angeles area wildfires.

was little to no contact with Vietnam in the early years after the war, but the U.S.-Vietnam relationship was changing in the mid-1980s. Communications were reopening.

Again, Nick wondered: Whatever happened to the child he last saw some 15 years ago?

▲ Nick Ut reflects on his "Napalm Girl" war photo. (AP Photo/Michel Euler)

Chapter Twelve

Vietnam Revisited

Nick's imagined visit to Vietnam became reality in 1989 but not before a new controversy involving his picture reminded him of Faas' comment: "It's a picture that doesn't rest".

Gen. William Westmoreland, who commanded U.S. forces in Vietnam, gave a speech in Florida about how media presented a distorted impression of the war. In questions later he cited Nick's picture of Kim on Highway 1 as an example. He said he read investigative reports on the incident and believed it impossible for anyone to survive a napalm attack, and that Kim's burns were the result of a cooking fire. NBC researchers in New York examined archival footage of the Trang Bang battle, but could find nothing that contradicted Nick's images or the time sequence of the napalm drop followed immediately by Vietnamese running on the road. Film showed the same imagery that Nick produced, the bombs falling, the explosion, Vietnamese running toward the correspondents.

Nick was incensed that the truth of his photo was questioned and issued a statement challenging anyone to examine the still images and the film and say they were anything but accurate.

The Miami Herald reported the NBC research and added:

"Archivists in the Army's center for crime records in Baltimore and in Washington, D.C., for the records management office and division of military history, could find no evidence of an investigation into the photo."

Some months later, Faas attended a conference also attended by Westmoreland. Faas asked the general about the photo. Westmoreland said he did not want to talk about it.

▲ Nick Ut visits a special school in Vietnam for children who suffer from the effect of chemicals used during the war.

The new Nick found the streets of Ho Chi Minh City much different than the Saigon streets he rushed through with a few shirts, extra pants and his cameras on April 28, 1975. "Quieter" was the word he used to describe the city. Food stalls gone, sidewalk merchants virtually disappeared, some street names changed, chatter and noise of the once exotic Saigon gone, most bars closed, black market stalls missing, maddening traffic of jeeps and military vehicles disappeared. Yes, he said, "Quiet." He was touched by the presence of children who looked frail and was thankful his own children were well fed and groomed in their California home.

The Esper/Ut team dutifully fulfilled their assignment and provided stories and pictures of the American vets checking out their old battle sites of Khe Sanh, Dong Ha and the DMZ. Memories haunted Nick as he passed through the same places he and Henri Huet traveled before Henri made his fatal 1971 flight into Laos.

Nick and George visited Nick's hometown to reunite after 14 years with his family. He found his mother had aged but was content living near his remaining six siblings. He proudly showed her pictures of her American grandchildren. One of Nick's brothers surprised him with a collection of some 50 negatives found in Nick's residence which he closed after Nick left. The photos were from June 8, 1972, when Nick photographed Kim on Highway 1. His brother hid them in a wall of his home during the intervening years.

Before leaving Vietnam, Esper and Nick drove to Trang Bang hoping to find Kim and/or her parents. Local residents told them that Kim was still in Cuba but did not know where her family lived. Back in Los Angeles, Nick received a letter from Kim's parents saying they read a magazine story about his visit and were disappointed that neighbors did not direct him to their new home. They confirmed that Kim was still in Havana.

Nick's desire to visit Vietnam was resolved by a call from George Esper, the AP Chief of Bureau who arranged Nick's evacuation from Saigon. Esper, now AP Special Correspondent in New England, was assigned to accompany a group of American veterans on a goodwill visit to Vietnam. The vets would help locate unexploded devices near the old DMZ. The big moment for Nick came when Esper said AP wanted him to photograph the visit. Plans were organized and in early 1989 the two APers, arrived in Vietnam.

The Nick of 1989 was not the Nick of 1975. He was now 38, a seasoned news photographer, an American citizen, husband and a father of two children.

Visiting Vietnam was a welcome break from the daily coverage that justified his Los Angeles AKA, "Hollywood Nick." During the months from 1988 into mid-1989, Nick photographed entertainers Zsa Zsa Gabor, Angie Dickinson, Joan Rivers, Mary Tyler Moore, Betty White, Carole King, Peter Falk, Jane Fonda, Angela Lansbury, Roddy McDowall, Rita Moreno and Michael Jackson, as well as boxer Mike Tyson. He photographed the Dalai Lama, astronaut-senator John Glenn, retired President Ronald Reagan and wife Nancy, former Vice President Dan Quayle and former first lady Barbara Bush. He even photographed Marilyn Monroe's grave.

Nick's Facebook friends knew the Napalm Girl image but photo bloggers revived and expanded interest in the picture. It appeared repeatedly in stories and reviews of famous photographs. A new, younger audience saw the picture, heard its story and became aware of the photographer. He became more than a byline beneath a photograph in a newspaper, and that contributed to his celebrity. And to the celebrity of Kim Phuc.

The possibility of a dramatic new assignment presented itself to Nick in 1993 when he heard of AP plans to reopen its Vietnam bureau. Several AP writers and photographers had visited Vietnam briefly since the war's end, including the 1989 Nick/Esper goodwill visit with American veterans. The new bureau, however, would mark AP's permanent return to Vietnam for the first time since 1975.

Nick was never shy about campaigning for an assignment. Horst Faas could testify to that as far back as 1965. Nick immediately made known his desire to be part of the new bureau. He was teamed up once again with Esper, and together they arrived in Hanoi in October 1993.

Much was at stake for AP. Vietnam was entering a new relationship with the U.S. and coverage would be sticky in a nation that lacked a free press. Both Esper and Ut were closely monitored by government watchers, somewhat limiting their coverage but nevertheless

▲ Horst Faas and Nick Ut meet in Ho Chi Minh City at a gathering of Vietnam War correspondents, April 28, 2005. The reunion of reporters and photographers marked the 30th anniversary of the end of the Vietnam conflict. (AP Photo/Richard Vogel)

maintaining an AP presence. Nick made pictures of visiting diplomats and views of street life in Hanoi. His pictures were well composed and useful as feature illustrations.

A visit to Ho Chi Minh City included a sentimental stop at AP's wartime office. The rooms were still there, French doors that enclosed the office still workable and a scarred, deteriorating AP Logo still adorned the wall above the entrance. The offices of AP and neighbor NBC were occupied by a large number of residents that Nick said looked like homeless people. In later years the building was taken down and replaced by a modern structure.

Nick visited his family in Ty Son. His mother had died at the age of 84 but his brothers and their families were well. Nick and Esper drove to Trang Bang but found only an empty lot once the site of Kim's home. Neighbors directed them to another nearby location where the family lived in a dark straw hut. Kim's father and mother greeted Nick with enthusiasm and talked about how Nick had saved the life of their daughter. Nick had not seen their daughter in years but shared information about her life in Canada that she had described in phone calls.

The now elderly couple retrieved newspaper clippings from their modest furnishings and with Nick recalled events of that June 8 more than 20 years earlier. Both parents described how they were gripped by terror when planes roared low overhead and dropped bombs. Like Kim, they fled the Cao Dai temple but not quickly enough to avoid the napalm explosions. Kim's mother was slightly burned as were her other six children. His visit, Nick remembers, ended with a tearful farewell, the tears prompted by revival of distant memories.

Back in LA Nick resumed contact with phone calls to Kim one of which included news that Kim and Toan were the parents of a baby son.

On several occasions Nick visited Vietnam to participate in reunions of correspondents and photographers who covered the Vietnam War. At one such gathering Horst Faas was struck with a health condition that demanded his air evacuation to Bangkok. His life was saved but he was paralyzed and would remain in a wheelchair the rest of his life. He had been lecturing and teaching photographers of the postwar Vietnam News Agency. Nick picked up on Horst's relationship with VNA and conducted several seminars for young VNA shooters.

Again, in 2000, the photo brought Nick and Kim together, this time in London to meet Queen Elizabeth II. Organizers of an exhibition

▲ Queen Elizabeth II with Kim Phuc and Nick Ut at a London exhibition, January 27, 2000. (AP Photo/Ian Jones)

at the London Science Museum titled "Making the Modern World" included Nick's picture, his camera and the photo transmitter that sent the photo to the world. Queen Elizabeth opened the exhibition in July. Nick and Kim were invited and the Queen stopped at the case holding the Trang Bang artifacts. Queen Elizabeth initiated the conversation, asking Kim, "Is that really you?" (in the picture). The group, Queen, Nick, Kim and Horst Faas, also present, talked for several minutes.

While in Hanoi and working with AP Correspondent George Esper,
Nick Ut helped reopen an AP bureau in the Vietnamese capital for the first time
since the Vietnam war ended. Here are a few pictures of street life
he photographed as he visited parts of the city.

▲ A fisherman tends his net in a lake near Hanoi.

▲ Bicycle riders pass by the walls of the prison that once held American POWs during the Vietnam War.

◄ A shop keeper attends to bicycle parts which he sells from his store in downtown Hanoi. His business was one of the early signs of entrepreneur activity.

146

Chapter Thirteen

Kim Phuc's Postwar Years

Kim's early postwar life slipped into obscurity. For Kim it was a welcome obscurity but an obscurity eventually replaced by government and public attention.

For a few years doctors and medical teams sought to ease the pain that was her constant companion. The first medical effort corrected fusion of her chin to her upper chest created by scars. Each treatment was extremely painful, the overall progress slow. Medicine required to treat her was hard to come by and funds were lacking.

Kim hated Nick's picture when finally her family showed it to her many months after it appeared. Her dislike persisted and hardened as Vietnam tentatively opened its doors to selected foreign correspondents. Vietnamese officials had forgotten the photo and its image of the terribly burned child but visiting reporters remembered it and its worldwide impact. Their frequent requests to interview Kim alerted government officials to propaganda possibilities.

Kim by this time was 19 and enrolled in university at Ho Chi Minh City (previously Saigon) to study medicine with the hope of becoming a doctor like those who worked so diligently over her scarred body. Whenever an interview request came up Vietnamese officials trotted her out, interrupting her college courses. Finally the

government took her out of school to become a regular propaganda item including participation in propaganda films.

Kim did not appreciate the attention. She lived with persistent pain and the photo repeatedly revived the embarrassment of her nakedness and the agony of that day on Highway 1. She felt trapped, unable to escape unwanted notoriety caused by frequent references to the photo.

In an interview she later expressed her feelings:

"I wanted the picture to go away," she recalled. "I wanted to forget it. But they wanted everyone to remember it.

"I was living with anger. I was living with bitterness. I saw my life as a burden. I became a victim all over again. My life was like a bird in a cage, and I became so bitter and angry. Deep in my heart I wanted to know the truth about why I had to suffer so." She saw her future as bleak. Would the pain ever go away? Could she hope to find love and marriage? Would there be a partner who could see past the scars and understand the woman she had become? Her frustration was that no apparent answers were in her future.

When Kim was not involved with the government and with interviews she spent time in the library reading books.

"That is where I found the Bible," she recalled. "I couldn't stop reading it." Her study of the Bible and its message literally captured her soul and led Kim at Christmas 1982 to convert to Christianity from her family's lifelong Cao Daism.

Two years later the magazine Der Stern sponsored a visit to Germany for Kim to undergo newly developed techniques for the treatment of severe burns. An AP story from Bangkok about Kim passing through Thailand on the way to Germany caught Nick's eye in LA. It was the first he heard of her since they were photographed together in 1973.

After treatment in Germany Kim returned to Vietnam refreshed at least temporarily by visiting new sights and hearing new sounds. Back in Vietnam, however, the old feelings were still there. But Kim was changing. Over the years her devotion to Christianity guided her to an appreciation of the positives in her life.

"The first miracle I count on is that my feet weren't burned. So I was able to run out of that fire and Nick Ut took that picture. And the second miracle that I count on is that yes, I got burned almost like sixty-five percent of my body. But my face and my hands still look beautiful."

In an effort to find a different life, one without constant interviews and repeated connections to the photograph of her naked, burned body, Kim asked the Vietnamese government to send her to Cuba for study at Havana University where, she heard, special courses for Vietnamese students were available. By 1986 Kim was in Havana studying English, Spanish and pharmacology. Constant interruptions and distraction caused by pain had forced her to abandon the intense study required for a medical career and she turned to the possibility of teaching. She made friends in Cuba and lived in a dormitory with several other Vietnamese students. She hoped the changed atmosphere would create a new life and that she could finally escape the picture and the interviews.

During these years, as Nick covered Hollywood, the *Los Angeles Times Magazine* worked up a story idea: a Nick–Phuc reunion in Cuba. The *Times* arranged for an August visit with Kim to take place at Havana's Riviera Hotel. Freelance photographer Jim Caccavo was assigned to photograph Nick photographing Kim.

Cuban authorities ruled the Americans would spend one day in Havana and four hours with Kim. They would meet at the hotel at 2 pm but Kim, excited over the coming visit, arrived at 9 am.

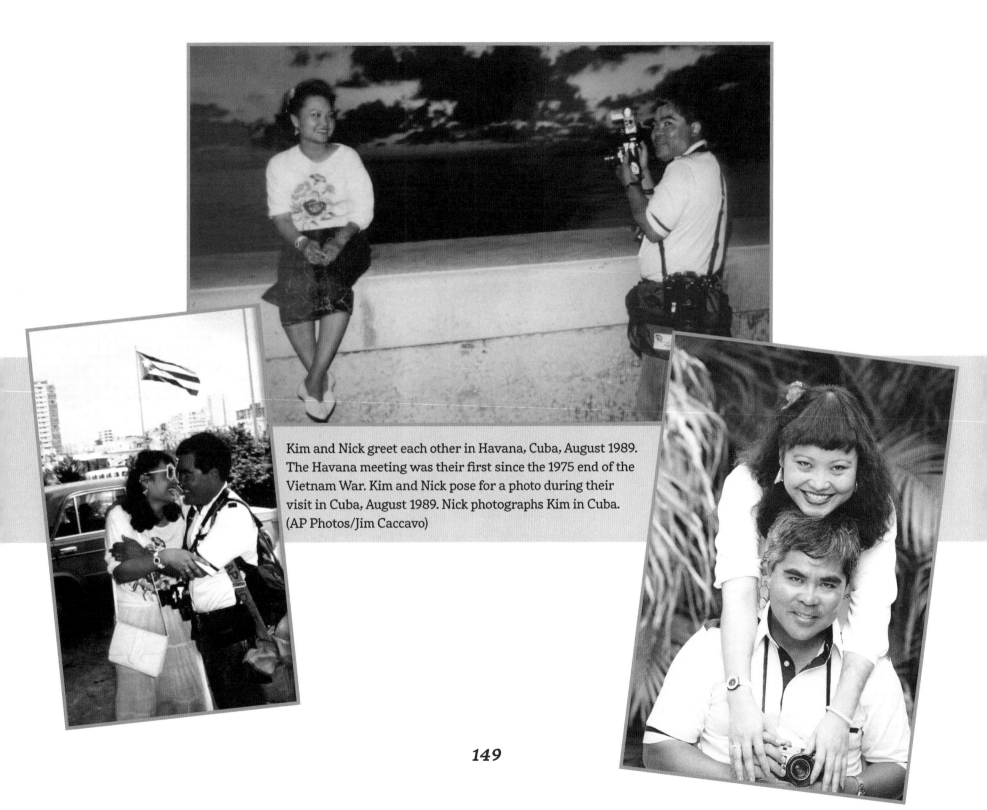

Kim and Nick greet each other in Havana, Cuba, August 1989. The Havana meeting was their first since the 1975 end of the Vietnam War. Kim and Nick pose for a photo during their visit in Cuba, August 1989. Nick photographs Kim in Cuba. (AP Photos/Jim Caccavo)

Nick had visited Kim after 1972, sometimes at her home, sometimes in hospitals, the last time in 1973. But she was a child then. Her painful wounds coupled with equally painful hospital treatments blanked out much of her memories of Highway 1 and the occasional visitor. She knew about Nick but had little or no recollection of what he looked like.

"In my mind," she said, "they (family members) talked about Nick Ut, the photographer who took my picture. But unfortunately I don't remember his face. Then 17 years later when I knew that he would come to visit me in Cuba . . . and I couldn't wait to see him. I knew everything, but I didn't know . . . I not realize the face. But as soon as he opened the door in the car, he walk out, instantly it come to me, this is Uncle Ut."

During the car ride to the hotel Nick recalled his last visit with Kim, then a 10-year-old child, her hair shaved in preparation for a hospital visit and a vacant expression in her eyes. What Nick saw in Havana was a 26-year-old woman, pretty and smiling with great excitement, reaching out to welcome him with a hug.

The meeting went well. Kim was outgoing, expressive. Together they pored over pictures of that day on Highway 1. Nick told her stories of the war including details of her photo and how a large blowup of the image was on the wall of a room in his home, and that he considered her a member of his family. She shared with Nick the story of her travels from Trang Bang to Havana. She was lonely and unhappy at first in Havana, she said, but she made friends and soon participated in the usual college activities. She explained how the scars had closed some sweat glands making her sensitive to heat and cold.

All the while Cuban and Vietnamese minders kept a close watch on their activities.

With great excitement Kim described plans for her to visit 12 U.S. cities on a speaking tour sponsored by American anti-war activists seeking improved diplomatic relations with Vietnam. Kim said she looked forward to seeing the U.S. Her conversion to Christianity and the depth of her devotion came through as she assured Nick that her appearances would not involve politics but would be aimed at reconciliation, peace, forgiveness and friendly relations between the two countries. In an eight-page story about the Cuba visit Kim was quoted in the *Los Angeles Times Magazine*:

"The past is the past and I'm not coming to talk about the war. I'm coming so Americans can meet the girl in the photograph and see that I'm alive. I'll tell them about my life and what is happening to my family."

Kim would eventually realize her ambition to speak to U.S. audiences but it would not happen in 1989. Vietnamese officials canceled the visit at the last minute because, Nick believed, the Hanoi government feared Kim would defect in the U.S.

After many years of separation Kim and Nick were different people than they were in the mid-'70s. War and a photograph connected them at a time when they were adult and child, but the years and changes in lifestyle intervened. They were both adults now. Whether they realized it or not the Havana reunion in many ways was the beginning of the lifelong Kim and Nick bond, a bond made stronger by experiences shared whenever their separate life journeys intersected.

Nick's short visit ended and he flew back to Los Angeles. Several years would pass before they met again.

Kim, isolated in Cuba, was unaware of Nick's world. After Nick's visit her life returned to what passed for normal. She continued to

suffer pain from the napalm scars. Would she ever find relief from the contant pain? She worried about her future. How much longer would she be in Havana? Would she end up back in Vietnam? Would the propaganda appearances resume?

Then came life-changing developments. Kim had met and dated fellow student Bui Huy Toan. In time they fell in love and in 1992 decided to marry. Contributions from fellow students financed a honeymoon trip to Moscow. On their return to Cuba Kim convinced her husband that they should defect in Canada during a refueling stop in Newfoundland. For too long, she believed, they had lived under tight governmental controls that dictated their life with no consideration for their personal ambitions.

At the Newfoundland stopover Kim and Toan simply walked out of the airport's transit lounge, approached an immigration agent and asked for asylum. It was granted and in a short time, with the help of a local Quaker group, they made their way to Toronto where the newlyweds settled down to build a new life.

Kim wanted to notify Nick of her decision, but her first attempt to reach him at AP was a miss. Nick was in Mexico on assignment. She left a message but, concerned about unwanted publicity, left no name, no phone number. She tried a second time days later but missed him again. Nick later received a letter from Kim's brother in Vietnam telling him that Kim was in Canada. He included her address and phone number. Nick wrote a letter to Kim and they were connected, but five years would pass since their Cuba visit before they met again.

The May 1995, issue of *LIFE* magazine featured a photo of Kim tenderly holding her baby boy and showing napalm scars and their ragged impressions across her back and arms.

In the accompanying text Kim briefly summarized her life since 1972. She described the fiery explosion of the napalm, how her family tended to her in many hospitalizations, her travels under rigid communist control and her marriage to Toan, the life partner she so desired. More than anything it was the government control that inspired her decision to defect.

She was specific about the photo:

"That picture made me very famous, but it made my life not what I want. I think a lot of people know of me, I need one, just one, to understand me. Toan does. I know my picture did something to help stop the war."

▲ Kim Phuc and her husband, Toan Huy Bui, September 2015.

▶ Kim Phuc plays with her son Thomas Huy Hoang in Toronto, Canada, May 25, 1997.

▼ Nick, in Vietnam to cover the 25th anniversary of the end of the Vietnam War, chats with Phan Thanh Tam during a visit to Trang Bang, April 2000. Tam is the 12-year-old brother of Kim Phuc. In Ut's famous photo he is the screaming boy at the far left. (AP Photo/Horst Faas)

Kim Phuc's Postwar Years

In October 1995, Kim made her first U.S. visit. She participated in the Eddie Adams Workshop for young photographers held annually in upstate New York. It was the first meeting for Kim and Nick since their Cuba reunion six years earlier. Also attending were photographer John Filo and Mary Vecchio, another photographer-and-subject combination similar to Nick and Kim. Vecchio was the screaming girl in Filo's famous 1970 Pulitzer Prize photo made at Kent State where four anti-war student demonstrators were killed.

Surrounded by a stand of towering pines nestled in the rolling hills of the New York countryside Kim and Vecchio laid flowers on a stone memorial as part of an annual workshop ceremony to remember photographers killed in Vietnam. Filo and Vecchio spoke to the workshop's 200 photographers and faculty. Nick showed slides of his combat pictures, including images from Highway 1. Kim turned away and sobbed as his photos filled the screen.

▲ Kim Phuc first visited the United States when she spoke at the Eddie Adams Workshop in Jeffersonville, NY, 1995. With her, from right is Nick Ut, Kim, Eddie Adams, Mary Ann Vecchio, John Filo. Vecchio is the woman screaming over the body of a slain student at Kent State photographed by Filo in 1970. The three photographers — Filo, Adams and Ut — are Pulitzer Prize-winners for pictures connected to the Vietnam War. (Courtesy, Tory Wesnoske)

She addressed the audience:

"That picture changed the world; also it changed my life. I suffered a lot. But as time passed, it gave me strong faith. I don't want to remember the pain. I am just thankful in my present and in my future. Even now, when the weather changes, have that pain. God bring me husband. Have a son. Finally I've got everything."

"She gets sick when she sees the picture, " Nick said, "but now she has freedom."

Recollections of Trang Bang's horror would always haunt Kim Phuc but her ambivalence toward the photograph changed. As her devotion to Christianity deepened and as her appreciation of the positives in her life became clear she saw the picture not as frightening reminder but as a tool that would help tell her story of forgiveness and emphasize her plea for peace.

In November 1996, Kim was invited to place a wreath at the Vietnam Veterans Memorial in Washington, D.C., and to address the several thousands of veterans who attended. She told her story and received a standing ovation. At meetings later, a discussion with Memorial officials planted the seed of an idea: To create a foundation designed to provide help to children injured in war.

◀ Kim Phuc appears with Nick Ut's famous picture at a presentation in Newport Beach, California, June 2012. For many years she hated the picture but in time came to believe the photo could help tell her story of war's horror. (AP Photo/Damian Dovarganes)

It would be called the Kim Foundation International and in time it grew to more than 70 local organizations that carried the same name and practiced the same ideals.

While Kim was in Washington Nick, who was invited to the memorial event, was in Las Vegas to cover a Mike Tyson-Evander Holyfield heavyweight championship boxing match.

UNESCO added to her growing fame by naming her a Goodwill Ambassador.

Nick and Kim met twice the following year. In April, Nick flew to Toronto secretly to participate in a CBS-TV "Where Are They Now" program. At the appropriate moment in the filming Nick appeared. A surprised Kim screamed in delight and rushed to Nick for hugs and laughs. That summer Kim flew to Los Angeles with a Canadian film crew to photograph her meeting with an Orange county surgeon who had operated on her years earlier.

During the visit Kim spent a day with Nick, visited him at home, met his family, more filming and interviews included. Interview questions were directed to Nick's wife and his two children, Michael and Bettina. Responses from the children, now high school students, were best described as blasé. They had, after all, heard stories, repeated stories, about the picture all their lives. Both said they never brought up the photo itself but teachers sometimes mentioned it as part of class discussions. Michael said that it was sometimes embarrassing but, "It's OK . . . I don't like bragging or making a big deal of it." Both children said they liked Kim.

Hong was more restrained. She said that in some circles there were surprising reactions to the picture. Some believed the photo was critical to the U.S. decision to leave Vietnam and the photo therefore was responsible for South Vietnam's defeat. She said she did not believe that but she sometimes feared Nick might be

▲ Nick Ut and Kim Phuc pose together in Miami, Florida, before her treatment of scar tissue. Ut photographed the treatment in May, 2015. (AP Photo/Jennifer McKay)

in danger from those who did. She said she does not mention the photo to her friends and that most of them do not know it was her husband who made the picture.

Kim traveled the world in subsequent years—to the U.S., to Europe, to Asia but not Vietnam. On several occasions Nick participated in the sessions, Kim telling her story of a child severely injured followed by years of painful treatment, of being the propaganda

tool of her government but in the end finding faith in herself and in Christianity. Kim delivered her story in near silent tones that held her audiences in rapt attention. Nick on some occasions would show his photographs.

A book, *The Girl in the Picture*, by Denise Chong, was published in 1999. Kim and Toan had as second son, which brought added happiness to their life in Canada.

▲ Nick photographs Kim Phuc during a medical treatment to ease her scar pain in Miami, Florida, September, 2015. Husband Toan Huy Bui is in background. (AP Photo/Gaston de Cardevas)

"My doctor, my medicine. My life."

With all the traveling one might think Nick missed out on coverage in LA. During this period he covered what felt like the endless OJ Simpson trial involving custody of OJ's children and other matters. Just a few of the celebrities Hollywood Nick photographed included Shaquille O'Neal, Patrick Stewart, Jane Withers, and the ailing Bob Hope attending the funeral of his movie pal, Dorothy Lamour. He photographed Sharon Stone, Kevin Bacon, Ryan O'Neal, the Dixie Chicks, Lionel Richie, Carol Tiegs, Harrison Ford, Norman Lear, Stephen Spielberg, Mickey Rooney, Chris Rock, Jackie Chan, Nick Nolte, Morgan Freeman, Don Rickles, Sid Caesar, Mikhail Gorbachev, and the late Sen. John McCain. And throw in baseball, soccer and football games, crime, an explosion or two, charity affairs and the Rose Bowl plus wild fires, mudslides, storms and pollution. Nick carried a busy camera.

During this period—late 1980s and into the '90s—digital technology created a revolution in the world of photography. Dramatic changes in picture journalism resulted within the media in general and for AP and other wire services in particular: The classic wet darkroom disappeared, enabling faster handling of pictures, better quality and transmission of all photos in color. A greater collection

of pictures became available to news pages and eventually Internet blogs and websites.

The digital camera was easier to use. A single device the size of a thumbnail held a day's shooting. The time consuming and costly business of film, film developing and print making vanished. Pictures, personal pictures, could now be prepared for delivery to friends or to the world in seconds. Facebook and eventually Instagram allowed photographers to show their work to expanded audiences.

Nick, like most photographers, adjusted quickly to the digital world but for him personally there was a special impact, a natural fit. Since his time in the AP's Saigon darkroom to the glitz of Hollywood Nick spoke better with pictures than with words. Digital offered a technology and an expanded communications gateway for him to stay in touch with friends by showing them his life in photographs. He took advantage of it, sharing with his Facebook community the travels he made, the celebrities he met and how he spent his professional and personal time. Nick displayed his self-inspired photography, a part of his talent not seen in his daily work as a wire service shooter. Some said he did this to excess. Whatever the volume, it was in photos not words.

Unexpected circumstance combined with coincidence caused the Napalm Girl photo to reappear in the daily news flow once again. "Hollywood Nick" was assigned to

▶ New York Daily news publication of the Paris Hilton/ Kim Phuc photographs made 35 years apart. (Courtesy, NY Daily News)

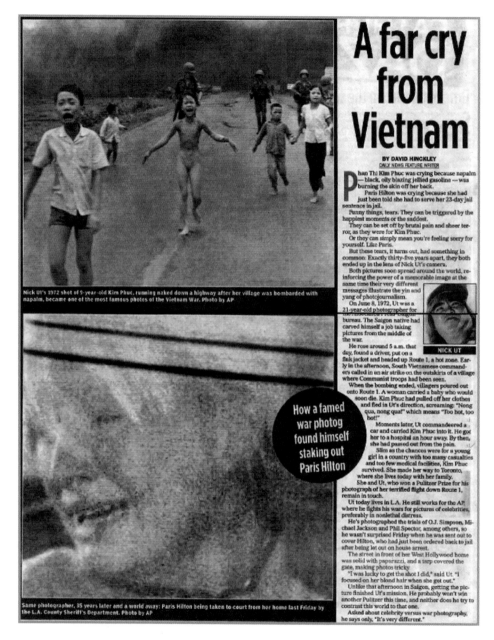

A far cry from Vietnam

BY DAVID HINCKLEY
DAILY NEWS FEATURE WRITER

Phan Thi Kim Phuc was crying because napalm — black, oily blazing jellied gasoline — was burning the skin off her back.

Paris Hilton was crying because she had just been told she had to serve her 23-day jail sentence in jail.

Funny things, tears. They can be triggered by the happiest moments or the saddest.

They can be set off by brutal pain and sheer terror, as they were for Kim Phuc.

Or they can simply mean you're feeling sorry for yourself. Like Paris.

But these tears, it turns out, had something in common: Exactly thirty-five years apart, they both ended up in the lens of Nick Ut's camera.

Both pictures soon spread around the world, reinforcing the power of a memorable image at the same time they very different messages illustrate the yin and yang of photojournalism.

On June 8, 1972, Ut was a 21-year-old photographer for the Associated Press's Saigon bureau. The Saigon native had carved himself a job taking pictures from the middle of the war.

He rose around 5 a.m. that day, found a driver, put on a flak jacket and headed up Route 1, a hot zone. Early in the afternoon, South Vietnamese commanders called in an air strike on the outskirts of a village where Communist troops had been seen.

When the bombing ended, villagers poured out onto Route 1. A woman carried a baby who would soon die. Kim Phuc had pulled off her clothes and fled in Ut's direction, screaming: "Nong qua, nong qua!" which means "Too hot, too hot!"

Moments later, Ut commandeered a car and carried Kim Phuc into it. He got her to a hospital an hour away. By then, she had passed out from the pain.

Slim as the chances were for a young girl in a country with too many casualties and too few medical facilities, Kim Phuc survived. She made her way to Toronto, where she lives today with her family.

She and Ut, who won a Pulitzer Prize for his photograph of her terrified flight down Route 1, remain in touch.

Ut today lives in L.A. He still works for the AP, where he fights his wars for pictures of celebrities, preferably in nonlethal distress.

He's photographed the trials of O.J. Simpson, Michael Jackson and Phil Spector, among others, so he wasn't surprised Friday when he was sent out to cover Hilton, who had just been ordered back to jail after being let out on house arrest.

The street in front of her West Hollywood home was solid with paparazzi, and a tarp covered the gate, making photos tricky.

"I was lucky to get the shot I did," said Ut. "I focused on her blond hair when she got out."

Unlike that afternoon in Saigon, getting the picture finished Ut's mission. He probably won't win another Pulitzer this time, and neither does he try to contrast this world to that one.

Asked about celebrity versus war photography, he says only, "It's very different."

NICK UT

How a famed war photog found himself staking out Paris Hilton

Nick Ut's 1972 shot of 9-year-old Kim Phuc, running naked down a highway after her village was bombarded with napalm, became one of the most famous photos of the Vietnam War. Photo by AP

Same photographer, 35 years later and a world away: Paris Hilton being taken to court from her home last Friday by the L.A. County Sheriff's Department. Photo by AP

photograph celebrity phenomenon Paris Hilton who, after a series of run-ins with the law, received a real-life jail sentence.

Nick took up a position outside her home to photograph her on the way to jail. As the sheriff's car with her in the back seat drove by, Nick made a through-the-window shot and captured a photo of a weeping woman with unkempt hair, a portrait of the now less than glamorous Ms. Hilton. It wasn't much of a picture but in paparazzi situations like that a photographer does what he can. The picture was widely published.

Now the coincidence. Nick photographed the weeping Paris Hilton on June 8, 2007, exactly 35 years to the day, even close to the hour, from when he photographed another weeping female, Kim Phuc, her hair also mussed, screaming in pain as she fled an inferno. The coincidence prompted a retelling of the Ut/Kim saga. Kim's photo appeared alongside the Hilton photo with stories comparing the horror and agony Kim endured versus Hilton's frivolous lifestyle misdeeds and jail sentence of several weeks. Some commentators criticized a media organization that would relegate a photographer of Nick's stature to what was described as a paparazzi event. Critics failed to realize that while a wire service photographer can be a hero today, tomorrow he or she takes assignments off the top just like everyone else on the staff.

Nick's comment? A philosophical, "The world cried for Kim Phuc, Paris Hilton cried alone."

The photo was back in the news again—this time during August of 2016. It appeared first in *Aftenposten*, Norway's most prominent newspaper as one of several illustrations with a story about famous war photographs. The story was posted on *Aftenposten*'s Facebook page. That is when technology kicked in and the photo was ejected by Facebook algorithms designed to eliminate whatever it considered pornography and/or nudity.

Espen Egil Hansen, editor of the paper, lambasted Facebook and its founder, Mark Zuckerberg, in an open letter saying that Facebook and Zuckerberg restricted his, Hansen's, rights as the editor of his newspaper and that he, Zuckerberg, was abusing his power. An international dustup followed as a large number of Facebookers posted copies of the photo. Posters included Norway's prime minister who added the picture on her Facebook page. The comments

▲ Front page of Norway's *Aftenposten* criticizing withdrawal of Napalm Girl picture from Facebook. (Courtesy, Aftenposten)

went beyond the picture with some critics indicating that Facebook had also restricted information from conservative sources.

In the end Facebook relented and the photo and story were reposted, but only after Hansen suggested in no uncertain terms that Facebook needed to reconsider its technology.

As his career wound down, Nick was asked whether he would ever want to photograph another war. Nick shook his head:

"I'm too old now to cover war," he said. "I have wife, children, grandchildren. As a young man I was not afraid for wounding, even possible death. But others now matter."

In that context Nick turned to nature to find new subjects for his personal photography. He connected with a group of photographers that called themselves Lunartics. On those nights when the sky was clear and the moon was full Lunartics gathered with their long lenses to photograph airliners taking off from the Los Angeles airport and silhouetted against the moon. Sounds easy but it can be difficult listening for the oncoming jets, hoping they pass across the moon and not over it or beneath it, but just as a full black silhouette against the moon's white surface. If everything is right the image lasts only a split second.

Nick photographed flowers, and he traveled to sanctuaries to photograph immense flocks of birds. He joined whale watchers off the California coast and photographed dolphins and humpback whales breaching, another difficult type of photography much like covering the unexpected action of sports. He traveled to Baja to photograph humpbacks and orcas and to capture images of eagles in flight.

When in New York City, Nick left his bed in the early morning to visit a nearby fenced park to photograph hawks hunting for mice and sometimes posing majestically for Nick.

. . .

Spring of 2017 brought Huynh Cong Ut—better known as Nick Ut, sometimes called "Hollywood Nick"—to his 65th birthday. He could have continued to cover news for AP but decided it was time for retirement, time to pursue other photographic projects.

News of his retirement led to a series of interviews and parties. Numerous stories appeared on the web, all centered on the Highway 1 photo. AP carried a gallery of his photographs. Among the many recognitions he received was a place in the Leica Photo Hall of Fame, awarded in 2012. Leica invited Nick to attend several of its local Leica showrooms, and travel to places like Bangkok and Singapore that extended well into his retirement days.

In Los Angeles a series of retirement celebrations marked Nick's career. The city threw one party, another LA party honored his life achievement; there was a gathering in the Vietnamese community, and AP held a retirement party. Many of Nick's AP friends attended: Linda Deutsch was the MC and speakers included AP President Gary Pruitt and AP photo boss Denis Paquin who reviewed Nick's career. Vietnam mates Peter Arnett and Neal Ulevich attended. Vietnam veterans in the crowd thanked Nick for ending the war with his photo. Judge Lance Ito, the jurist of the OJ Simpson trial, stopped by. Paris Hilton sent Nick a video of her singing retirement congratulations.

One question was repeated: "Nick, what are you going to do now?"

"I will always take pictures," he replied. "Taking pictures is my doctor, my medicine. My life."

"My doctor, my medicine. My life."

▲ Nick Ut holds up two long lenses in the AP LA bureau as he turns in his equipment on his final day as a staff photographer. (Courtesy, Scott Templeton)

▲ Comrades and AP colleagues Peter Arnett and Nick Ut, who together covered the war in Vietnam.

AFTERWORD

PETER ARNETT, AP WAR CORRESPONDENT

In 2017, Nick Ut and Peter Arnett were in Vietnam to attend a conference. They visited Trang Bang where Nick was interviewed for a documentary. The two veteran war correspondents walked along Highway 1 much as they had in 1972 when Arnett wrote a story about what remained of the town after the battle in which Kim Phuc was burned. He wrote again about Trang Bang for this book, describing the town some 45 years later. Here are Arnett's reflections:

"I returned to Trang Bang with Nick Ut four decades later, crammed into a van with a Swiss television crew that planned to feature Nick in a documentary about the postwar years. Two weeks earlier, an American camera crew had accompanied him on the same route, intent on producing a documentary about his life. To Nick Ut, the attention was routine. For anyone interested in his life, and many were interested, all roads now led to Highway 1 and Trang Bang, and to the instant when a click from his camera immortalized a shocking moment in the waning days of the Vietnam War.

"As in so much of modernizing Vietnam, the present has swallowed the past, with Highway 1, once a route to the western border, now the main thoroughfare to the Cambodia capital of Phnom Penh. On the four traffic lanes that replaced the old potholed road, trucks, automobiles and motor bikes now flow past Trang Bang night and day, and ribbon development along the roadsides obscures the rice paddy fields with two- and three-story office buildings, restaurants and truck parks.

"But in approaching the town, a distinctive element of Nick's historic photographic record of his dramatic coverage in Trang Bang appeared in the distance: the twin towers of the Cao Dai temple that loomed through the napalm smoke and flames behind the children fleeing fearfully down the

▲ Ut and Arnett together again as residents of southern California, photographed shortly after a return from Vietnam in 2017.

road. Pulling into the front yard of the yellow building with its "left eye of god" decorations symbolizing the Cao Dai religion, Nick explained that the parents of Kim Phuc took refuge there as she and the other children raced for apparent safety down the road.

"And in a sliver of the muddy roadside next to the temple, another shrine of sorts; a makeshift soup and tea shop, with a dirt floor, unsteady wooden tables and chairs and a tiny kitchen, with a copy of Nick's historic picture of Kim Phuc tacked to the inside of the crude entranceway. The owner is herself historic for her inclusion in the group of desperate children photographed by Nick, her name Ho This Hien, running at Kim Phuoc's right, wearing a white garment and holding the hand of her young brother. Nick's reunion with this woman occasioned great excitement for the Swiss television team, as did his encounter with a pair of young women who eagerly posed for pictures with him as word got around the local community that Nick was back in town.

"A heavy downpour of rain ended the visit, but not Nick's professional instincts. He crouched at roadside, shooting pictures of the motor bikes and automobiles splashing through the water, maybe remembering the first time, over forty years earlier, when he had taken his life-changing photographs on the same highway."

LIFE AFTER AP

(Courtesy, Remo Buess)

AP retirement ended Nick Ut's daily pursuit of news assignments. He remained busy as ever, however, driven by his desire to make photos — a compelling need he described as "my doctor and my medicine."

Worldwide travel increased to a point where it seemed he spent more time in the air than on the ground. Nick was invited to participate in a photo workshop in Switzerland, another in Shanghai. He made guest appearances at photo festivals in Kerala, India. As a celebrity guest he attended the opening of Leica showrooms in Singapore and Jakarta. He visited Vietnam, once with Peter Arnett as an invited guest at a conference, another time to visit family and friends. Nick joined Kim Phuc as a speaker when she attended Chicago and Miami fund raising functions for her foundation.

When he wasn't traveling, he created self-made assignments focused mostly, but not exclusively, on the world of nature. Some were close to home, others distant. He visited Los Angeles parks and other nearby sites. He joined whale watchers off California shores and visited nearby forests where Bald Eagles nested to protect and feed their young.

Though no longer on the daily news beat, LA's high-profile events tempted Nick to witness history as he had the past 50 years. On his own he occasionally took to the streets and roadways to photograph breaking news and reported such adventures to friends via a steady flow of images on social media.

Early in 2020, Nick was named as a recipient of the prestigious National Medal of Arts, which would make him the first wire service, hard news photojournalist so honored in the award's 36-year-history.

▲ Nick Ut with President Trump during ceremony honoring the photographer with the National Medal of Arts on January 13, 2021. (David Burnett/Contact Press Images)

President Trump was scheduled to present the award during a White House ceremony in March, but the deadly Covid-19 pandemic forced postponement. However, in January 2021, President Trump presented the award medals to Nick and his fellow recipients in the East Room of The White House. Nick received many congratulations from friends and colleagues, but some messages laced with criticisms of his participation created a bit of dustup.

Some believed that Nick should have refused the award. They attributed their opinions to the President's connection with the January 6, 2021, attack on the U.S Capitol and with massive criticism of methods Trump used to challenge his defeat in the 2020 presidential election. Attention to the comments were emphasized because The White House ceremony took place the same day Congress voted to impeach the president.

Nick's reaction to critics of his participation was simple. The award was for his photography, he felt, and had nothing to do with politics. It was, he believed, his personal choice to accept the medal and the honor it placed on his work and on picture journalism.

During his stay in Washington, he wandered the local DC streets without media credentials, but with his photographer's eye on full alert and photographed what he saw. This included one symbolic photo of chained and padlocked fences that underscored the city's lockdown for the inauguration of President Joseph Biden.

It took a pandemic to slow down Nick's retirement activity; not stop but force him to ease up on the vigorous lifestyle he's known for. The global bug forced him to avoid most long-distance air flights and cut back on lunches and dinners with friends. Nick, always with camera in hand, continued to capture the world as he sees it.

"I will make pictures," he once exclaimed, "until it is too painful for my fingers to push the camera button."

BONUS GALLERY

During his years in Los Angeles Nick Ut photographed news — disasters, sports, politics, the glitzy celebrity world — daily taking assignments off the top of the LA news budget. He still found time, however, to turn his camera on vignettes that what would otherwise go unnoticed providing a glimpse at everyday California and as he traveled to other American and foreign locations.

▶ Nick poses with Paris Hilton.

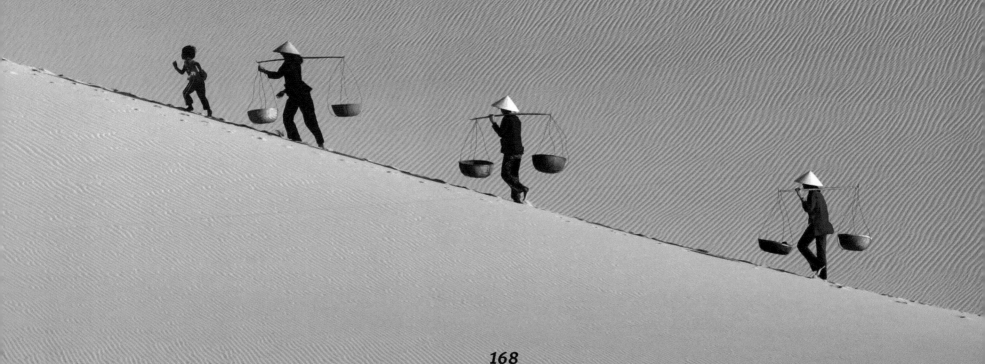

VIETNAM

Most of Nick's photography captured moments of bitter fighting but there were also opportunities for quiet vignettes of the land and its people, like this unusual photo of peasants crossing sand dunes . . .

168

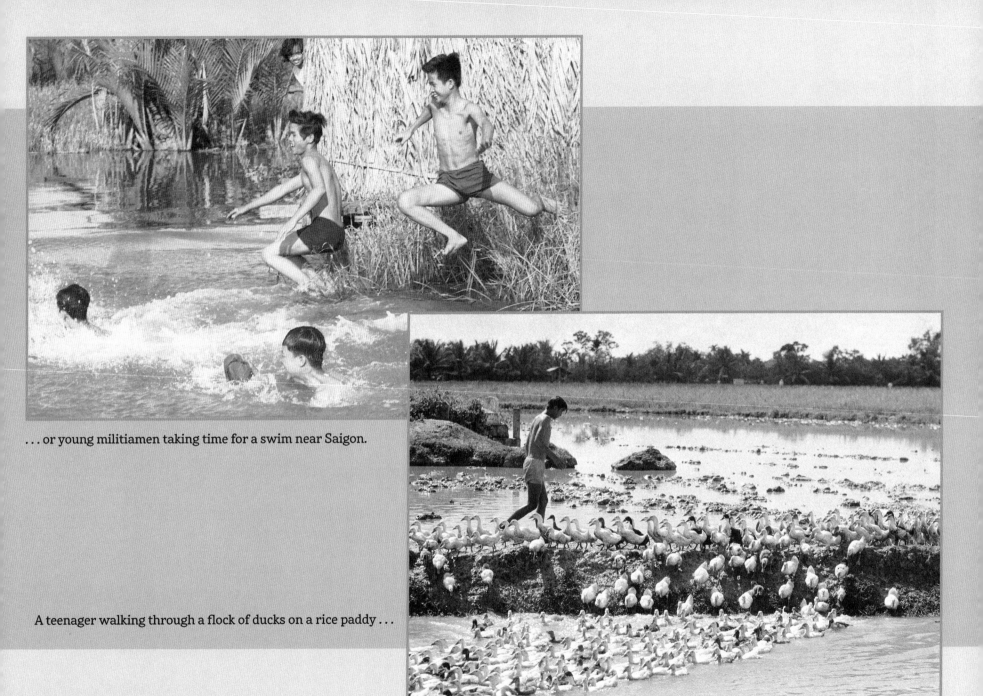

... or young militiamen taking time for a swim near Saigon.

A teenager walking through a flock of ducks on a rice paddy ...

169

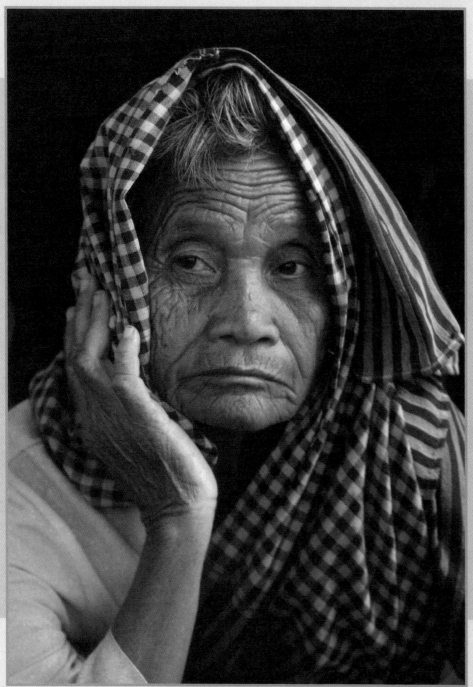

... and this elderly Cambodian refugee.

A little Vietnamese girl.

170

NATURE

▶ A bumblebee tests a flower at the North Hollywood train station, May 2000.

▲ Bison lock horns near Grand Island, Nebraska.

◀ A Giant White Egret feeds in a small body of water near downtown Los Angeles, November 2017.

171

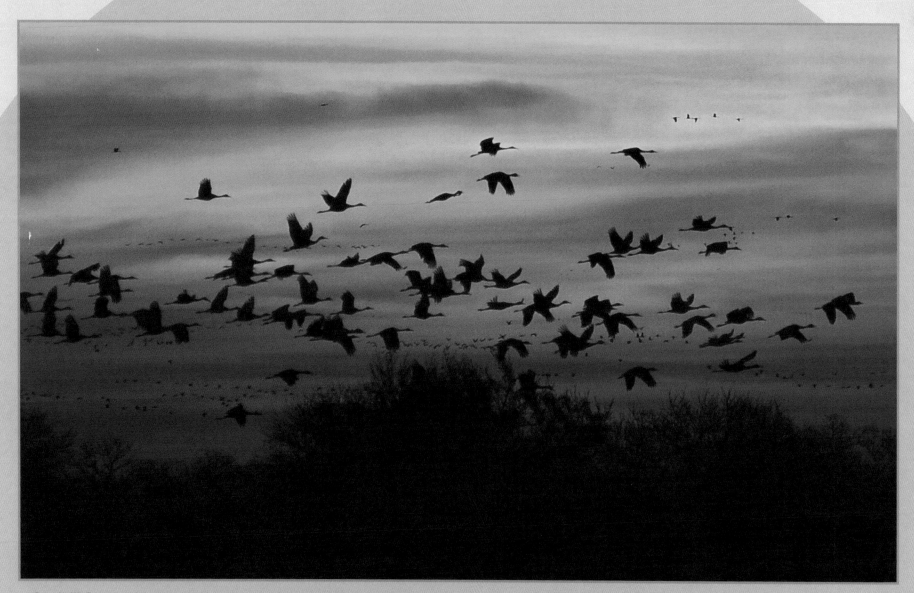

▲ Sandhill Cranes photographed in the setting sun at the Platte River in Grand Island, Nebraska, March 2017.

▲ An Osprey makes a major catch over California waters.

▲ A blooming flower attracts a hummingbird in Los Angeles, May 2018.

▶ A Japanese snow monkey enjoying the warmth of the hot springs in Nagano Prefecture, February 2012.

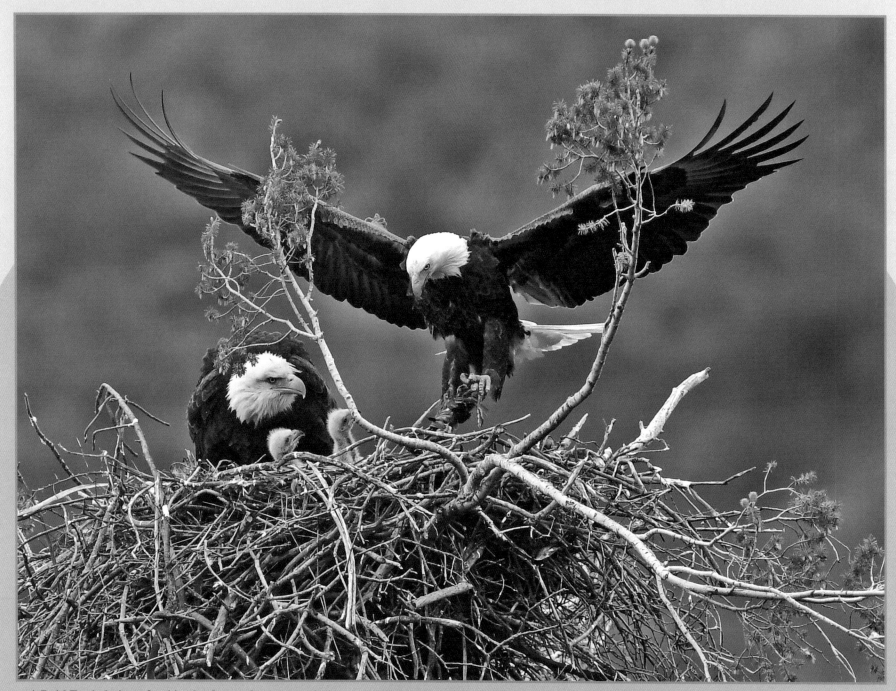

▲ A Bald Eagle brings food in the form of a captured pigeon to his family nest in the Angles National Forest, California, in March 2019.

▲ Deer forage across a snow covered meadow near Yellowstone National Park, November 2019.

▲ A picture postcard Japanese scene: A lone walker faces a snow landscape in Yahikio Mura City, Japan, May 24, 2004.

▲ A different view of a zebra at the Los Angeles Zoo in April 2019.

▲ Morning dew waters a Frangipani blossom at a Los Angeles train station in August 2020.

▶ A face in closeup at the San Diego Zoo in California.

177

A Humpback whale breaches off the Long Beach, California coast during a whale watching expedition, July 2015.

FIRES

▶ A wall of fire erupts on a hill near Santa Clarita, California, on the outskirts of Los Angeles, July 2016.

▲ A DC-10 plane drops fire retardant on the San Gabriel Mountains in an effort to halt spreading wildfires, September 2013.

◀ Firemen battle wildfires in the Angeles National Forest near Glendora, California, September 2002.

179

SPORTS

▲ Former Heavyweight boxing champion Mike Tyson takes a phone call during a news conference, December 1998. He marked his return to boxing.

◄ George Foreman and Tommy Morrison slug it out in a heavyweight title fight in Las Vegas, June 1993.

▶ U.S. goalkeeper makes a save of Iran's kick during an international soccer game at the Pasedena Rose Bowl, January 2000.

▼ Home plate action in a Dodger-Marlins game in Los Angeles, July 1996.

PROTESTS

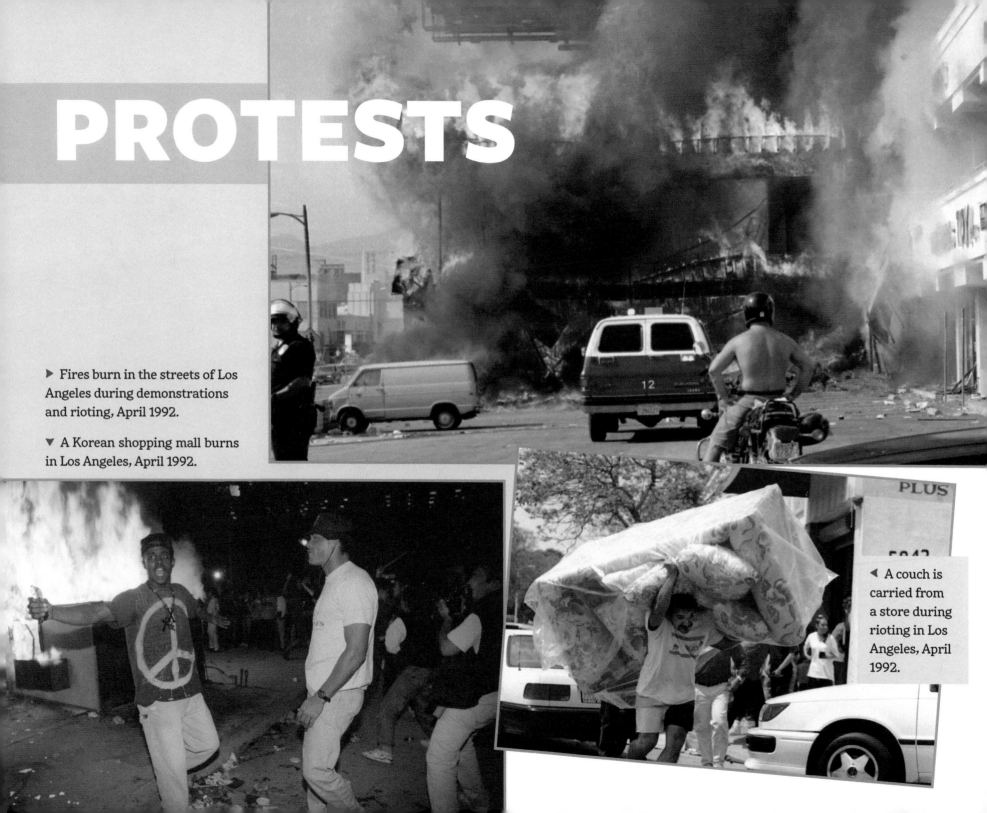

▶ Fires burn in the streets of Los Angeles during demonstrations and rioting, April 1992.

▼ A Korean shopping mall burns in Los Angeles, April 1992.

◀ A couch is carried from a store during rioting in Los Angeles, April 1992.

COURTS

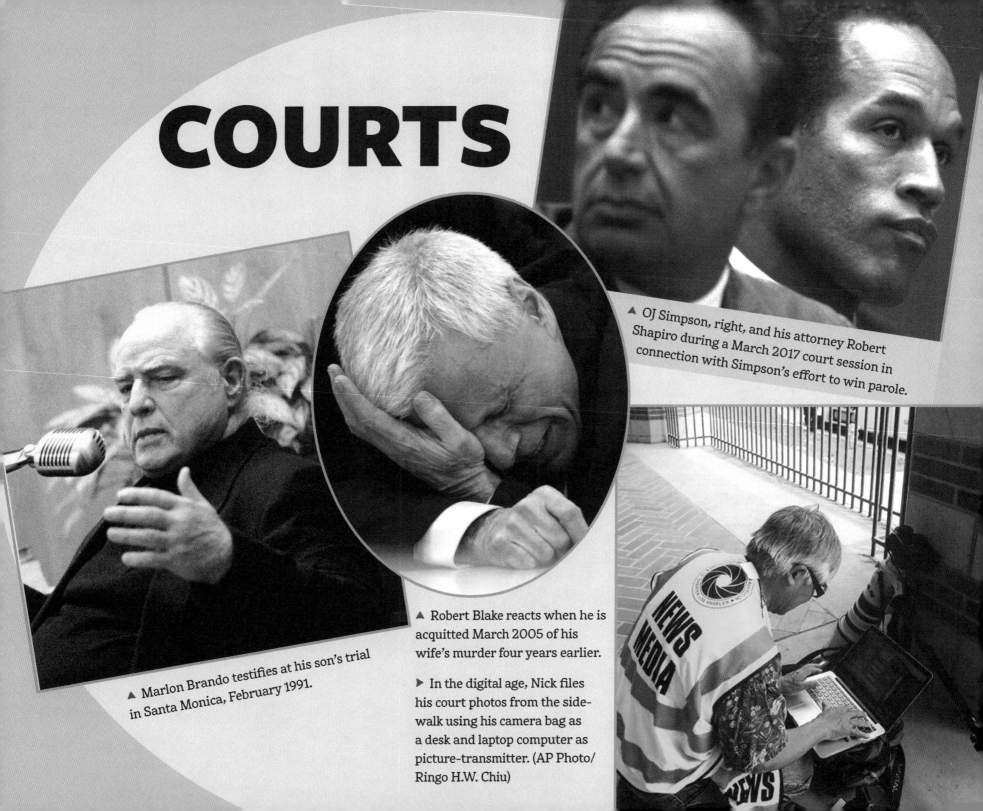

▲ OJ Simpson, right, and his attorney Robert Shapiro during a March 2017 court session in connection with Simpson's effort to win parole.

▲ Marlon Brando testifies at his son's trial in Santa Monica, February 1991.

▲ Robert Blake reacts when he is acquitted March 2005 of his wife's murder four years earlier.

▶ In the digital age, Nick files his court photos from the side-walk using his camera bag as a desk and laptop computer as picture-transmitter. (AP Photo/ Ringo H.W. Chiu)

MOMENTS

▲ U.S. Air force jets in formation at the Marama Air Show in San Diego, September 2019.

▶ A surfer creates a wall of water along the Malibu coast, May 2020.

184

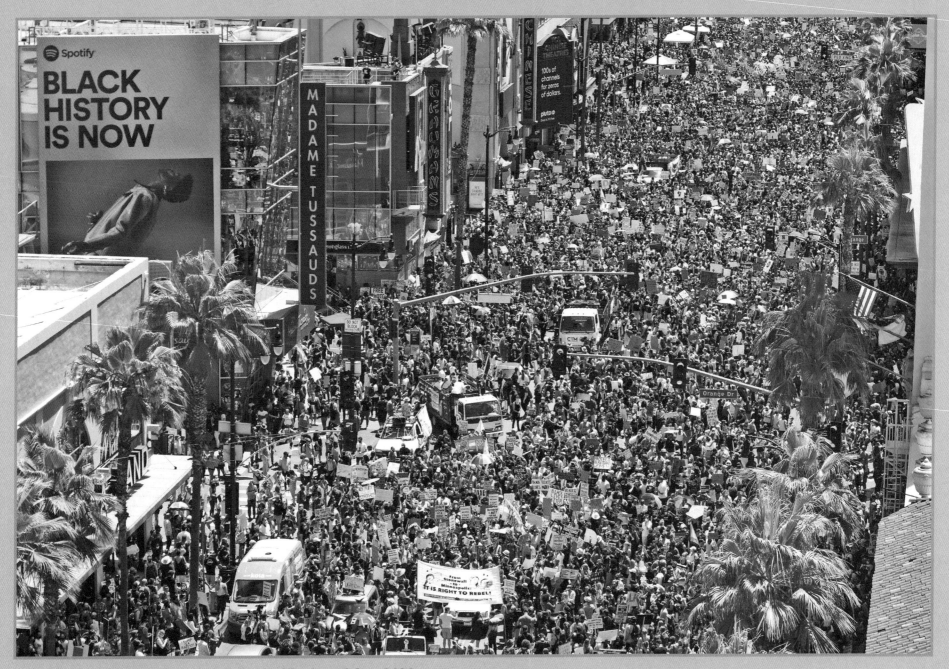

▲ Black Lives Matter protesters fill Hollywood Boulevard, June 2020.

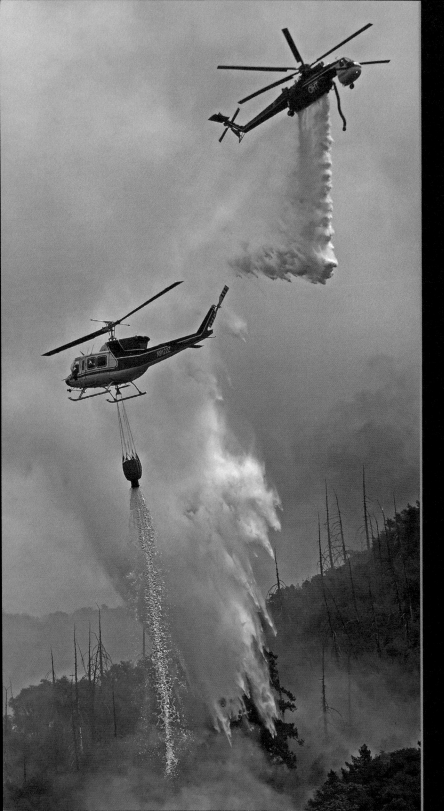

▲ An airliner near Los Angeles International Airport is silhouetted in an autumn moon, September 2016. A group of camera enthusiasts known as Lunartics photograph the planes whenever clear weather offers a bright lunar background.

◄ Helicopters, rarely seen this close together, drop their firefighting load during California fires, September 2020.

186

Lunar eclipse, start to finish, photographed from an Oregon location in August 2017.

◀ The streets of
Washington, DC, in
lockdown as a result of
the siege of the Capitol
on January, 6, 2021.

HOLLYWOOD

◀ Actress Bette Davis at awards presentation dinner recognizing her contribution to movie making, April 1982.

▶ Meryl Streep and Roy Scheider at Film Critics Award dinner, January 1982.

189

▲ Alice Cooper after he was honored with a star on the Hollywood Walk of Fame, December 2003.

▶ SEAL performs in Los Angeles, July 2018.

▶ Jay Leno and Rodney Dangerfield exchange gags at a Hollywood ceremony, March 2002.

▼ Anna Nichole Smith at Federal Court in Los Angeles, October 1999.

▶ Steven Spielberg in cap and gown as he receives his degree at California State University, May 2002.

191

▲ Michael Jackson atop his limousine to wave to his fans after a court appearance, January 2004.

◀ Joan Collins raises her glass to toast a libel suit settlement and to honor Nick's picture of Kim Phuc. The celebration came during an interview at the star's home

▲ Tom Hanks and wife Rita at Mann's Chinese Theater, July 1998.

ABOUT THE AUTHOR

▲ Author Hal Buell with Nick Ut. (Courtesy, Peter Costanzo)

Hal Buell was the head of the Photography Service at The Associated Press for twenty-five years where he supervised an international staff of 300 photographers. He is also the author of "Moments: The Pulitzer Prize-Winning Photographs" and "Uncommon Valor, Common Virtue," a book about war photographer Joe Rosenthal and his famous photo of the American flag raising on Iwo Jima.

ACKNOWLEDGMENTS

Many knowledgeable colleagues contributed to the story and photographs of Nick Ut's life as an AP combat photographer in Vietnam and his many years covering Los Angeles and Hollywood.

Claudia DiMartino's English teacher's eye and photo editor's experience kept the narrative moving forward.

Valerie Komor, Director of AP's Corporate Archive provided transcripts of oral history interviews conducted by her and others that documented Nick's activities over the years. Her staff, Francesca Pitaro and Sarit Hand, likewise contributed interview information.

AP Corporate Communications editor Chuck Zoeller shared his knowledge of Vietnam photography. Sean Thompson, AP photo archive staffer, dug deeply into AP film negative files to find pictures by Nick not digitized.

Neal Ulevich, who covered the Vietnam War alongside Nick, offered specific insights not available elsewhere including personal family correspondence about Vietnam. David Burnett, a Time/Life photographer who was at Trang Bang when Kim Phuc was injured, provided detailed photographer reaction to scenes like those of June 8, 1972. Peter Arnett, AP's Pulitzer Prize winning correspondent and long time friend of Nick, contributed detail of the photographer's life in Vietnam, and wrote the Afterword for this book.

John Nance (RIP), Vietnam colleague and friend of Nick, transcribed Nick's early career notes in English.

Spencer Jones was Nick's first Los Angeles editor and shared information about Nick's first months on the Hollywood beat. Linda Deutsch, AP's long time star court reporter, found Nick in the Guam refugee tent city and years later worked with him covering countless courtroom stories in Southern California. Kelly Tunney, who covered Vietnam and later headed up AP Corporate Communication, contributed insightful guidance on Nick's story.

Peter Costanzo, Director of Programming who manages AP's book publishing division, suggested this project and guided the effort from idea to publication. Thanks to editor Chris Sullivan who provided helpful guidance. And Kevin Callahan, book designer from BNGO books, who helped bring these pages to life.

Nick Ut, of course, was and is the primary teller of his life long work as a wire service photographer. Most of the photos in this book come from his cameras.

PHOTO CREDITS

All photos featured in "From Hell to Hollywood" were taken by Nick Ut on behalf of The Associated Press or provided from Nick Ut's personal collection, unless indicated otherwise.

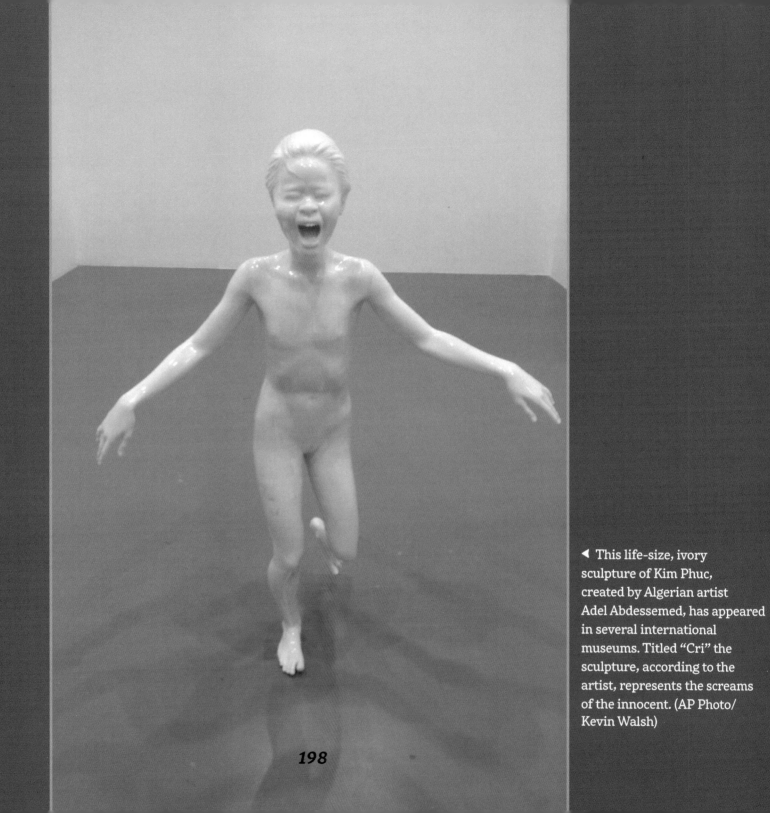

◄ This life-size, ivory sculpture of Kim Phuc, created by Algerian artist Adel Abdessemed, has appeared in several international museums. Titled "Cri" the sculpture, according to the artist, represents the screams of the innocent. (AP Photo/ Kevin Walsh)

CPSIA information can be obtained at www.ICGtesting.com
Printed in the USA
BVIW121100150321
602549BV00009B/27